W9-ASP-708

Cera mic Art:

Comment and Review

1882–1977

WITHDRAWN

Illinois Central College
Learning Resources Center

Ceramic Art

Comment and Review 1882-1977

An Anthology of Writings
on Modern Ceramic Art

EDITED BY

Garth Clark

E. P. DUTTON • NEW YORK

Grateful acknowledgment is made to the following for permission to use copyright material:

Sandy Ballatore: "The California Clay Rush." Reprinted by permission of *Art in America*. Copyright © 1976 by *Art in America*.
Michael Cardew: "Industry and the Studio Potter," "Stoneware Pottery," "Potters and Amateur Potters." Reprinted by permission of Michael Cardew. Copyright 1942, 1950, © 1972 by Michael Cardew.
John Coplans: "Abstract Expressionist Ceramics." Reprinted by permission of John Coplans. Copyright © 1966 by John Coplans.
Harry Davis: "Some Thoughts on Attitudes." Reprinted by permission of *Ceramic Review*. Copyright © 1971 by *Ceramic Review*.
Suzanne Foley: "A Decade of Ceramic Art: 1962–1972, from the collection of Professor and Mrs. R. Joseph Monsen." Reprinted by permission of the San Francisco Museum of Modern Art. Copyright © 1972 by the San Francisco Museum of Modern Art.
Erik Gronborg: "Viewpoint: Ceramics 1977." Reprinted by permission of Grossmont College Art Gallery. Copyright © 1977 by Grossmont College Art Gallery.
Bernard Leach: "Towards a Standard." Reprinted by permission of Faber & Faber. Copyright 1940 by Bernard Leach. "Belief and Hope." Reprinted by permission of Bernard Leach. Copyright © 1961 by Bernard Leach.
Bernard Pyron: "The Tao and Dada of Recent American Ceramic Art." Reprinted by permission of *Artforum*. Copyright © 1964 by California Artforum, Inc.
Bob Rogers: "Reflections on Freedom and Ceramics." Reprinted by permission of *Ceramic Review*. Copyright © 1975 by *Ceramic Review*.
Rose Slivka: "The New Ceramic Presence." Reprinted by permission of *Craft Horizons*. Copyright © 1961 by *Craft Horizons*.
Soetsu Yanagi: "The Buddhist Idea of Beauty," from *The Unknown Craftsman*. Reprinted by permission of Kodansha International, Tokyo. Copyright © 1972 by Kodansha International.

For information contact: E. P. Dutton, 2 Park Avenue, New York, N.Y. 10016

Library of Congress Catalog Card Number: 78-53107

ISBN: 0-525-47497-8 (DP)/0-525-07850-9 (Cloth)

Designed by Jacqueline Schuman

Published simultaneously in Canada by Clarke, Irwin & Company Limited, Toronto and Vancouver

10 9 8 7 6 5 4 3 2 1

First Edition

NK
3920
.C47
.1978

Contents

I / The European Arts and Crafts Movement

II / The Anglo-Oriental Influence

III / Postwar America: The Liberation of Clay

Color insert follows page 102.

Introduction:
The Search
for Context

In selecting this anthology, I found that a natural structure began to emerge, different from that which I had originally conceived, that traced the ceramist's search for context. The articles and essays fell easily into three basic groups, representing the dominant influences on the modern movement in ceramics. The first is the Victorian Arts and Crafts phase that produced the philosophical base for the artist-potter. The second is the influence of England and the Japanese Arts and Crafts philosophy, through Bernard Leach, and on the other hand the more pragmatic school of Western classicism through Michael Cardew. The third is the group of writings that concentrate on that period from the early 1960s when the so-called Abstract Expressionist movement in ceramics began to be identified and examined, giving the American potter a self-confidence and energy that has placed ceramics within the mainstream concerns of fine art today.

It cannot be said, however, that these writings were drawn from a plentiful cache of writings on the ceramic arts. Ceramics has developed in the twentieth century out of an "art education" background. Writings, therefore, have tended to reflect this orientation, and an enormous quantity of technical "how-to" literature has been produced. In dealing with the problems of aesthetics, two general approaches have been adopted. The one is to treat ceramics as a means of illustrating aesthetic qualities in general (texture, color, form, decoration), without dealing with the ceramic aesthetic in particular, or even for that matter, acknowledging that one existed. The other, is to deal with aesthetic discussion of early Chinese or Greek pottery in cold, archaeological terms. Overall, one finds an unease with the twentieth century, and so the ceramist has tended to take refuge in a romantic, and at times retrogressive, adulation of the past. What the potter, sculptor, or ceramist needs today is a more meaningful context for his choice of working in a single material and process, in an art world that is now strongly committed to pluralism.

In the process of selection, I have been obliged to leave out writings, which although instructive and valuable, did not fit the anthology format for one or

1. Paul Gauguin and Ernest Chaplet:
Brussels Vase, glazed stoneware vase. Paris,
1886. 11½″ (29.2 cm). Musée d'Art et
d'Histoire, Brussels, Belgium.

another reason. However, I wish to explore some of these briefly in this introduc-
tion, beginning with the writings of Paul Gauguin. Gauguin first worked with
clay in the winter of 1886/87, in the Paris studio of artist-potter Ernest Chaplet.
He produced an extraordinary output of ceramic objects, mainly based on a
thematic interpretation of the vessel. His rude and naked use of the clay pre-
dictably resulted in the objects' being dismissed as eccentric in their day, and it
is only recently that the ceramic aesthetic has broadened sufficiently to acknowl-
edge the genius in these expressive, intense, and symbolic objects.

Gauguin's involvement with clay resulted in a large correspondence on his
experiences and reactions to the disciplines of the fire, and what emerges from

these letters is Gauguin's ritualistic appreciation of the ceramic processes as part of a climactic buildup to the firing itself.[1] In 1889, for the magazine *Le Moderniste*, Gauguin wrote a review of ceramics on the Exposition Universelle of the same year, lamenting that the so-called art connoisseurs were unable to enjoy the beauty and depth on show at the ceramics pavilion:

> Ceramics is not a futile activity. In the most remote times of our history, among the Indians of America one finds their art constantly in favour. God made man with a little bit of clay. With a little bit of clay one can make metal, precious stones. With a little bit of clay, and a little bit of genius. Let us examine the question, and take a small piece of clay. Such as it is, it has no interest, you put it into a kiln, it cooks like a lobster and changes colour. A low firing transforms it but slightly. One must wait for a much higher temperature so that the metal which it contains reaches fusion. I feel this is an interesting subject, and nevertheless, out of ten educated persons, nine pass in front of this section with an extreme indifference. What can we say? They simply do not know.[2]

The review goes on to insist that ceramics obeys its own dynamics, and that even though a sculptor may be familiar with clay to create models for his bronze sculpture, there is a fundamental difference in concept when the fired clay object is intended to be the final product and the sculptor needs to relearn his vocabulary. If the artist superficially applies his skills as a painter or modeler, he would never coax the beauty out of the material, for the beauty could only be released by the liberating passage of the processes, and in particular, once it has "passed through the hell" of the firing. It was an interesting espousal of the views that were later to be proposed by Leach and Yanagi. But its source was not oriental, instead it came out of Gauguin's involvement in symbolism. His use of the word *hell*, for instance, was instructive. In later correspondence he talks of the pot surviving the firing, as a man burned to death in the fires of Hades, and, out of the fires of retribution, being purged and reborn. Gauguin's aesthetic is inspiring, even though his overall view was limited and somewhat narrow, looking upon low-fired objects as being "flirtatious and frivolous," and any single piece fired at several different temperatures as being incapable of achieving harmony.

[1] Extracts of Gauguin's correspondence can be found in Christopher Gray, *Gauguin's Sculpture and Ceramics* (Baltimore: Johns Hopkins University Press, 1963). See also Merette Bodelson, *Gauguin's Ceramics* (London: Faber & Faber, 1960).
[2] The quotation is an edited quotation taken from two reviews of the exhibition appearing in *Le Moderniste* (Paris), June 4, and June 13, 1889.

In the twentieth century, ceramics acquired a friend, whose gentle writings have proved to be a source of constant joy and inspiration, Herbert Read. Read has written frequently and with great affection about the ceramic arts. His two books on the subject, unfortunately, deal with a historical period out of the scope of this anthology, and his other writings were frequently one or two paragraphs to illustrate a point in a broader context. But these occasional paragraphs have contributed to a sense of pride and identity in the ceramic arts. The following excerpt is from *The Meaning of Art* (1931), a book compiled from a series of articles that Read wrote for the BBC's *The Listener* in the late 1920s and early 1930s. Under the heading of "Art Without Content," he deals with ceramics in these two paragraphs:

> Pottery is at once the simplest and the most difficult of all arts. It is the simplest because it is the most elemental; it is the most difficult because it is the most abstract. Historically it is among the first of the arts. The earliest vessels were shaped by hand from crude clay dug out of the earth, and such vessels were dried in the sun and wind. Even at that stage, before man could write, before he had a literature or even a religion, he had this art, and the vessels then made can still move us by their expressive form. When fire was discovered, and man learned to make his pots hard and durable; and when the wheel was invented, and the potter could add rhythm and uprising movement to his concepts of form, then all the essentials of this most abstract art were present. The art evolved from its humble origins until, in the fifth century before Christ, it became the representative art of the most sensitive and intellectual race that the world has ever known. A Greek vase is the type of all classical harmony. Then eastward another great civilization made pottery its best-loved and most typical art, and even carried the art to rarer refinements than the Greek had attained. A Greek vase is static harmony, but the Chinese vase, when once it had freed itself from the imposed influences of other cultures and other techniques, achieves dynamic harmony; it is not only a relation of numbers, but also a living movement. Not a crystal but a flower.
>
> The perfect types of pottery, represented in the art of Greece and China, have their approximations in other lands: in Peru and Mexico, in mediaeval England and Spain, in Italy of the Renaissance, in eighteenth-century Germany—in fact, the art is so fundamental, so bound up with the elementary needs of civilization, that a national ethos must find its expression in this medium. Judge the art of a country, judge the fineness of its sensibility, by its pottery; it is a sure touch-

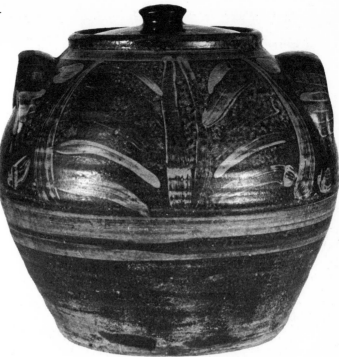

2. Michael Cardew: Slip-decorated earthenware. Winchcombe, England, c. 1935. H. 17¹¹⁄₁₆″ (45 cm). Private collection. Photograph: Garth Clark.

stone. Pottery is pure art; it is art freed from any imitative intention. Sculpture, to which it is most nearly related, had from the first an imitative intention, and is perhaps to that extent less free for the expression of the will to form than pottery; pottery is plastic art in its most abstract essence.[3]

In 1936 when Read published *Art and Industry*, he devoted a chapter to pottery. Most of this was a relatively didactic explanation of the principles of clay handling, although dealing briefly as well with some aesthetic implications. One issue that surfaced in this chapter was of particular interest and that was Read's change of mind on the subject of relative merits of wheel-thrown and moldmade vessels. In *English Pottery*, a book he had written with Bernard Rackham in 1924, they argued that:

Forms capable of being multiplied without variation from a single original model cannot but have a much smaller interest than those in which each individual piece is the direct expression of the potter's instinct. The molds used for casting pottery are, it is true, made by hand, but their employment is a purely mechanical process; moreover, the handwork involved in the cutting of them is of quite

[3] Herbert Read, *The Meaning of Art* (London: Faber & Faber, 1931), pp. 41–42.

3. Keith Murray: Earthenware with moonstone glaze. Wedgwood, England, 1935. H. 7⅞″ (20 cm). Private collection. Photograph: Garth Clark.

a different order from that of the potter's wheel. Both processes, it is true—casting and throwing—depend for their results on the cohesive quality of clay, but the stuff as it whirls and changes shape on the wheel under the hand gains, in a physical sense, a toughness and power to withstand strain which is not without its psychological appeal. Such vital quality in the finished work can never come from the passive settling of particles of clay on the inner side of a porous mold.[4]

Read arrived at this view from defining what he meant by vitality in pottery. All pottery, he maintained, should possess symmetry, or some more subtle balance. But this did not in itself promise vitality. Vitality in a pot would occur due to the "suggestibility of the lines and mass of a vessel. The eye registers and the mind experiences in the contemplation of energetic lines and masses a sense of

[4] Bernard Rackham and Herbert Read, *English Pottery: Its Development from Early Times to the Eighteenth Century: With an Appendix on the Wrotham Potters* by Dr. J. W. L. Glaisher (London: Ernest Benn, 1924), p. 19.

movement, rhythm, or harmony which may indeed be the prime cause of all aesthetic pleasure."[5]

However, when Read wrote *Art and Industry*, he admitted that he had oversimplified the aesthetic tenets of ceramics and that "vitality is not the simple unique quality we suppose it to be." Vitality in fact required a dichotomy, acknowledging one vitality that Read termed *mechanic dynamism* (energetic lines and masses), and another, he termed *organic vitality* (a sense of movement, rhythm). "What I want to suggest," concluded Read, ". . . is that the vitality proper to thrown pots is organic, and the vitality proper to cast pots is mechanical. What the cast pot loses in individuality, it gains in precision. Its precision

[5] *Ibid.*

4. Tullio D'Albisola and Farfa: Earthenware, polychrome underglaze decoration. Giuseppe Mazzotti Ceramiche, Albisola Mare, Italy, 1930. H. 9⅞″ (25 cm). Collection Esa Mazzotti, Albisola Mare. Photograph: Garth Clark.

is in the service of a pattern; the pattern is a human invention—it should be the invention of an artist."[6]

Toward the end of the 1930s a manifesto titled "Aeroceramica" was published that put forward a more anarchistic view than that of Read but found a consensus with his belief that the ceramic object should be the work of an artist. Its signatories were the founder of the Futurist movement, Filippo Tommaso Marinetti, and the potter Tullio D'Albisola.[7] It is a short statement, avowing the turning of ceramics into a fine art. This paragraph summarizes the movement's views, with Marinetti taking an uncharacteristically lenient view of traditional values:

> The Futurists have created ceramics characterised by the aesthetics of the machine, by geometry and any desire to return to the hybrid and static classicism is cretinous and unpatriotic. Our Aeroceramisti have an awareness of the corpus vasorum of all Oriental porcelain, of the pothecary's jars with their lustre surfaces, of the barbarian; and the bowls of the Blacks and Indians. They know too the shining classic Italian majolica and value it as the best in the world. But this is not to imitate. From this knowledge they can forget and overcome. And overthrow ideas and techniques with the VERY NEW, the VERY ORIGINAL, and the NEVER SEEN.[8]

The work of the *Aeroceramisti*, as they were generically known, was produced at Albisola Mare, between 1925 and 1939, by a group of artists, painters, sculptors, poets, potters, and ceramists. It was extraordinary in the way that it mirrored the development in West Coast ceramics today, taking a similar palette of colors, forms and the same insouciant throwaway line of humor.

In the 1940s a change began, away from the cultish "machine art" values that had become so popular during the 1930s, with the shows of industrial design at The Museum of Modern Art in New York and The Royal Academy in London. The view of Marinetti and Tullio D'Albisola, that pottery would become art by applying the principles of an established contemporary art form, was also short-lived. The Orient again became the dominant influence. In Scandinavia it was translated into a modern idiom, with clean hard forms and rich

[6] Herbert Read, *Art and Industry* (London: Faber & Faber, 1936).

[7] Although the manifesto was only published in 1938, its objectives and values had been established in 1927, during a meeting between Marinetti and D'Albisola, in Milan.

[8] Tullio D'Albisola and F. T. Marinetti, "Il Manifesto Futurista Ceramica e Aeroceramica," *Gazetta del Popolo* (Torino), September 7, 1938.

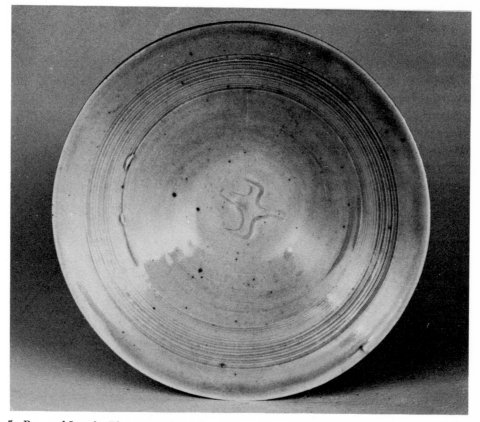

5. Bernard Leach: Plate, porcelain. St. Ives, Cornwall, 1956. D. 7½″ (19 cm).
Collection Fred and Mary Marer, Los Angeles. Photograph: Paul Soldner.

glaze treatment. More dominant however, was the oriental philosophy put forward by Bernard Leach in A *Potter's Book*. Published in 1940, it has since become the classic of ceramic literature, and its opening chapter, "Towards a Standard," the most widely read statement in the ceramic arts.

The book was published at the time that ceramics was looking for a bible. After the war, there was a rapid growth of the crafts, both in England and America, as those who had directly or indirectly experienced the horror of conflict sought a more gentle life-style. Leach's concept of art was close to that of William Morris, who looked upon art as being an expression of man's joy in his labors. In a sense this is the view expressed by George Wingfield Digby in his appraisal of Leach and the oriental concepts of beauty:

Pottery and porcelain is not, or need not be, just a matter of utensils for food, whose worth is gauged by the price paid or the refinement of the ornamentation. Nor has it anything to do with pretty, or perhaps facetious ornaments to stand about on table or mantelpiece. Nor is it something to be made with reference to the latest style in sculpture, as a credential of the *avant-garde* taste of the owner. Bernard Leach, obviously, thinks of pottery as being in an aesthetic category quite different from this. He thinks of a pot, even the most unpretentious piece, as being specifically a work of art. Other European artist-potters have proclaimed that a ceramic pot *can* be a work of art. But Leach, who absorbed the Oriental aesthetic attitude which had become part of the heritage of Japan and which is still not altogether extinct there, seems to say rather that every pot, every artifact, when made according to the tradition of the true artist-craftsman is a work of art, something complete and integrated, however humble.[9]

The writings of Leach and the many publications in the 1950s, on his work and that of other English artist-potters, tended to dominate the aesthetic values of the 1950s as functional stoneware and oriental glazes became the style of the decade and the Leach philosophy de rigueur in the art schools. This in itself was beneficial, bringing to those who worked in clay a standard of excellence and a sense of tradition. What was unfortunate was that so few of the Leach disciples were able to transform his beliefs into a meaningful contemporary statement, a standard that Leach himself set as a requirement for the potter who aspired to the role of artist in his society.

It was in America in the mid-1950s that the most significant synthesis of ceramic tradition and contemporary art expression took place, under the loose leadership of Peter Voulkos at the Otis Art Institute (then the Los Angeles County Art Institute) from 1954 to 1958. As this and the subsequent developments at Berkeley are covered in the anthology, I shall not go into further detail. But it is instructive to read this statement by Voulkos, written just at the close of the Otis period:

For me the making of pottery is not different from any other art form. One might say that the descriptive problems may vary. By this I merely mean that a pot is like a pot, like a painting is a painting. From this point on there is a world of difference. In between lies art.

[9] George Wingfield Digby, "Bernard Leach—The Bridge Between East and West" in "Essays in Appreciation of Bernard Leach," *New Zealand Potter*, Special Issue (February 1960).

These values in between must be constantly challenged. Only by recognizing and by being aware of all perceptory faculties can there be a recognition of identity. Automatic clarity becomes apparent on recognition and elimination of the obstacle.[10]

The activity around Otis and Berkeley later became identified with the Abstract Expressionist movement, first in Rose Slivka's early and intuitive article "The New Ceramic Presence" (*Craft Horizons*, July/August 1961) and in the writings of John Coplans for *Artforum* and for his groundbreaking "Abstract Expressionist Ceramics" exhibition in 1966. With this exhibition, ceramics acquired a national identity after decades of slavish imitation or reinterpretation of European and oriental influence. The same crosscultural play was still apparent in the work of the Abstract Expressionist ceramists, but the unifying energies, transformation, and self-confidence, were undeniably American.

10 Peter Voulkos, *Design Quarterly*, Double Issue, 42/43 (1958), p. 63.

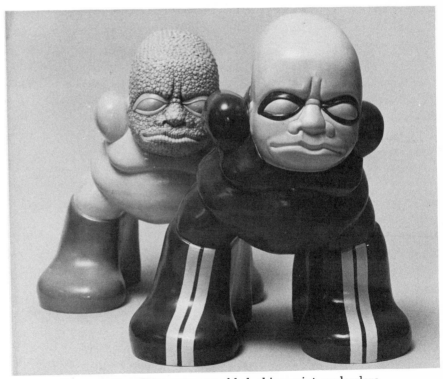

6. Tony Bennett: Two figures, press molded, china paint, underglaze. London, 1974. H. 17¾" (45 cm). Collection the artist. Photograph: Royal College of Art, London.

At the time of this exhibition, a new aesthetic had emerged in clay, and that was the Funk movement that was centered around Robert Arneson and his students at Davis, California. Its name came from the 1965 Funk exhibition at the University of California, Berkeley. Although the title was inappropriate to the exhibition as a whole, it did suit the work of Arneson, David Gilhooly, and a few other ceramists in the show. Funk adapted the low-fired traditions of clay, deliberately embracing hobby craft and lowbrow humor.

A superficial style of Funk became the rage throughout America, and even in Sweden and England. But it lacked the bite of the Davis Circle. Funk was a Lorelei, it was a regional expression that could only draw life from the Bay Area and even then in the hands of very few artists. The spirit of Funk, said Harold Paris, is "The casual, irreverent, insincere California atmosphere, with its absurd elements—weather, clothes, 'skinny-dipping,' hobby craft, sun-drenched mentality, Doggie Diner, perfumed toilet tissue, do-it-yourself—all this drives the artist's vision inward. This is the land of Funk."[11] What destroyed Funk's potency was the tendency toward a stylish elegance. The toilet jokes were replaced with elegant visual wit, and the penis teapots and tit casseroles became so tasteful that they lost their power to involve.

So as each decade has left its mark; the 1950s, with Abstract Expressionism, the 1960s with Funk—the 1970s is the decade of the Super Object. The style is identified by its decadent use of craft, extravagant lustre surfaces, trompe-l'oeil china painting, and soft-core surrealist imagery. The objects are elegant and tightly controlled, suppressing most of the expressionist qualities of ceramic processes and materials. The Super Object is not a new genre at all. It is a cyclical visitor. It arrives whenever the ceramist has lost a sense of his roots and has taken refuge in technical achievement. A few artists on the American West Coast and at London's Royal College of Art, where the Super Object makers have tended to congregate, have been able to convert the passive, stylish qualities with a fresh vision or biting satire. But generally the genre remains nihilist in its activity. Throughout history one finds that the Super Object results in horizontal activity, actively moving out into other fashionable disciplines to draw its eclectic imagery, and in no way advancing the vertical growth of ceramics.

The emergence of the Super Object also indicates the arrival of another problem. In 1937 *Fortune* magazine labeled ceramics "the art with the inferiority complex." The condition remains. This was painfully clear in "Illusionistic Realism, as Expressed in Contemporary Ceramic Sculpture," an exhibition that

[11] Harold Paris, "Sweet Land of Funk," *Art in America* (March/April 1967).

7. Anne Currier: Box, earthenware.
Seattle, Washington, 1975–1976.
19¹¹⁄₁₆″ × 19¹¹⁄₁₆″ × 9⅞″ (50 cm ×
50 cm × 25 cm). Private collection.
Photograph: Courtesy the artist.

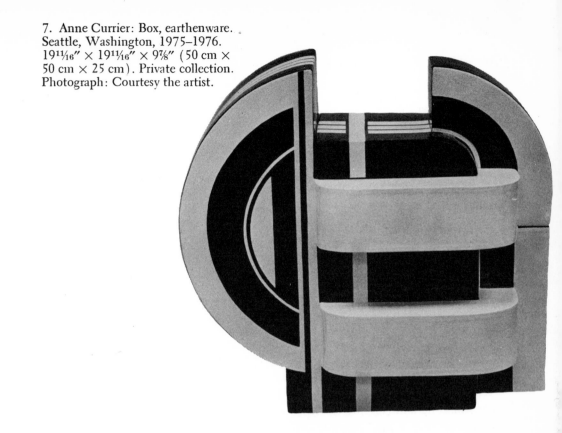

set out to create a genre for the Super Object.[12] In a pretentious essay Lukman Glasgow called on Magritte, Duchamp, and even Gestalt theory to provide respectability for the diverse works on show. Nowhere was there any mention of the long ceramic tradition, particularly vital in the eighteenth century, of ceramic trompe-l'oeil that occurred in China and Europe. As irritating was the use of the term *ceramic sculpture*, instead of *ceramics*. It had the snobbish double-barreled pretension of a Jones-Rockefeller combination. It also ignored the long debate in the 1930s, when Surrealist objects first emerged, about whether or not the pieces were sculpture. The consensus was very much that the objects were "extra sculptural," because they did not rely on form, but on tableaux of a purely pictorial order.[13]

[12] Lukman Glasgow, *Illusionistic Realism as Expressed in Contemporary Ceramic Sculpture*, Laguna Beach Museum of Art, California, January 4–February 3, 1977.

[13] See William Rubin, *Dada and Surrealist Art* (London: Thames and Hudson, 1969), pp. 9, 43. See also Salvador Dali, "Objets Surréalistes," *La Surréalisme au Service de la Révolution*, Paris, December 1931, p. 16.

A smaller exhibition that arrived and departed without any ballyhoo made a more convincing point and showed a better range of work. In the essay to the catalogue of "Viewpoint: Ceramics 1977," Erik Gronborg argues that the desire on the part of the artist to involve himself in the ceramic materials and traditions places him in a separate genre from the rest of the disciplines. In answer to the question why he had not used the term *ceramic sculpture*, he replied:

> Why do we not make general categories of bronze cast sculpture, or plastic sculpture, or acrylic painting? The only answer to me is that there is a particular tradition of involvement with clay and glazes, which gives these ceramic works, whether pots or sculpture, a certain character. Though the trends in ceramics largely follow general stylistic developments in art, the ceramic works never quite lose the craft element: the manipulation of a plastic mass, the emphasis on *object*, the ready use of color as part of the glaze tradition, the small scale and preciousness of appearance, and the reference in various degrees to the useful object, the pot and the plate. These are the qualities which make the difference between *ceramics* and *sculpture made of clay*.[14]

Now that there are signs of the ceramist getting over his embarrassment at the exuberant decorative quality of his material and his apologist attitude to his humble, functional origins, he is freeing himself to compete in the contemporary arts on his own terms. The difficulty of the Super Object is that the meticulous china-painted surfaces and multiple firings have resulted in little more than a theatrical charm. Because the ceramist is so heavily involved in processes, he now has to employ what I call "dialectic" craft, so that each process becomes yet another step in logical contribution to the content of the piece.

One area where this has worked, combining a high craft input—without the means of expression outrunning the content to be expressed—was in Rose Slivka's "Object as Poet," an exhibition at the Renwick Gallery (National Collection of Fine Arts, Smithsonian Institution, Washington, D.C., December 15, 1976–June 26, 1977). Although the examples in the show tended to be overliteral, the concept held good. Each element in the making process added to a visual poetry, applied with restraint and a highly personal vision. Slivka comments:

> In "The Object as Poet," craft and art join the poem in erasing lines and distinctions that the choice of materials and techniques

[14] Erik Gronborg, Introduction to *Viewpoint: Ceramics 1977*, Grossmont College Art Gallery, El Cajon, California, 1977.

heretofore imposed, maintaining an outworn hierarchy of forms and functions. The concerns with ideas, energy, irony, mystery, traditionally the realm of "fine art," are equally the concerns of modern craft. In this exhibition, there are no separations. Art crosses over into craft, liberating and celebrating materials, bringing attention to function and method, sometimes making craft actual subject matter, as abstract and philosophical considerations of process or the treatment of treatment, even as a joke.[15]

The seductive quality of process as an end in itself can result in craft addiction with the tendency toward "one process too many." In the 1970s, as has happened frequently in this century, it is the visitors to the medium that have awakened ceramics to the simpler and more direct qualities of the material. In 1976, the Everson Museum of Art, Syracuse, New York, held an exhibition titled "New Works in Clay by Contemporary Painters and Sculptors," curated by Margie Hughto. Most ceramists dismissed the exhibition as simplistic, merely exercises in clay. Yet for many the works, particularly those of Anthony Caro, were a reminder of purer notes of the art. It was a refreshing view after a season of leather-clay, denim-clay, paper-bag-clay, metal-clay, and painterly graphic surfaces. The same directness is apparent in the work of another artist, Mary Frank; although no longer a visitor, she first worked in clay in 1969, after establishing herself as a graphic artist and sculptor. In reviewing the work in one of her exhibitions, critic Hilton Kramer manages not only to describe her work but to suggest a context for the sculptural element of ceramics:

> Mary Frank is a magnificent anomaly among contemporary sculptors. While so many others expend their energies on making sculpture a language of cerebration, securely quarantined against direct expressions of feeling, she insists on making it a language of passion. The result is an oeuvre unlike any other on the current art scene, in which an imagery of great inwardness and intimacy is combined with an earthy articulation of emotion.[16]

Intimacy, emotion, earthiness, and passion—the vocabulary that comes so easily to ceramics is also paradoxically the area that so many ceramists today have attempted to suppress in their work. But it is these common qualities that have enabled artists such as Robert Arneson and Mary Frank to overcome artistic apartheid, integrating and being accepted in the fine arts. It is to be hoped that

15 Rose Slivka, Introduction to *The Object as Poet*, Renwick Gallery of the National Collection of Fine Arts, Smithsonian Institution, Washington, D.C., December 15, 1976–June 26, 1977.

16 Hilton Kramer, "Art: Sensual, Serene Sculpture," *The New York Times*, January 25, 1975.

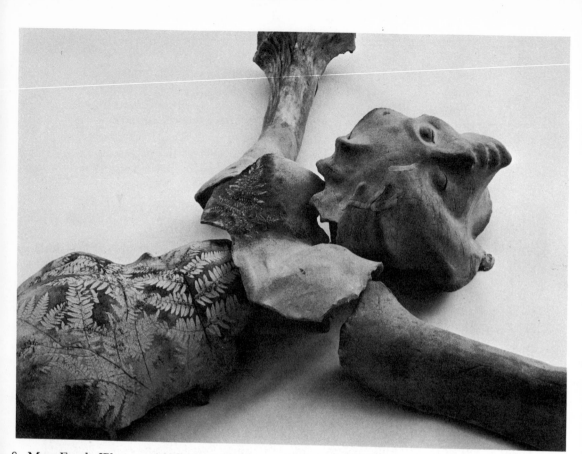

8. Mary Frank: *Woman with Outstretched Arms*, eight-part ceramic.
New York, 1975. L. 89¾" (2.28 m). Photograph: Courtesy Zabriskie
Gallery, New York.

the myth that the ceramist needs to do that same thing as the sculptor and
painter, but in clay, is beginning to evaporate.

A sign that a new sense of self is emerging is the ground-swell movement
back to the vessel that I encountered on two national tours of the United States.
The vessel remains the touchstone of the ceramic arts. Its subtlety and expres-
sion have been able to inspire and engage man for over 6,000 years. Nothing in
contemporary ceramic art suggests that the pot cannot continue to deal per-
tinently with its dynamics of volume, surface, and line.

The return of the vessel does not mean another generation of quasi-oriental,
"brown-bread" stonewares. The vessel is returning in the most abstract sense.
Function will continue to be a factor, whether as a reality or simply a metaphor,
serving the same purpose as function in Plato's republic, to thwart a tendency to
arbitrariness. The vessel will also be dealt with as an idea, rather than a reality,

9. Wayne Higby: *Black Granite Quarry*, landscape container, earthenware, raku technique. Alfred, New York, 1975. $10^{13}/_{16}'' \times 10^{13}/_{16}'' \times 10^{1}/_{2}''$ (27.5 cm \times 27.5 cm \times 26.7 cm).

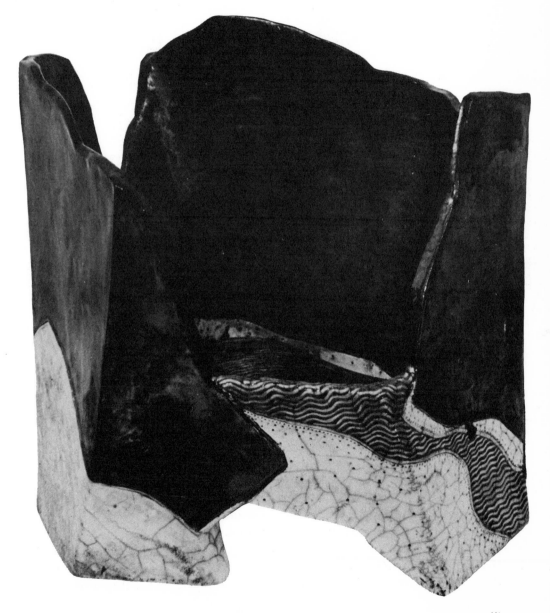

as seen in the cups of Kenneth Price and Ron Nagle, in the perspectival illusions of England's Elizabeth Fritch, and the landscape bowls and boxes of Wayne Higby.

Its appreciation as a contemporary expression is somewhat limited by a lack of vocabulary. Terms such as *craft, potter,* and even *vessel* are emotional labels with little common meaning. At a recent seminar in which I participated, the problems of discussing the vessel became so acute that we had to invent a new word, free of personal interpretation. The acronym we arrived at was absurd, VOCO (Vessel-Oriented Clay Object), but it immediately settled the furor and, in dealing with a neutral term, the discussion became positive and open. This is the challenge in ceramics today—a meaningful and precise vocabulary.

This challenge does not entail an instant dictionary of new words. Most of the existing vocabulary is perfectly adequate. What is needed is the discipline of applying the vocabulary to critical discussion and evaluation. This anthology represents the greater part of the achievements in this area, and although the articles and essays are excellent in themselves, this fact does reflect the limited activity that has taken place in ceramic criticism in the past century. A number of conditions account for this state, some of which were mentioned at the beginning

10. Erik Gronborg: Three from a set of five porcelain cups with dusters
and photo decals. San Diego, California, c. 1976.
H. (maximum) 5¹⁵⁄₁₆″ (15 cm). Collection the artist.
Photograph: Courtesy Grossmont College Art Gallery, El Cajon, California.

of this introduction. In addition, the decision of the magazines that serve ceramics—to adopt a supportive, paternalistic role—has dulled the teeth of criticism. Furthermore, these magazines also adopt the policy of having ceramists write about ceramists, and in most cases selecting those who are close friends. Comment, evaluation, and criticism therefore seldom rise above the level of a backslapping, self-congratulatory exercise.

Now that ceramics is entering a period of complexity and critical reevaluation, both aesthetically and in terms of concerns of energy and changing patronage, it requires more than ever before a sincere and intuitive critical feedback. This anthology has been assembled with this need in mind and not simply as an archival exercise. It does not represent a panacea, but a diversity of views from which the reader will need to distill the essence. Furthermore, it was conceived in the hope that it will, even in the humblest sense, be a catalyst that will spark an energetic dialogue between viewer and maker and so contribute to the future search for the ceramist's contemporary context.

GARTH CLARK

Los Angeles, Autumn 1977

I

The European Arts and Crafts Movement

The Lesser Arts of Life

William Morris

"Now all nations, however barbarous, have made pottery, sometimes of shapes obviously graceful, sometimes with a mingling of wild grotesquery amid gracefulness; but none have ever failed to make it on true principles, none have made shapes ugly or base till quite modern times. I should say that the making of ugly pottery was one of the most remarkable inventions of our civilization."

Throughout the writings of William Morris one finds declarations of his respect for the ceramic arts, in particular that period which was "progressive," that is, pre-Renaissance. Although his appreciation of the medium was a trifle narrow and romantic, Morris does set out a manifesto for the honest pot in this essay that stands up well to the scrutiny of time. The principles he proposed were not fully met in his time, however. The Victorian Arts and Crafts Movement, of which he was a founder, produced a curiously academic concept of an artist-potter. Nikolaus Pevsner rightly refers to them as "gentlemen potters." They approved certain elements of the potter's craft as being respectable, such as surface decoration and glaze science. Other aspects, particularly throwing or any other handling of the wet clay, were generally considered the function of a common laborer. As a result the Victorian art pottery shows its drawing-board origins in its sterile perfection. A few artists deserve exemption from this blanket condemnation, notably William de Morgan, the Martin Brothers, and the so-called rustics, rural potters such as Edwin Beer Fishley, Edward Bingham, and others.

"The Lesser Arts of Life" was first delivered as a lecture in Birmingham, England, on January 23, 1882, and published the following year in *Lectures on Art Delivered in Support of the Society for the Protection of Ancient Buildings*, edited by J. H. M. London. Owing to the length of this piece, I have deleted a section that dealt

with wood, weaving, printing, and clothing. The essay has been illustrated with examples of medieval English pottery from the collection of The Metropolitan Museum of Art, as well as examples of the work of Victorian potters mentioned above, and a tile panel produced at Morris, Marshall, Faulkner and Co. by Edward Burne-Jones.

The Lesser Arts of Life, A Lecture Delivered in Support of the Society for the Protection of Ancient Buildings

The "lesser arts of life" may not seem to some of you worth considering, even for an hour. In these brisk days of the world, amidst this high civilization of ours, we are too eager and busy, it may be said, to take note of any form of art that does not either stir our emotions deeply, or strain the attention of the most intellectual part of our minds. Now for this rejection of the lesser arts there may be something to be said, supposing it be done in a certain way and with certain ends in view; nevertheless it seems to me that the lesser arts, when they are rejected, are so treated for no sufficient reason, and to the injury of the community; therefore I feel no shame in standing before you as a professed pleader and advocate for them, as indeed I well may, since it is through them that I am the servant of the public, and earn my living with abundant pleasure.

Then comes the question, What are to be considered the "lesser arts of life?" I suppose there might be pros and cons argued on that question, but I doubt if the argument would be worth the time and trouble it would cost; nevertheless, I want you to agree with me in thinking that these lesser arts are really a part of the greater ones which only a man or two here and there (among cultivated people) will venture to acknowledge that he contemns, whatever the real state of the case may be on that matter. The "greater arts of life," what are they? Since people may use the word in very different senses, I will say, without pretending to give a definition, that what I mean by an art is some creation of man which appeals to his emotions and his intellect by means of his senses. All the greater arts appeal directly to that intricate combination of intuitive perceptions, feelings, experience, and memory which is called imagination. All artists, who deal with those arts, have these qualities superabundantly, and have them bal-

11. Thirteenth-century English earthen-
ware. Waterpot with orange brown glaze
remaining on upper part of body and neck
except around handle between rim and
shoulder, bottom pierced with holes.
H. 11¹³⁄₁₆″ (30 cm). The Metropolitan
Museum of Art, New York.

12. Thirteenth- to 15th-century English
earthenware. Jug, gray with mottled green
glaze on upper half. H. 6⅞″ (17.5 cm). The
Metropolitan Museum of Art, New York.

5

anced in such exquisite order that they can use them for purposes of creation. But we must never forget that all men who are not naturally deficient, or who have not been spoiled by defective or perverse education, have imagination in some measure, and also have some of the order which guides it; so that they also are partakers of the greater arts, and the masters of them have not to speak under their breath to half-a-dozen chosen men, but rather their due audience is the whole race of man properly and healthily developed. But as you know, the race of man, even when very moderately civilized, has a great number of wants which have to be satisfied by the organized labor of the community. From father to son, from generation to generation, there has grown up a body of almost mysterious skill, which has exercised itself in making the tools for carrying on the occupation of living; so that a very large part of the audience of the masters of the greater arts have been engaged like them in making things; only the higher men were making things wholly to satisfy men's spiritual wants; the lower, things whose first intention was to satisfy their bodily wants. But though, in theory, all these could be satisfied without any expression of the imagination, any practice of art, yet history tells us what we might well have guessed would be the case, that the thing could not stop there. Men whose hands were skilled in fashioning things could not help thinking the while, and soon found out that their deft fingers could express some part of the tangle of their thoughts, and that this new pleasure hindered not their daily work, for in the very labour that they lived by lay the material in which their thought could be embodied; and thus, though they laboured, they laboured somewhat for their pleasure and uncompelled, and had conquered the curse of toil, and were men.

Here, then, we have two kinds of art: one of them would exist even if men had no needs but such as are essentially spiritual, and only accidentally material or bodily. The other kind, called into existence by material needs, is bound no less to recognize the aspirations of the soul and receives the impress of its striving towards perfection. If the case be as I have represented it, even the lesser arts are well worthy the attention of reasonable men, and those who despise them must do so either out of ignorance as to what they really are, or because they themselves are in some way or other enemies of civilization, either outlaws from it or corrupters of it.

As to the outlaws from civilization, they are those of whom I began by saying that there are or were people who rejected the arts of life on grounds that we could at least understand, if we could not sympathize with the rejecters. There have been in all ages of civilization men who have acted, or had a tendency to act, on some such principle as the following words represent: The world is full of grievous labour, the poor toiling for the rich, and ever remaining poor;

with this we, at least, will have nought to do; we cannot amend it, but we will not be enriched by it, nor be any better than the worst of our fellows. Well, this is what may be called the monk's way of rejecting the arts, whether he be Christian monk, or Buddhist ascetic, or ancient philosopher. I believe he is wrong, but I cannot call him enemy. Sometimes I can't help thinking, Who knows but what the whole world may come to that for a little? the field of art may have to lie fallow a while that the weeds may be known for what they are, and be burnt in the end. I say that I have at least respect for the dwellers in the tub of Diogenes; indeed I don't look upon it as so bad a house after all. With a plane-tree and a clear brook near it, and some chance of daily bread and onions, it will do well enough. I have seen worse houses to let for seven hundred pounds a year. But, mind you, it must be the real thing. The tub of Diogenes lined with padded drab velvet, lighted by gas, polished and cleaned by vicarious labour, and expecting every morning due visits from the milkman, the baker, the butcher, and the fishmonger, that is a cynical dwelling which I cannot praise. If we are to be excused for rejecting the arts, it must be not because we are contented to be less than men, but because we long to be more than men.

For I have said that there are some rejecters of the arts who are corrupters of civilization. Indeed, they do not altogether reject them; they will eat them and drink them and wear them, and use them as lackeys to eke out their grandeur, and as nets to catch money with, but nothing will they learn or care about them. They will push them to the utmost as far as the satisfying of their material needs go, they will increase the labour infinitely that produces material comfort, but they will reach no helping hand to that which makes labour tolerable; and they themselves are but a part of the crowd that toils without an aim; for they themselves labour with tireless energy to multiply the race of man, and then make the multitude unhappy. Therefore let us pity them, that they have been born coarse, violent, unjust, inhuman; let us pity them, yet resist them. For these things they do unwitting indeed, but are none the less oppressors; oppressors of the arts, and therefore of the people, who have a right to the solace which the arts alone can give to the life of simple men. Well, these men are, singly or in combination, the rich and powerful of the world; they rule civilization at present, and if it were not through ignorance that they err, those who see the fault and lament it would indeed have no choice but to reject all civilization with the asectic; but since they are led astray unwittingly, there is belike a better way to resist their oppression than by mere renunciation. I say that if there were no other way of resisting those oppressors of the people, whom we call in modern slang Philistines, save the monk's or ascetic's way, that is the way all honest men would have to take whose eyes were opened to the evil. But there is another way

7

13. Thirteenth- to 15th-century English earthenware. Jug, buff earthenware, dark green slightly iridescent glaze handle, bottom, and spattered unevenly on body, neck, and rim. H. 6½″ (16.5 cm). The Metropolitan Museum of Art, New York.

8

of resistance, which I shall ask your leave to call the citizen's way, who says:
There is a vast deal of labour spent in supplying civilized man with things which
he has come to consider needful, and which, as a rule, he will not do without.
Much of that labour is grievous and oppressive; but since there is much more of
grievous labour in the world than there used to be, it is clear that there is more
than there need be, and more than there will be in time to come, if only men of
goodwill look to it; what therefore can we do towards furthering that good
time and reducing the amount of grievous labour: first, by abstaining from multi-
plying our material wants unnecessarily, and secondly, by doing our best to
introduce the elements of hope and pleasure into all the labour with which we
have anything to do?

These, I think, are the principles on which the citizen's resistance to Philis-
tine oppression must be founded: to do with as few things as we can, and as
far as we can to see to it that these things are the work of freemen and not of
slaves; these two seem to me to be the main duties to be fulfilled by those who
wish to live a life at once free and refined, serviceable to others, and pleasant to
themselves. Now it is clear that if we are to fulfil these duties we must take
active interest in the arts of life which supply men's material needs, and know
something about them, so that we may be able to distinguish slaves' work from
freemen's, and to decide what we may accept and what we must renounce of
the wares that are offered to us as necessaries and comforts of life. It is to help
you to a small fragment of this necessary knowledge that I am standing before
you with this word in my mouth, the "lesser arts of life." Of course it is only on
a few of these that I have anything to say to you, but of those that I shall speak
I believe I know something, either as a workman or a very deeply interested on-
looker; wherefore I shall ask your leave to speak quite plainly, and without fear
or favour.

You understand that our ground is that not only is it possible to make the
matters needful to our daily life works of art, but that there is something wrong
in the civilization that does not do this: if our houses, our clothes, our house-
hold furniture and utensils are not works of art, they are either wretched make-
shifts or, what is worse, degrading shams of better things. Furthermore, if any of
these things make any claim to be considered works of art, they must show
obvious traces of the hand of man guided directly by his brain, without more
interposition of machines than is absolutely necessary to the nature of the work
done. Again, whatsoever art there is in any of these articles of daily use must be
evolved in a natural and unforced manner from the material that is dealt with:
so that the result will be such as could not be got from any other material; if
we break this law we shall make a triviality, a toy, not a work of art. Lastly, love

9

of nature in all its forms must be the ruling spirit of such works of art as we are considering; the brain that guides the hand must be healthy and hopeful, must be keenly alive to the surroundings of our own days, and must be only so much affected by the art of past times as is natural for one who practices an art which is alive, growing, and looking toward the future.

Asking you to keep these principles in mind, I will now, with your leave, pass briefly over the "lesser arts," with which I myself am conversant. Yet, first, I must mention an art which, though it ministers to our material needs, and

14. Thirteenth- to 15th-century English earthenware. Jug, buff earthenware with mottled green glaze remaining on shoulder and lower part of handle. H. 6⅞″ (17.5 cm). The Metropolitan Museum of Art, New York.

therefore, according to what I have said as to the division between purely spiritual and partly material arts, should be reckoned among the "lesser arts," has, to judge by its etymology, not been so reckoned in times past, for it has been called architecture; nevertheless it does practically come under the condemnation of those who despise the lesser or more material arts; so please allow me to reckon it among them. Now, speaking of the whole world and at all times, it would not be quite correct to say that the other arts could not exist without it; because there both have been and are large and important races of mankind who, properly

15. Thirteenth- to 15th-century English earthenware. Jug with green glaze, mottled yellow, black, and orange remaining on major part of body, handle, and rim. H. 7″ (18 cm). The Metropolitan Museum of Art, New York.

16. Thirteenth- to 15th-century English earthenware.
Jug, tan with mottled green glaze remaining on upper part. H. 3⅛" (8 cm).
The Metropolitan Museum of Art, New York.

speaking, have no architecture, who are not house-dwellers, but tent-dwellers, and who, nevertheless, are by no means barren of the arts. For all that it is true that these non-architectural races (let the Chinese stand as a type of them) have no general mastery over the arts, and seem to play with them rather than to try to put their souls into them. Clumsy-handed as the European or Aryan workman is (of a good period, I mean) as compared with his Turanian fellow, there is a seriousness and meaning about his work that raises it as a piece of art far above the deftness of China and Japan; and it is this very seriousness and depth of feeling which, when brought to bear upon the matters of our daily life, is in fact the soul of architecture, whatever the body may be; so that I shall still say that among ourselves, the men of modern Europe, the existence of the other arts is bound up with that of architecture. Please do not forget that, whatever else I may say to-day, you must suppose me to assume that we have noble buildings which we have to adorn with our lesser arts: for this art of building is the true democratic art, the child of the man-inhabited earth, the expression of the life of man thereon. I claim for our society no less a position than this, that in calling on you to reverence the examples of noble building, and to understand and protect the continuity of its history, it is guarding the very springs of all art, of all cultivation.

Now I would not do this noble art such disrespect as to speak of it in detail as only a part of a subject. I would not treat it so even in its narrower sense as the art of building; its wider sense I consider to mean the art of creating a building with all the appliances fit for carrying on a dignified and happy life. The arts I have to speak of in more detail are a part, and comparatively a small part, of architecture considered in that light; but there is so much to be said even about these, when we have once made up our mind that they are worth our attention at all, that you must understand that my talk to-night will simply be hints to draw your attention to the subjects in question.

I shall try, then, to give you some hints on these arts or crafts: pottery and glass-making; weaving, with its necessary servant dyeing; the craft of printing patterns on cloth and on paper; furniture; and also, with fear and trembling, I will say a word on the art of dress. Some of these are lesser arts with a vengeance; only you see I happen to know something about them practically, and so venture to speak of them.

So let us begin with pottery, the most ancient and universal, as it is perhaps (setting aside house-building) the most important of the lesser arts, and one, too, the consideration of which recommends itself to us from a more or less historical point of view, because, owing to the indestructibility of its surface, it is one of the few domestic arts of which any specimens are left to us of the ancient and

classical times. Now all nations, however barbarous, have made pottery, sometimes of shapes obviously graceful, sometimes with a mingling of wild grotesquery amid gracefulness; but none have ever failed to make it on true principles, none have made shapes ugly or base till quite modern times. I should say that the making of ugly pottery was one of the most remarkable inventions of our civilization. All nations with any turn for art have speedily discovered what capabilities for producing beautiful form lie in the making of an earthen pot of the commonest kind, and what opportunities it offers for the reception of swift and unlaborious, but rich ornament; and how nothing hinders that ornament from taking the form of representation of history and legend. In favour of this art the classical nations relaxed the artistic severity that insisted otherwhere on perfection of figure-drawing in architectural work; and we may partly guess what an astonishing number of capable and ready draughtsmen there must have been in the good times of Greek art from the great mass of first-rate painting on pottery, garnered from the tombs mostly, and still preserved in our museums after all these centuries of violence and neglect.

Side by side with the scientific and accomplished work of the Greeks, and begun much earlier than the earliest of it, was being practised another form of the art in Egypt and the Euphrates valley; it was less perfect in the highest qualities of design, but was more elaborate in technique, which elaboration no doubt was forced into existence by a craving for variety and depth of colour and richness of decoration, which did not press heavily on the peoples of the classical civilization, who, masters of form as they were, troubled themselves but little about the refinements of colour. This art has another interest for us in the fact that from it sprang all the great school of pottery which has flourished in the East, apart from the special and peculiar work of China. Though the fictile art of that country is a development of so much later date than what we have just been considering, let us make a note of it here as the third kind of potter's work, which no doubt had its origin in the exploitation of local material joined to the peculiar turn of the Chinese workmanship for finesse of manual skill and for boundless patience.

Northern Europe during the Middle Ages, including our own country, could no more do with a native art of pottery than any other simple peoples; but the work done by them being very rough, and serving for the commonest domestic purposes (always with the exception of certain tile-work), had not the chance of preservation which superstition gave to the Greek pottery, and very little of it is left; that little shows us that our Gothic forefathers shared the pleasure in the potter's wheel and the capabilities of clay for quaint and pleasant form and fanciful invention which has been common to most times and places, and this

rough craft even lived on as a village art till almost the days of our grandfathers, turning out worthy work enough, done in a very unconscious and simple fashion on the old and true principles of art, side by side with the whims and inanities which mere fashion had imposed on so-called educated people.

Every one of these forms of art, with many another which I have no time to speak of, was good in itself; the general principles of them may be expressed somewhat as follows. First. Your vessel must be of a convenient shape for its purpose. Second. Its shape must show to the greatest advantage the plastic and easily-worked nature of clay; the lines of its contour must flow easily; but you must be on the look-out to check the weakness and languidness that comes from striving after over-elegance. Third. All the surface must show the hand of the potter, and not be finished with a baser tool. Fourth. Smoothness and high finish of surface, though a quality not to be despised, is to be sought after as a means for gaining some special elegance of ornament, and not as an end for its own sake. Fifth. The commoner the material the rougher the ornament, but by no means the scantier; on the contrary, a pot of fine materials may be more slightly ornamented, both because all the parts of the ornamentation will be minuter, and also because it will in general be considered more carefully. Sixth. As in the making of the pot, so in its surface ornament, the hand of the workman must be always visible in it; it must glorify the necessary tools and necessary pigment: swift and decided execution is necessary to it; whatever delicacy there may be in it must be won in the teeth of the difficulties that will result from this; and because of these difficulties the delicacy will be more exquisite and delightful than in easier arts where, so to say, the execution can wait for more laborious patience. These, I say, seem to me the principles that guided the potter's art in the days when it was progressive: it began to cease to be so in civilized countries somewhat late in that period of blight which was introduced by the so-called Renaissance. Excuse a word or two more of well-known history in explanation. Our own pottery of Northern Europe, made doubtless without any reference to classical models, was very rude as I have said; it was fashioned of natural clay, glazed when necessary transparently with salt or lead, and the ornament on it was done with another light-coloured clay, sometimes coloured further with metallic oxides under the glaze. During the fourteenth and fifteenth centuries the more finished work, which had its origin, as before mentioned, in Egypt and the Euphrates valley, was introduced into Southern Europe through Moorish or rather Arab Spain, and other points of contact between Europe and the East. This ware, known now as Majolica, was of an earthen body covered with opaque white glaze, ornamented with colours formed of oxides, some of which were by a curious process reduced into a metallic state, giving thereby strange and beauti-

17. Eighteenth-century English earthenware. Mug, slipware.
The Metropolitan Museum of Art, New York.

ful lustrous colours. This art quickly spread through Italy, and for a short time was practised there with very great success, but was not much taken up by the nations of Northern Europe, who for the most part went on making the old lead or salt-glazed earthenware; the latter, known as Grès de Cologne, still exists as a rough manufacture in the border lands of France and Germany, though I should think it is not destined to live much longer otherwise than as a galvanized modern antique.

When Italy was still turning out fine works in the Majolica wares much of

the glory of the Renaissance was yet shining; but the last flicker of that glory had died out by the time that another form of Eastern art invaded our European pottery. Doubtless the folly of the time would have found another instrument for destroying whatever of genuine art was left among our potters if it had not had the work of China ready to hand, but it came to pass that this was the instrument that finally made nonsense of the whole craft among us. True it is that a very great proportion of the Chinese work imported consisted of genuine works of art of their kind, though mostly much inferior to the work of Persia, Damascus, or Granada; but the fact is, it was not the art in it that captivated our forefathers, but its grosser and more material qualities. The whiteness of the paste, the hardness of the glaze, the neatness of the painting, and the consequent delicacy, or luxuriousness rather, of the ware, were the qualities that the eighteenth-century potters strove so hard to imitate. They were indeed valuable qualities in the hands of a Chinaman, deft as he was of execution, fertile of design, fanciful though not imaginative, in short, a born maker of pretty toys: but such daintinesses were of little avail to a good workman of our race; eager, impatient, imaginative, with something of melancholy or moroseness even in his sport, his very jokes two-edged and fierce, he had other work to do, if his employers but knew it, than the making of toys. Well, but in the time we have before us the workman was but thought of as a convenient machine, and this machine, driven by the haphazard whims of the time, produced at Meissen, at Sèvres, at Chelsea, at Derby, and in Staffordshire, a most woeful set of works of art, of which perhaps those of Sèvres were the most repulsively hideous, those of Meissen (at their worst) the most barbarous, and those made in England the stupidest, though it may be the least ugly.

Now this is very briefly the history of the art of pottery down to our own times, when styleless anarchy prevails; a state of things not so hopeless as in the last century, because it shows a certain uneasiness as to whether we are right or wrong, which may be a sign of life. Meanwhile, as to matters of art, the craft which turns out such tons of commercial wares, every piece of which ought to be a work of art, produces almost literally nothing. On this dismal side of things I will not dwell, but will ask you to consider with me what can be done to remedy it; a question which I know exercises much many excellent and public-spirited men who are at the head of pottery works. Well, in the first place, it is clear that the initiative cannot be wholly taken by these men; we, all of us I mean who care about the arts, must help them by asking for the right thing, and making them quite clear what it is we ask for. To my mind it should be something like this, which is but another way of putting those principles of the art which I spoke of before. First. No vessel should be fashioned by being pressed

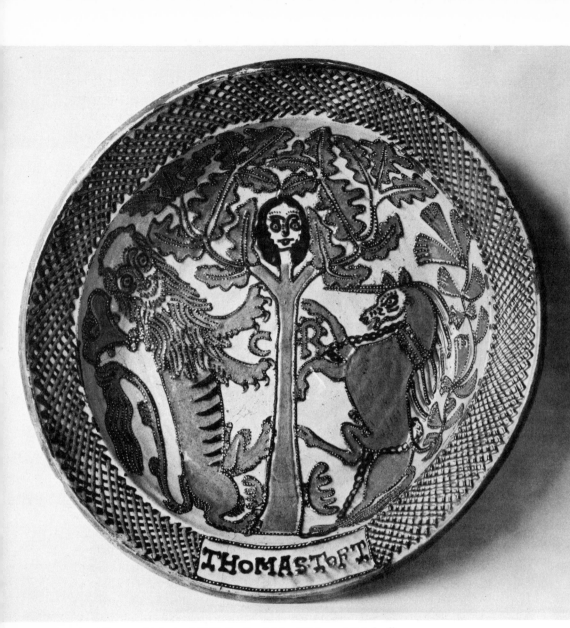

18. Thomas Toft (c. 1680) Staffordshire. Dish, reddish buff
earthenware decorated in red, brown, and white slips, yellowish
lead glaze. The Metropolitan Museum of Art, New York.

into a mould that can be made by throwing on the wheel, or otherwise by hand.
Second. All vessels should be finished on the wheel, not turned in a lathe, as is
now the custom. How can you expect to have good workmen when they know
that whatever surface their hands may put on the work will be taken off by a

machine? Third. It follows, as a corollary to the last point, that we must not demand excessive neatness in pottery, and this more especially in cheap wares. Workmanlike finish is necessary, but finish to be workmanlike must always be in proportion to the kind of work. What we get in pottery at present is mechanical finish, not workmanlike, and is as easy to do as the other is hard: one is a matter of a manager's system, the other comes of constant thought and trouble on the part of the men, who by that time are artists, as we call them. Fourth. As to the surface decoration on pottery, it is clear it must never be printed; for the rest, it would take more than an hour to go even very briefly into the matter of painting on pottery; but one rule we have for a guide, and whatever we do if we abide by it, we are quite sure to go wrong if we reject it: and it is common to all the lesser arts. Think of your material. Don't paint anything on pottery save what can be painted only on pottery; if you do, it is clear that, however good a draughtsman you may be, you do not care about that special art. You can't suppose that the Greek wall-painting was anything like their painting on pottery; there is plenty of evidence to show that it was not. Or take another example from the Persian art; it is easy for those conversant with it to tell from an outline tracing of a design whether it was done for pottery-painting or for other work. Fifth. Finally, when you have asked for these qualities from the potters, and even in a very friendly way boycotted them a little till you get them, you will of course be prepared to pay a great deal more for your pottery than you do now, even for the rough work you may have to take. I'm sure that won't hurt you; we shall only have less and break less, and our incomes will still be the same.

Now as to the kindred art of making glass vessels. It is on much the same footing as the potter's craft. Never till our own day has an ugly or stupid glass vessel been made; and no wonder, considering the capabilities of the art. In the hands of a good workman the metal is positively alive, and is, you may say, coaxing him to make something pretty. Nothing but commercial enterprise capturing an unlucky man and setting him down in the glassmaker's chair with his pattern beside him (which I should think must generally have been originally designed by a landscape gardener): nothing but this kind of thing could turn out ugly glasses. This stupidity will never be set right till we give up demanding accurately-gauged glasses made by the gross. I am fully in earnest when I say that if I were setting about getting good glasses made, I would get some good workmen together, tell them the height and capacity of the vessels I wanted, and perhaps some general idea as to kind of shape, and then let them do their best. Then I would sort them out as they came from the annealing arches (what a pleasure that would be!) and I would put a good price on the best ones, for they would be worth it; and I don't believe that the worst would be bad.

In speaking of glass-work, it is a matter of course that I am only thinking of that which is blown and worked by hand; moulded and cut glass may have commercial, but cannot have artistic value. As to the material of the glass vessels, that is a very important point. Modern managers have worked very hard to get their glass colourless: it does not seem to me that they have quite succeeded. I should say that their glass was cold and bluish in colour; but whether or not, their aim was wrong. A slight tint is an advantage in the metal; so are slight specks and streaks, for these things make the form visible. The modern managers of glassworks have taken enormous pains to get rid of all colour in their glass; to get it so that when worked into a vessel it shall not show any slightest speck or streak; in fact, they have toiled to take all character out of the metal, and have succeeded; and this in spite of the universal admiration for the Venice glass of the seventeenth century, which is both specked and streaky, and has visible colour in it. This glass of Venice or Murano is most delicate in its form, and was certainly meant quite as much for ornament as use; so you may be sure that if the makers of it had seen any necessity for getting more mechanical perfection in their metal they would have tried for it and got it; but like all true artists they were contented when they had a material that served the purpose of their special craft, and would not weary themselves in seeking after what they did not want. And I feel sure that if they had been making glass for ordinary table use at a low

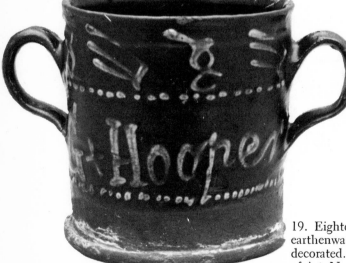

19. Eighteenth-century English earthenware. Cup, earthenware, slip-decorated. The Metropolitan Museum of Art, New York.

20. Seventeenth- to 18th-century English earthenware. Jug with sgraffito decoration on slipware. The Metropolitan Museum of Art, New York.

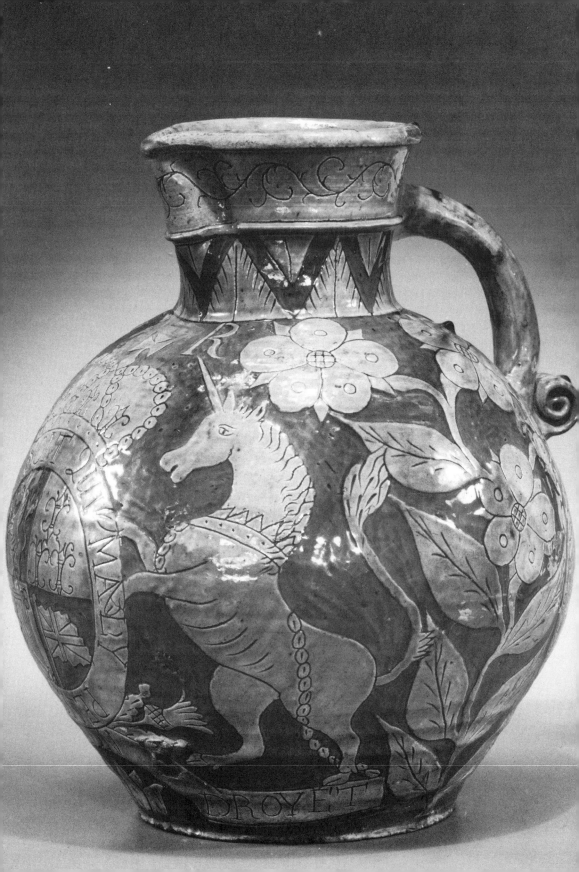

price, and which ran more risks of breakage, as they would have had to fashion their vessels thicker and less daintily they would have been contented with a rougher metal than that which they used. Such a manufacture yet remains to be set on foot, and I very much wish it could be done; only it must be a manufacture; must be done by hand, and not by machine, human or otherwise.

So much, and very briefly, of these two important "lesser arts," which it must be admitted are useful, even to Diogenes, since the introduction of tea: I have myself at a pinch tried a tin mug for tea, and found it altogether inconvenient, and a horn I found worse still; so, since we must have pottery and glass, and since it is only by an exertion of the cultivated intellect that they can be made ugly, I must needs wish that we might take a little less trouble in that direction: at the same time I quite understand that in this case both the goods would cost the consumers more, even much more, and that the capitalists who risk their money in keeping the manufactories of the goods going would make less money; both which things to my mind would be fruitful in benefits to the community. . . .

Thus I have named a certain number of the lesser arts, which I must ask you to take as representing the whole mass of them. Now all these arts, since they at all events make a show of life, one may suppose civilization considers desirable, if not necessary; but if they are to go on existing and to occupy in one way or other the lives of millions of men, it seems to me that their life should be real, that the necessity for them should be felt by those that allow them to be carried on; for surely wasted labour is a heavy burden for the world to bear.

I have said that, on the other hand, I am ready to accept the conclusion that these arts are vain and should not be carried on at all; that we should do nothing that we can help doing beyond what is barely necessary to keep ourselves alive, that we may contemplate the mystery of life, and be ready to accept the mystery of death. Yes, that might be agreed to, if the world would; but, you see, it will not: man's life is too complex, too unmanageable at the hands of any unit of the race for such a conclusion to be come to except by a very few, better, or it may be worse, than their fellows; and even they will be driven to it by noting the contrast between their aspirations and the busy and inconsistent lives of other men. I mean, if most men lived reasonably, and with justice to their fellows, no men would be drawn towards asceticism. No, the lesser arts of life must be practised, that is clear. It only remains therefore for us to determine whether they shall but minister to our material needs, receiving no help and no stimulus from the cravings of our souls, or whether they shall really form part of

21. Eighteenth-century English earthenware. Signed and dated: Robt. Burnal/Cutcombe/Ashel/1781. Harvest jug, brown with sgraffito decoration on slipware. H. 12⁷⁄₁₆″ (31.5 cm). The Metropolitan Museum of Art, New York.

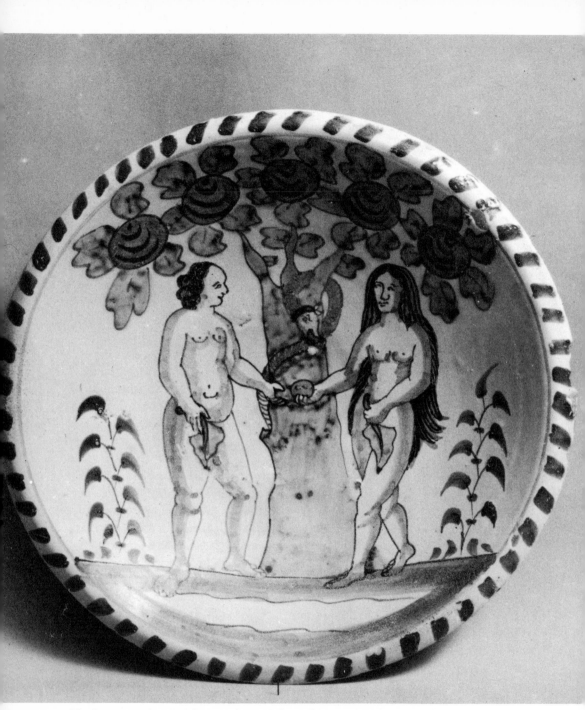

22. Seventeenth- to 18th-century English earthenware. Dish, tin-enameled "Delft ware." The Metropolitan Museum of Art, New York.

our lives material and spiritual, and be so helpful and natural, that even the sternest philosopher may look upon them kindly and feel helped by them.

Is it possible that civilization can determine to brutalize the crafts of life by cutting them off from the intellectual part of us? Surely not in the long run; and yet I know that the progress of the race from barbarism to civilization has hitherto had a tendency to make our lives more and more complex; to make us more dependent one upon the other, and to destroy individuality, which is the breath of life to art. But swiftly and without check as this tendency has grown, I know I cannot be alone in doubting if it has been an unmixed good to us, or in believing that a change will come, perhaps after some great disaster has chilled us into pausing, and so given us time for reflection: anyhow, in some way or other, I believe the day is not so far distant when the best of men will set to work trying to simplify life on a new basis; when the organization of labour will mean something else than the struggle of the strong to use each one to his best advantage the necessities and miseries of the weak.

Meanwhile I believe that it will speed the coming of that day if we do but look at art open-eyed and with all sincerity; I want an end of believing that we believe in art-bogies; I want the democracy of the arts established: I want every one to think for himself about them, and not to take the things for granted from hearsay; every man to do what he thinks right, not in anarchical fashion, but feeling that he is responsible to his fellows for what he feels, thinks, and has determined. In these lesser arts every one should say: I have such or such an ornamental matter, not because I am told to like it, but because I like it myself, and I will have nothing that I don't like, nothing; and I can give you my reasons for rejecting this, and accepting that, and am ready to abide by them, and to take the consequences of my being right or wrong. Of course such independence must spring from knowledge, not from ignorance, and you may be sure that this kind of independence would be far from destroying the respect due to the higher intellects that busy themselves with the arts. On the contrary, it would make that respect the stronger, since those who had themselves got to think seriously about the arts would understand the better what difficulties beset the greatest men in their struggles to express what is in them. Anyhow, if this intelligent, sympathetic, and serious independence of thought about the arts does not become general among cultivated men (and all men ought to be cultivated), it is a matter of course that the practice of the arts must fall into the hands of a degraded and despised class, degraded and despised at least as far as its daily work goes—that is to say, the greater part of its waking hours.

Surely this is a serious danger to our political and social advancement, to our cultivation, to our civilization in short; surely we can none of us be content

to accept the responsibility of creating such a class of pariahs, or to sit quiet under the burden of its existence, if it exist at present, as indeed it does. Therefore I ask you to apply the remedy of refusing to be ignorant and nose-led about the arts; I ask you to learn what you want and to ask for it; in which case you will both get it and will breed intelligent and worthy citizens for the common weal; defenders of society, friends for yourselves.

Is not this worth doing? It will add to the troubles of life? Maybe; I will not say nay. Yet consider after all that the life of a man is more troublous than that of a swine, and the life of a freeman than the life of a slave; and take your choice accordingly. Moreover, if I am right in these matters, your trouble will be shifted, not increased: we shall take pains indeed concerning things which we care about, hard and bitter pains, maybe, yet with an end in view; but the confused, aimless, and for ever unrewarded pains which we now so plentifully take about things we do not care about, we shall sweep all that away, and so shall win calmer rest and more strenuous, less entangled work.

What other blessings are there in life save these two, fearless rest and hopeful work? Troublous as life is, it has surely given to each one of us here some times and seasons when, surrounded by simple and beautiful things, we have

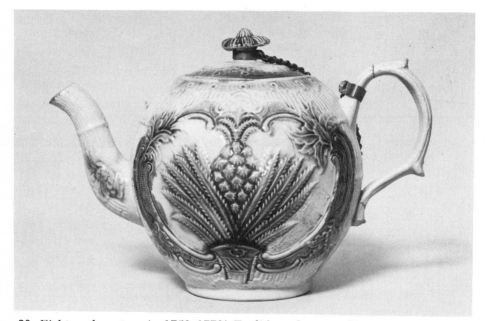

23. Eighteenth-century (c. 1750–1770) English earthenware. Teapot, creamware. The Metropolitan Museum of Art, New York.

really felt at rest; when the earth and all its plenteous growth, and the tokens of the varied life of men, and the very sky and waste of air above us, have seemed all to conspire together to make us calm and happy, not slothful but restful. Still oftener belike it has given us those other times, when at last, after many a struggle with incongruous hindrances, our own chosen work has lain before us disentangled from all encumbrances and unrealities, and we have felt that nothing could withhold us, not even ourselves, from doing the work we were born to do, and that we were men and worthy of life. Such rest, and such work, I earnestly wish for myself and for you, and for all men: to have space and freedom to gain such rest and such work is the end of politics; to learn how best to gain it is the end of education; to learn its inmost meaning is the end of religion.

The Revival of the Art of Faïence Painting

Louis Marc Emanuel Solon

"At the sight of the marvels revealed to them for the first time, the designer, the carver, the painter—in short, all craftsmen of the higher grade—became suddenly alive to the sense of their own capacity, and strove, from that moment, to impart to their work at least a reflex of the genius and the talent that pervaded the creations of the old masters."

"The Revival of the Art of Faïence Painting" was published in Solon's *A History and Description of Old French Faïence with an Account of the Revival of Faïence Painting in France* (London: Cassell, 1903). Solon was an active ceramic historian and a noted ceramic artist. While chief designer at Sèvres, he became a master of pâte-sur-pâte, a method of painting with porcelain slips on a ground of contrasting color, to achieve tonal values in relief. In 1870 Solon joined Minton's in England, where he remained until his retirement in the early twentieth century. His paper on the faïence revival examines the first step toward the concept of a self-contained ceramic artist, raising the status of clay as an art material and attracting to ceramics some of the most accomplished decorative artists of the nineteenth century.

The Revival of the Art of Faïence Painting

Faïence painting, as an art, was dead and forgotten during the first part of the nineteenth century. Its dying days had been grotesque, and no one cared whether it would ever be revived. As a trade it still found its application in the pencilling of social and revolutionary emblems much appreciated by the rural politician, and of the "gay" rose which his wife found greatly to her taste. But the treatment of all these popular subjects had gradually become so crude and coarse that anything which looked like painted faïence was rejected, by the fastidious inhabitants of the town, as thoroughly objectionable.

Another cause of this disfavour was that radical improvements in the manufacture of hard porcelain had brought a new ware within the reach of the middle classes. So beautiful was its white and pure substance that a costly decoration could well be dispensed with. This gave rise to a preference for plain surfaces; from porcelain the taste soon extended to faïence and earthenware, which it became fashionable to use in the white. Nothing that might recall the vulgarity of the painted soup plates and salad dishes sold on the marketplace could be tolerated in a house furnished with any pretension to good taste and refinement. Pottery decoration was on the point of being completely banished; a few subjects in black transfer-printing found an exception to this general rule, but only on account of the novelty of the process just introduced by some English potters.

I am not forgetting that, at the time I am speaking of, handsomely and expensively decorated wares were still required for the palace and the mansion. In the porcelain manufactories the noble and the wealthy could obtain the gratification of their most extravagant fancies. But the faïence decorator, whose popular talent had long supplied all classes with artistically-painted vessels, had completely disappeared, and, as I have just said, faïence painting, as an art, was dead and forgotten.

Here I beg leave to introduce a few words by way of vindication of a fascinating pursuit, mercilessly scoffed at by the witty, and severely censured by the wise, as soon as it threatened to take an extensive development. While the debased handicrafts of the day were sinking to the lowest level, and all the traditions of a glorious past were being well-nigh forgotten, a small group of spirited men, gifted with inborn taste and guided by a fast-growing experience, were actively engaged in hunting out and quietly hoarding up the relics of the de-

29

parted arts which the living generation was ruthlessly discarding as old-fashioned and worthless encumbrances. The collecting rage was still in its embryonic state, and yet the results achieved by these few members of the gentle craft were nothing short of astounding. It is strange that the part played by the collector of "curiosities," as he was called, in the artistic revival that was taking place at that moment should have been so completely misinterpreted. A collector was represented as a kind of harmless monomaniac, piling up, aimlessly, a host of nondescript oddities, with no possible profit to himself or to others; he was above all taunted with unpardonable selfishness for wasting upon futile antiquities the money that would have been so much better employed in supporting the industries of his own country. The character of the true collector, his influence on the transformation of public taste, should not suffer from the recollection of a caricature which no judicious person could ever take as a portrait. It ought to be recollected that by redeeming from their hiding place, rescuing from impending destruction, and bringing into full light masterpieces of workmanship of unparalleled excellence, the collector has, unquestionably, headed the revolutionary movement of his epoch and done more than anybody else in arousing from their inertia the various branches of decorative art.

A cabinet of curiosities—the compound term "Works of industrial Art" had not yet been coined—offered a miscellaneous assemblage of objects which, undeniably artistic as they were in their scope, had not yet received admittance into public museums. Connoisseurs and artists were always welcome to inspect and study the treasures accumulated by a liberal-minded collector. In the contrast that these choice productions of the past presented to all that was made at the moment the appreciative visitor found ample food for cogitation. At the sight of the marvels revealed to them for the first time, the designer, the carver, the painter—in short, all craftsmen of the higher grade—became suddenly alive to the sense of their own capacity, and strove, from that moment, to impart to their work at least a reflex of the genius and the talent that pervaded the creations of the old masters.

It should always be recollected that, if the stupendous museums formed shortly afterwards, on a similar plan, have done so much to improve the tendencies of all artistic industries by providing for the higher education of industrial artists, their formation was chiefly due to the influence exerted by the eclectic amateur, and the immense interest elicited by the private collections.

Among the household ornaments which a sweeping change in the public taste had condemned as vulgar and unseemly, none had been more abruptly put out of sight by their owner than the articles of old-fashioned faïence. Regardless of this unjust verdict, the early collector gave a large share of attention to the

ancient vessels of painted clay, for which he entertained a marked predilection. Such an immense quantity of decorative ware had been manufactured in France, that, as long as he remained the isolated explorer of an untrodden field, the harvest he gathered in his researches was as precious as it was abundant.

Let us, now, represent to ourselves what must have been the feelings of an earnest man, conscious of the degraded state of the manufactures of his time, when brought face to face with the finest examples of Palissy ware, or of the Nevers, Rouen, and Moustiers faïence of the best period, proudly staged in the cabinets of the collector in imposing array. Excited by such an inspiring display, a fervid ambition to revive the forgotten art and to produce anew ceramic marvels was bound to arise within the brains of the few admirers who felt themselves bold enough to make the attempt. Strenuous efforts were prosecuted with a view to recovering the lost secrets of the faïence painter, and it must be said, to the credit of the collector, that the first experiments found in him an enlightened patron and a most liberal supporter.

A curious tale could be written about those probationary times, and the singular individualities that the fad of a moment, and the interest created by their mysterious experiments, brought into notice, fifty or sixty years ago. In the gallery of the collector, and in the studio of the artist, certain erratic and impecunious persons could often be met with who gave themselves out as the "arcanists" of faïence-making. They boasted no special qualification either as chemists or potters, but they dabbled with glazes and colours, and exulted in the firm conviction that Destiny had marked them out to be the renovators of ceramic art. No precise information concerning their doings could be obtained from them; they looked grave and suspicious, and repeatedly hinted at some researches and discoveries just on the point of completion, which had only to come into light to show that the modern potter had nothing to envy in the greatest masters of ancient times. The names of "Bernard" and "Luca" recurred constantly in their discourses. In their own estimation, a kindred nature of soul and of genius, which connected their intellectual being with the spirits of Palissy and Della Robbia, warranted this brotherly appellation.

Little was known about the worldly circumstances of these eccentric personages; they managed, however, to excite sympathy and to inspire a certain degree of confidence. It was accepted that they were the pioneers of the coming science, and that, so far, poverty and ill-luck had hampered their labours and retarded their assured success. The dingy hovel, dignified by the name of laboratory, and the rickety kiln built with their own hands, in which their cryptic operations were performed, were forbidden ground. Occasionally, however, some faithful believer was admitted into the precincts and permitted to have a peep

at the latest trials. Had the *genius loci* been an adept of the black art, the practice of his magical incantations could not have excited more reverential curiosity than the production of his surprising achievements as a transcendental potter. As a matter of course, the privileged visitor who had enjoyed such a rare favour hastened to circulate, within the circle of his acquaintances, a glowing account of the promise yielded by all that he had seen. Then it happened that some good-natured art critic, moved by the forsaken conditions of one of these outlaws of the ceramic art, ventured to insert a notice of his life and work in some influential periodical. The article narrated, with heart-rending pathos, the story of the sufferings, the hopes and the disappointments that the down-trodden potter had had to go through in his search after the Unknown, and it ended in foretelling the triumphant finish which was soon to crown so many years of toilsome ordeal. Little more was wanted to bring the man into momentary notoriety, and the commonplace original of a highly fanciful literary sketch hastened to profit by the interest thus thrown upon his name.

These irregular forerunners of the true renovators of a disused art formed a rather mixed group. Some were mere impostors who, during their short stay in the various factories where they had found casual employment, had acquired a smattering of pottery manufacture. This enabled them to present, with a great flow of technical terms, alluring schemes and projects, framed with sufficient cunning to impose upon friendly credulity. Elaborate preparations were set on foot, on their suggestion, at the expense of their dupes, but, as a rule, they did not lead to anything of practical value.

Others were, on the contrary, thoroughly honest in their purpose; but they were often no more than self-deluded dreamers, miscalculating the range of their possibilities, and although full of glorious aspirations, quite as incapable of lending real assistance to the movement as the unscrupulous deceiver. Heedless of their utter ignorance of the most elementary rules, these aspirants to ceramic fame were ceaselessly concocting random mixtures of chemical substances, and making trials of colours that would not develop, and glazes that would not shine, upon pots that would always break. Any result that was not a complete failure was to them a step towards the coming victory. Naturally enough they valued their miserable achievements in proportion to the trouble they had taken in producing them.

The Marquis of Monestrol is to be remembered as the most accomplished personification of the type. A fanatic admirer of pot-making and of its mysteries, the impoverished marquis set up a very scantily equipped workshop in the small village of Rungis, near Orléans. There he lived for years in absolute seclusion,

throwing, glazing and baking pots with his own hands, and after his own ideas. Anxious to have all the credit of his discoveries, he declined to receive any advice from practical potters. His ambition was to be regarded by his contemporaries as a modern Palissy. He was proud to relate that, in his lonely retreat and in the course of his experiments, he had suffered the same misfortunes, ill-success, and privations as the legendary hero. As a counterpart to Palissy's memoirs he published, under the title of "Le Potier de Rungis," a poem in twenty-six cantos, in which the tale of the struggles he had manfully sustained against an inexorable fatality, which always defeated his best matured plans, was unfolded in pathetic but execrable verse. In all other respects than his unfortunate passion for the ceramic art—a life-long attachment which was never to be requited—Monestrol is said to have been a man of remarkable intellect.

Meantime some good work was being done, apart from the false pretences of the quack and the despicable failures of the crank. A few sincere and painstaking enthusiasts—half potters, half artists—had been prosecuting researches in the right direction, and could show some really creditable results. Their aim was to produce an artistic pottery that could stand close comparison with the best works of the Renaissance times, then considered as inimitable. They copied Palissy ware, Nevers and Rouen faïence. To the great astonishment of all those interested in the matter, and probably to their own surprise also, some of the copies happened to be almost as good as the originals. Far from confessing, however, that the success was due to a judicious use of the regular traditions of the faïence-maker, still partially preserved in the trade, they surrounded their operations with increased mystery, and talked louder than ever of the arduous difficulties they had had to overcome. No one was prepared to contest the veracity of their pretensions, and the outcome of their simple discovery was acclaimed as an astounding revelation.

It must be said that the sanguine and confident amateur of the time was but too ready to admire blindly anything that appealed to his love of the ceramic art. So intense was his infatuation for the old faïence, that any tolerable reproduction made by a modern potter, was to him a wonderful performance. His ill-grounded judgment seemed to court deception; and many an impudent forgery gained access to his collections without having raised the slightest suspicion.

It was in those days that a Palissy dish of exceptional dimensions was purchased for 20,000 francs, a record price, by Dr. J. Cloquet. The specimen was the envy of all collectors; but their hope of securing it at any cost, if ever it came into the market, was baffled by the doctor bequeathing his treasure to the Louvre Museum. I remember having seen the dish exhibited in a special glass

case in the faïence gallery, where it was the cynosure of all eyes. The centre of the huge piece was occupied by a large red lobster. This was well calculated to astonish the connoisseurs, for Palissy had never included the lobster among the "Bestioles" with which he was wont to adorn his ware; moreover, he was not known to have used a red colour on any other piece. Either for these reasons or for some other, doubts were, at last, entertained as to the genuineness of the piece, and it was carefully examined. A cut with a steel blade into its shining surface disclosed the unpalatable fact that the substance the dish was made of was mere mastic, while the supposed enamels were nothing else than varnish colours. The article was immediately transferred into the lumber room of the museum, where it is now resting in peace.

The name of Avisseau, of Tours, heads the list of those who presented, for the first time, an artistic pottery of their own, quite as attractive as the average productions of the old masters. Avisseau had served his apprenticeship as a potter and as a common faïence painter. In 1825 he was made manager of a small factory. Deeply dissatisfied with the drudgery he had to go through every day in the village pot-works, where nothing but the cheapest crocks were manufactured, he sighed for the day when he should find an opportunity of improving his knowledge and acquiring some practical ability. The direction his efforts were to take was determined by the sight of a fine Palissy dish that was one day shown to him. His surprise and admiration were unbounded; he had never suspected that so much refinement and beauty could be obtained on a piece made of ordinary clay. The perusal of the romantic history of the potter of Saintes acted as a keen incentive to his mind. He formed the resolution of recovering the secrets that Palissy was said to have carried away with him to the grave, and to take no rest until that end had been achieved. Fifteen years, it is said, were spent in misdirected trials—years of trouble and misery—before he mastered at last the mystery of the coloured glazes.

The story of the harrowing difficulties he had to face for the sake of his art —a period of endless tribulations which made him, as it were, a second incarnation of the old French potter—was opportunely circulated; it contributed not a little to direct public attention to the first examples of ornamental pottery that Avisseau exhibited in 1845. A few years afterwards his fame was firmly established, and the most influential connoisseurs had taken his work under their patronage.

The modest house in which he lived and worked was situated in the vicinity of Tours, on the banks of the Loire; it was surrounded with a neat little garden, where the potter cultivated the plants and kept the small stock of living reptiles

and insects he copied in the ornamentation of his ware; it was his pride to assert that nature alone inspired his conceptions and supplied his models. A son and a daughter, both talented modellers and painters, assisted him in his work. Visitors came from all parts to see the *atelier,* and make the acquaintance of the self-made artist, the ingenious craftsman who had had to discover anew the lost technical processes he required, before he could invest with the perfection of fictile form the quaint conceits of his imagination. A cordial welcome was extended to all; and it goes without saying that no one left the place without having secured, for adequate consideration, a memento of an interesting visit.

Avisseau's early facsimiles of Palissy ware are very superior to the pieces he made after his own design; these latter, which savour highly of the "romantique" taste of the period, strike us as pretentious and extravagant. The Victoria and Albert Museum has a few examples of Avisseau faïence; we notice that the glaze is thin and dull, and the colours pale and weak. It would be difficult to understand the cause of its success, if we did not bear in mind that, for a time, the maker remained alone in his speciality, and also that the pen of the art critic, which makes and unmakes transient reputations, had been particularly busy concerning the potter of Tours and his wonderful creations.

Pull was soon afterwards to enter into the path opened by Avisseau. He made the same pretensions to being a worthy successor of Palissy, and to having acquired his knowledge of pottery at the cost of many years spent in labours and disappointments. The new-comer stuck almost exclusively to the reproduction of the old models, and he executed his replicas with an accuracy that left little to be desired. Collectors may have cause to regret the perfection of the work; many of his copies have passed muster as original pieces, and it is as such that they have found a place in some of the finest collections. The art potters of the time had their show at the Agricultural and Industrial Exhibitions. On these occasions Pull easily distanced all his competitors. One of them, Barbizet, gave a more commercial turn to the business. He undertook to make "Palissys" for the million. For years small articles of his manufacture, decorated in the "rustic" style with shells, fishes and reptiles, and to be had at prices varying from a few sous to a few francs, filled the bazaars of the towns and the seaside shops. They had little ceramic value. Highly fusible glazes were running over an underfired biscuit; a bright scarlet red was added by the application of a solution of sealing-wax. Very few specimens of Barbizet's production, considerable as it was, have escaped destruction. They never entered the French collections. A few of them, however, have drifted into the minor museums of foreign countries, where I have seen them confidently labelled, "Palissy ware."

Greater difficulties had to be encountered, before satisfactory imitations of

the various types of faïence with stanniferous enamel could be obtained, than had been the case with the making of embossed pottery coloured with variegated glazes. Not only were the processes of manufacture much more complicated, but the ware had to be fired in a regular oven, instead of a small muffle kiln—a costly requirement which placed the practice of the art out of the reach of many. It is true that to be enabled to produce a fair reproduction of the Nevers and Rouen faïence it was merely a question of settling the simple composition of the metallic colours used in the ancient factories; good white faïence with a fine enamel was still manufactured for the common trade, and the making of the ware had not, therefore, to trouble the would-be reproducer of old models. The first essays had been started, not by practical potters, but by artists who, although unacquainted with chemical manipulation, persisted in preparing with their own hands the colours they required. They were rather slow in arriving at a reliable result; but, as soon as they had secured the fewest possible pigments, they presented to an admiring and credulous public the *"faïence grand feu"* of which they claimed to be the inventors. As a matter of fact, their pieces were made after the design of the artist by a well-known manufacturer, who also fired the ware in his oven after it had received its decoration; but this course of action had been followed with great secrecy, and all the credit was given to the painter.

Ulysse, of Blois, was to the revival of painted faïence what Avisseau had been to that of the Palissy ware. His small works were also situated on the banks of the Loire. He made the ware himself on a small scale, and he had his circle of wealthy patrons, who encouraged and subsidised his experiments. The imitations of Nevers ware that he produced in the beginning of his career, and his trials of metallic lustre which promised to equal those seen on the Italian majolica, placed him in the first rank among the renovators of the ceramic art. In the same town another probationer, of the name of Tortat, attracted momentary attention by his attempts to reproduce the Henry II ware. If forgery was intended the maker cannot be accused of having ever carried it out—his imitations could not deceive anyone acquainted with the originals.

One of the most conspicuous figures of the irregulars engaged in the movement, and one from whom great things were expected, was the Italian, G. Devers. He came from Turin, and was said to be in possession of the secrets of the ancient majolists. A short course of study in the *ateliers* of the most celebrated painters and sculptors of Paris completed his artistic education; he was then fully armed to begin the campaign.

He expounded, with southern verbosity, his theory on the introduction of enamelled faïence in architectural decoration; the forcible exposition of his

schemes found many listeners and not a few actual supporters. It was rumoured that the mantle of Andrea della Robbia had fallen upon his shoulders, and that the man only wanted an occasion to decorate a whole building to show what could be done by a well-conceived association of coloured plastic work with the other resources of modern architecture. Encouragement from private friends and from higher quarters was not wanting. Devers received a commission to execute sets of decorative panels in painted faïence for the adornment of some public monuments then in course of erection. Inconsiderable as it was, the task was more than he could achieve. His panels proved a decided failure. As he had in reality very limited experience as a potter, and no talent as an artist, he had to depend for the manufacture of his large pieces on the slab-and-stove makers of the "Rue de la Roquette," and for the painting of each article upon such casual journeymen painters as were willing to work for him. No good work could possibly be produced under such conditions. An inspection of the shanty in which he worked and where he kept the results of his empiric experiments would have enlightened any unbiassed observer as to the extent of Devers' ceramic abilities. All the worst faults that can disfigure a piece of pottery badly made, badly painted, and badly fired, were amply represented on his trials. One could scarcely understand the reason of such a distressing exhibition, unless it were to impress the visitor with the sense of the innumerable difficulties the great potter had to contend with. His reputation in Paris came to an end on the first occasion in which the validity of his pretensions was put to a crucial test. Devers returned to Italy, where, on the strength of his Parisian success, he was appointed to a professorship of ceramic art.

Such were the men on whose achievements the hopes of the revival of the art were centered at that moment.

Modesty was certainly not one of the failings of any of those who were fighting their way to the front. From a printed notice, published by one of the most enterprising leaders, named Gaidan, we extract what follows: "Everybody is bound to acknowledge that I have raised myself to the highest position among the makers of artistic pottery. My discoveries are so numerous that one might refuse to believe that they are the fruit of the efforts of a single man, but my fame is now so well established that my talent and my success are recognised by all," and much more of it, in the same strain. This must not be considered as the bombastic advertisement of a charlatan wanting to throw dust in the eyes of the public; Gaidan was a good potter in his way. It was the candid expression of the high opinion he entertained of his own merit; he saw no reason why anyone should differ from it. With few exceptions, all those who then meddled with pot-making displayed an equal measure of ludicrous vanity.

37

So far the regular manufacturer had remained quite unconcerned with the progress that was being made entirely through the exertions of outsiders. He was quite willing to sell white faïence to the artists and let them fire their work in his ovens; but he took no trouble to help them out of their technical difficulties and blunders. The whole thing was to him a foolish fancy, from which no profitable business could ever be derived. Yet it was only when the manufacturer became alive to the advantage that would accrue to him from working hand in hand with artists, and placing better processes at their disposal, that the making of artistic pottery began its course of sound improvements and entered the high road to success.

At Bourg-la-Reine, a few miles from Paris, Laurin was manufacturing plain but sound stanniferous faïence. The Laurins were chips of the old block; the methods that their fathers had followed were preserved by them in their integrity. They sold dishes, plaques, and vases to all those who liked to try their hand at faïence painting. Amateurs and artists came there in preference, knowing that they would get good biscuit and fine glaze. One of the difficulties connected with this style of painting is that, to be quite successful, it must be executed on the dusty coat of powdered enamel adhering to the surface of the ware before any firing, except of the clay, takes place. This rendered the carriage of pieces prepared for decoration a rather delicate affair. On this account a few of the regular customers were allowed to work in the factory, and were also given facilities to see their work through the firing and place their trials in the oven. From this constant association of labours arose a community of interest between the manufacturer and the artist; so, instead of remaining isolated and divergent, researches and improvements became collective and co-efficient.

No one among the frequenters of the Laurins' works showed such an aptitude for solving technical problems and removing stumbling blocks from the path of the faïence painter as E. Lessore. He soon brought the composition of glazes and metallic colours to the point at which they were most bright and intense, and his brush was uncommonly skilful in bringing out charming effects from their harmonious combinations. His style marked a frank departure from the imitation of the ancient types. A rapid outline sketch in pure manganese, relieved with occasional patches of blue, yellow and green, constituted his usual scheme of colour. The essays he made for the production of ruby lustre were also very successful; but although his lustre was easily obtained upon a white piece, he could never fire any other colours in association with it. He laid especial stress on the technical excellence of his work, and did not trouble much about the originality of his designs. The Lessore faïence is, with a few unimportant ex-

ceptions, painted with very free renderings of ancient engravings. Laurin offered him a permanent engagement, which he accepted and kept for a few years; by far his best works belong to that period of his life. He left to join the Imperial manufactory of Sèvres. But his rough and sketchy style did not suit dainty porcelain; the eccentricity and independence of his ways could not accommodate themselves to the exigencies of an officially conducted establishment, so this ill-assorted connection was shortly severed, to the advantage of both parties. He then resolved to try his fortune in England. Talent was sure of a hearty welcome at the factory of Messrs. Minton, and Lessore was at once admitted to make preliminary experiments. His work was much admired, but did not offer any of the attractive qualities that would insure a large patronage; the conditions that could be offered to him fell short of the expectations he had formed; he therefore retired highly disappointed from Minton's works, and made arrangements with the firm of Messrs. Josiah Wedgwood and Sons. After having worked at Etruria for a few years, still troubled by his insatiable longing for change of place, he obtained from his employers permission to return to his cottage at Marlotte, near Fontainebleau, and there he decorated the ware that was sent to him from England in large consignments. This agreement lasted up to the time of his death. English collectors are well acquainted with Lessore's faïence paintings. They all show a good understanding of colour and effect; the treatment is remarkably bold and spirited. No special example, however, could be singled out from his countless productions as a true model of ceramic art. He was so fully impressed with the idea that a piece of faïence was above all an article of trade, and that a ceramic artist had to turn out an immense quantity of work if he wanted to make a living out of it, that he never attempted to surpass himself and execute the masterpiece that no artist ever fails to perfect, on certain occasions, for the love of his art and the sake of his reputation. The earthenware Lessore has painted in, or for, England discloses this constant pre-occupation for rapidity of execution and cheapness of cost even more than the pieces he produced in his own country.

Chaplet was one of the pupils whom Lessore trained at Bourg-la-Reine. He painted in the style of his master, and was for long the chief artist attached to Laurins' works. To him was due the introduction of a process destined to have a success as sudden and complete as it was to be short-lived, viz: "Barbotine painting." It consisted in mixing fusible colours with clay and opaque substances, so that they could be employed in any degree of thickness; the sharpness of the artist's touch was not impaired by the firing; when completed, the work had the appearance of an oil painting. Artists patronised with enthusiasm a process which seemed to offer unbounded resources. At Haviland's porcelain works, where

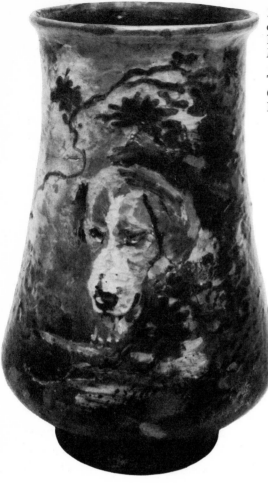

24. Haviland Autieul: Vase, decorated by F. Laford, in Ernest Chaplet's *procès Barbotine*. Paris, c. 1876. H. 13″ (33 cm). Collection Ralph and Terry Kovel. Photograph: Courtesy Smithsonian Institution, Washington, D.C.

Chaplet imported it, it found the most clever exponents. I remember the days when, on the stands of a ceramic exhibition, or in the windows of a fashionable china shop, all the best places were occupied by dishes and vases painted in "Barbotine." This likeness to oil painting, so highly praised in the new method, was precisely the cause of its falling rapidly into discredit. The effect was not truly ceramic. Within a couple of years every piece of "Barbotine" had discreetly disappeared from all the places where they had, for a short season, figured with so much honour. Chaplet gave up painting to devote all his time to the research for technical novelties. His name must always be remembered in connection with the first essays of "rouge flambé," and also with the production of a large variety of coloured glazes, blended in marbling, sprinkling and veining, of all possible and impossible hues.

Michel Bouquet, the landscape painter, was never attached to the Laurin factory; but as he brought his work there to be fired, he was, to some extent, connected with the place. I have no hesitation in saying that a plaque by M. Bouquet stands apart from all ceramic painting of every description as embodying, in an almost perfect form, the notion of using ordinary vitrifiable colours in the rendering of purely pictorial subjects. The treatment is highly finished, but without undue minuteness; delicate shades are skilfully contrasted with powerful tints; the general effect is always true to nature. If we compare it with a valued canvas, the plaque will hold its own and lose nothing of its intrinsic qualities; but it does not suggest any pretension to an imitation of oil painting. Owing to the true method employed in its execution—which consists in painting upon the white enamel, in the powdery state, with the elementary metallic pigments which alone can stand the oven's fire—it retains an absolutely ceramic character.

Bouquet was a constant exhibitor at the Paris Salon. His work has remained in private hands, and is never seen in the trade. Neglected as his plaques may be at the present day, they have only to be better known to be appreciated as they deserve. The time is not far removed when the task of illustrating with adequate examples the phases of a highly interesting revival will be taken in hand by appreciative collectors. Bouquet's landscapes on faïence will then be eagerly sought after as representing the most striking instance of the old processes having yielded results undreamed of by the ancients, when cleverly handled by a modern painter.

Gustave Noël, another ceramic artist, followed, later on, in the same track; he has left many realistic landscapes executed in an equally legitimate manner, and not unworthy of notice. For years Noël held periodic sales in Paris, in which the current work left on his hands was disposed of by auction.

It is not possible to enumerate all the artists and amateurs who, at some time in their career, used the Laurins' faïence and had their work fired in their ovens. Special mention must be made, however, of two gifted ladies—Madame Moreau-Nélaton, whose fanciful productions were much admired, and Madame Escalier, who found the highest expression of her truly decorative feelings in the painting of bold and effective flowers upon broad dishes and large vases.

Above the names of all those who contributed in various degree to the advance of the art, that of the potter Theodore Deck stands out conspicuously. His achievements summed up and crowned all the partial progress individually made in the collective movement. If a consistent association of technical superiority with an incomparable display of artistic excellence constitutes the highest form of ceramic art, I venture to say that it is in a choice piece of Deck's faïence that

one may look for the nearest approach to ideal perfection. The Persian potter, with his amazing command over the magic of colour, has never obtained anything that surpasses the gem-like effects produced by a happy combination of the bright, *chatoyant* and harmonious enamels used by Theodore Deck; in addition to this, no supercilious art critic could look down on one of Deck's decorative panels as a merely commercial article; in the hands of his talented collaborators, faïence painting ceased to be one of the minor arts; the restrictions imposed upon the artist by the limitations of the process detract nothing from the final merit of his work.

Deck was a self-made man in the best sense of the word. At the end of his apprenticeship in a stove factory at Strasburg, he started on foot to visit the pottery works of the north of Europe, and by taking temporary employment in the best establishments, he acquired a consummate knowledge of all branches of the trade. He came to Paris, where, for a few years, he acted as foreman to the important manufactory of slabs and earthenware stoves of Madame Dumas. But his budding ambition could not rest satisfied with a dependent situation. A designer and modeller of no common taste, if not of much acquired talent, he dreamed of breaking away from obsolete traditions and creating a new style of pottery better calculated to answer the artistic tendencies of the moment. He was impressed with the idea that a complete transformation of the potter's art could only be effected by enlisting into the service of the cause the interest and assistance of the most talented among the young painters of the day. He also knew that to gain this end it was imperative that technical means very superior to those employed in the trade should be placed at the disposal of the artist. For a long time he toiled in silence and secrecy, and gradually mastered the composition of new bodies and glazes which permitted the use of a variety of colours embracing all degrees of delicacy and intensity. It was in the Persian and Rhodian faïence, the first specimens of which had just come under general notice, that he found the fundamental notions on which he meant to establish a completely new style of manufacture.

Not only did he succeed in producing turquoises and azure blues, warm greens, dark purples and scarlet reds equal to those seen laid in flat tints on the Rhodian ware, but he found the way of blending these colours to serve the purposes of the figure painter.

A dilapidated store-house on the Boulevard Montparnasse had been hastily turned into a workshop; it contained the indispensable potter's wheel, a few tables and benches, and two small kilns standing at the far end. There, every weekday, Deck was at work with his brother, throwing, turning, decorating, and firing a small stock of vases and dishes. On Sundays a few young and friendly

25. Theodore Deck: Polychrome earthenware plaque. Paris, c. 1878. L. 8⅞″ (22.5 cm). Collection United Arts and Antiques, Beverly Hills, California. Photograph: Mark Schwartz.

artists, all of the Bohemian persuasion, assembled in the extempore *atelier*, anxious to see the results obtained in the last firing, and ready to make more trials with ceramic colours. It was a hard day's work, interrupted only by the luncheon hour, a pleasant interval in which capital jokes were cracked, and cheap wine freely imbibed by the witty and cheerful party. At the end of the day each painter had covered with a light sketch of his own invention a vase or a plate; a mere suggestion of decorative effects which might be, later on, more fully brought out in a finished piece. Such were the modest beginnings of the greatest of all French potters.

The earliest outcome of the unprecedented collaboration of a practical man of Deck's stamp with artists who, like Hamon, Ranvier, Hermann, Hancker, and others, united accomplished talent to natural originality, could not fail to take the amateurs' world by surprise. The success of Deck's faïence was sudden and immense.

It is needless to say that the working capital of the enterprise was meagre in the extreme. But by the geniality of his manners, the straightforwardness and honesty of his dealings, the leader had won the confidence and friendship of all those who worked in association with him. His painters were satisfied to wait for the remuneration of their work until the advent of an eventual purchaser. Owing to these conditions, and notwithstanding the scantiness of his financial resources, Deck had his small show-room always full of remarkable works of art which, under ordinary circumstances, could not have been brought together without an enormous outlay. Up to the end his transactions with artists were subject to a similar settlement.

Without the assistance of foreign capital, as business was steadily increasing, the premises were enlarged; the humble workshop developed into a spacious manufactory. Deck assumed an unrivalled position among the makers of artistic

pottery growing every day more numerous. His style of manufacture was imitated by many, but the high standard of his productions was never approached. Artists of great repute did not disdain to display their talents upon his matchless faïence; the making of plaques and dishes worth as much as four or five hundred pounds was a common occurrence, and enthusiastic amateurs were not slow in securing possession of them. The reward was equal to the results achieved; no other potter has, perhaps, during his lifetime enjoyed such a well-deserved and universal fame. His appointment as director of the national factory of Sèvres, a position that no practical potter had occupied before him, added official sanction to his public success. Death carried him away, unfortunately, before he had time to carry out the changes and improvements he intended to introduce in the conduct of the national establishment.

Entering into competition with Deck for the imitation of Persian faïence, several manufacturers took their inspiration from the same sources. A. de Beaumont and Collinot, and later on Parvillier, greatly extended the making of tiles, panels, and decorative objects chiefly intended for architectural purposes, all painted in the Oriental style. Ornamental and elegant as were the designs, the ware itself lacked the technical superiority that Deck alone could impart to the body, the glazes, and the colours. These enterprises, well patronised at the outset, lasted but a few years, and collapsed without having yielded what was expected of them.

Brief also were the days of many smaller establishments that a passing fashion had brought into existence. I may briefly mention the faïence of Jean, which purported to imitate Italian majolica, and was painted over the glaze with designs not always in classical taste. An immense quantity of it was manufactured and sold. Genlis and Rudhart produced a white ware much appreciated for the brilliancy of its glaze and the delicacy of a decoration traced in pale blue after the Moustiers style.

A reference to the catalogues of the universal exhibitions shows how numerous are the names of the potter-artists, now forgotten, who profited by a momentary success.

I purposely refrain from speaking of the regular manufacturers who stood then at the head of the trade, and still occupy the same honourable position, joining the making of artistic pottery to the manufacture of domestic ware. Anything I might attempt to introduce concerning their productions would either carry me away too far or be altogether inadequate. I may have to apologise for having devoted so many pages to the modern revival of faïence painting in an account which was intended to deal only with the history of old French faïence.

The Potter's Art

Gabriel Mourey

"But there is nothing more mysterious, nothing more risky or more incomprehensible, than the art of firing. Science and study and research, united with every precaution, are often at fault, and have to admit defeat from this formidable force, this terrible element, which devours, destroys, and annihilates, and can turn the potter's work either into a masterpiece of art, unique in colour and in material beauty, or into an unlovely thing, dry and hard and dull and commonplace."

In including Gabriel Mourey's article, I have taken poetic license with my own guidelines in this anthology of excluding pieces that are devoted to a single artist. Yet, although Mourey deals with Auguste Delaherche at some length, I have included the piece, for it captures so accurately one of the schools of ceramic aesthetic in Europe: the search for control and perfection. Even when Delaherche is quoted on his views, he seems to be speaking less of his own work than of a taste that remains alive in Europe today, for perfection at the expense of the other, livelier virtues of the material.

"The Potter's Art" by the French critic Gabriel Mourey was published in *Studio*, 12 (1898). The illustrations are not those that originally accompanied the article. I have expanded the scope of illustration to give a broad sense of the type of art pottery being produced in France at the time of this review.

The Potter's Art;
With Especial Reference to the
Work of Auguste Delaherche

M. Auguste Delaherche holds a high place among the artists who by their efforts have brought about the successful renaissance of the potter's art in France. He was one of the first of them to devote himself entirely to this work, rightly holding that, as there is no such thing as "inferiority" in art, one may exhibit just as much originality, talent, and genuine merit in shaping a pot or a vase or any other article of daily use, as in transferring some picturesque scene onto canvas; and moreover, amid all the vagaries which were bound to accompany this revival, he at least has succeeded in remaining true to the traditions of his art.

Before considering M. Delaherche's work in detail, I should like to say something about pottery in general, and its new developments.

In the first place, it is curious to note that this love for the primitive arts has revealed itself at a period and amidst surroundings of excessive refinement. Just by way of contrast, it will be said; and one may well believe that such is the case. Certain it is, in any case, that France may justly pride herself on being the first among the nations to welcome and foster the new movement.

Two men beyond all others have exercised a preponderating influence in this direction, and, to do them full justice, have been chiefly responsible for the restoration to favour of the art of pottery after years and years of neglect. I refer to MM. Ernest Chaplet and Jean Carriès.

Without injustice to the merits of his successors, Chaplet may truly be styled the father of the whole movement: he it is who was the real restorer of a neglected old-fashioned art, the secrets and methods of which seemed lost for ever. Chaplet's *grès flambés,* or fired stoneware, is and will continue to be regarded as among the finest ceramic work of modern times, both from the artistic and the documentary standpoints. An indefatigable worker, he devoted his whole energy to the arduous task, beset by frequent fruitless experiments and failures, of discovering the processes of this art. As examples he had, of course, the admirable bits of Japanese ceramics, marvellous *grès flambés,* in which every fanciful colouring, every phase of imagination, every degree of technical richness seem to be concentrated. But there is nothing more mysterious, nothing more risky or more incomprehensible, than the art of firing. Science and study and

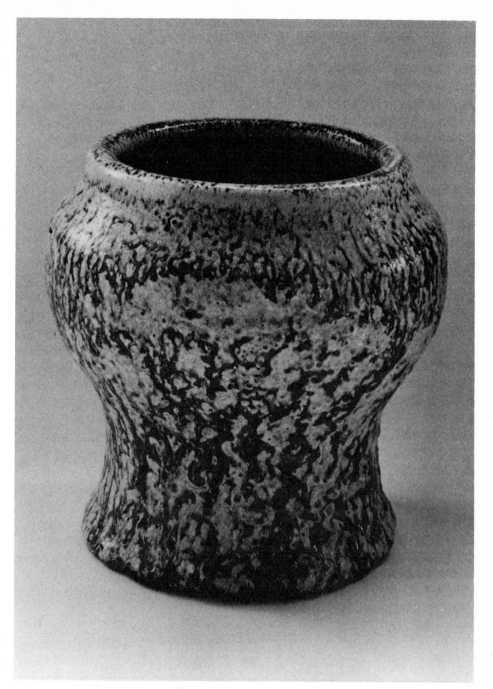

26. Ernest Chaplet: Porcelain, *sang-de-boeuf* glaze.
Choisy le Roi, France, c. 1900. H. 7⅞" (20 cm). Collection
Alain Lesieutre, Paris. Photograph: Garth Clark.

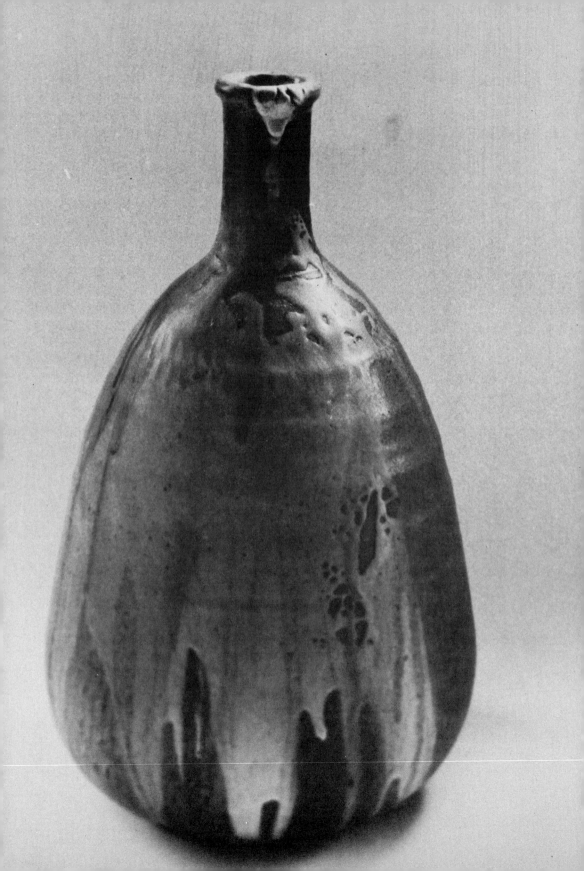

research, united with every precaution, are often at fault, and have to admit defeat from this formidable force, this terrible element, which devours, destroys, and annihilates, and can turn the potter's work either into a masterpiece of art, unique in colour and in material beauty, or into an unlovely thing, dry and hard and dull and commonplace.

Jean Carriès thus was largely instrumental in bringing about this revival. A sculptor of remarkable talent, endowed with a rare gift of imagination, and eager to extend indefinitely the sphere of the processes he used, Carriès gave up pure carving to devote himself to what may be termed applied sculpture. His portrait of himself in working dress, with a statuette in his hand, his busts of Auguste Vacquerie, Velásquez, and Franz Hals, all indicated a sculptor of the first rank; and in addition to his bronzes *en cire perdue* in the Salon of 1892, where he gained his first real successes, he exhibited a series of busts, and pots, and animal figures in enamelled stoneware—frogs, salamanders, and other fantastic creatures looking as though they had escaped from some Gothic cathedral or Japanese temple. His pots were in the shape of strange, deformed fruits—gourds fashioned like an *aubergine* or a pumpkin, whose form and colour he sought to reproduce. And the simple ornamentation of these curious productions consisted of thick overflowings (*coulées*) of enamel, skilful glazing which the action of the fire had invested with the most sumptuous colourings, and drops of gold stopped in their course.

Carriès, who was born in 1855, was in the prime of his fresh genius when he died in 1894. M. Arsène Alexandre, in a charming book simply entitled *Jean Carriès*, has paid the tribute of admiration so well deserved both by the man and by his works. If not exactly an originator, he was at any rate a marvellous workman, full of will and patience, and of quite exceptional originality and boldness.

Unfortunately his influence has not produced the happy results that were hoped for; and this demands a little explanation.

Carriès, with his own hand, executed the sculptures which afterwards he moulded in stoneware. He designed them to suit the material in which he intended them to be produced; thus there was direct and complete connection and unity of conception and execution. In fashioning the rough models of his busts, his animals, and the other strange grimacing figures which he intended for the decoration of a sort of church front, Carriès knew exactly what the effect of the firing would be on his work, both as a whole and in detail. The practice of adapting stoneware in this fashion may perhaps be condemned; but at any rate the originality of his ideas and the success with which he carried them out are incontestable. He himself succeeded admirably; but it must be confessed his

27. Jean Carriès: Stoneware, poured glaze. Saint Amand en Puisaye, France, c. 1892. H. 12¹³⁄₁₆″ (32.5 cm). Collection Alain Lesieutre, Paris. Photograph: Garth Clark.

example led to deplorable results, for stoneware sculpture has now become a hateful thing. This very special material, by no means suitable for all purposes, is now used indiscriminately in all kinds of decorative objects. One manufacturer has gone so far as to exhibit stone arm-chairs of antique pattern, fireplaces, lamps, &c.; while an architect, who piques himself on being quite up to date, has used this stoneware for the *façade* of a house, for the staircases, and Heaven knows what beside.

As for true pottery, few there are, amid all this confusion, who have remained faithful to its traditions, few who are content to trust in the simplicity and sincerity of their work to attract the attention of the public, instead of producing eccentricities like those I have just mentioned.

Auguste Delaherche is of those who had rather remain unknown than condescend to debase the very essence of an art process by applying it at random, without regard for its requirements or limitations. He has too much admiration for the Japanese *grès* on the one hand, and the every-day potteries on the other, ever to go wrong; too well he knows the wonderful resources of earth and fire. He is a potter, and has no ambition to be anything else; holding his craft to be one of sufficient dignity, and considering it needless to resort to fantastic shapes and ornamentations in turning out sound pottery work.

Thus his work maintains the strictest simplicity of shape, in which one can always note the impress of the workman's hand. A pot, to please him, must be executed in the plainest, easiest manner, without touching up or complication of any sort; must, in a word, have come straight from the potter's fingers. Accordingly his curves are simplicity itself, his object being to produce those traditional harmonies of line, the whole charm of which lies in their perfect proportion. One looks in vain in Delaherche's works for the eccentricities indulged in by others under the pretext of modernising an art which has no need of being modernised, seeing it reached perfection long ago, and that everything that can be done in it has already been done, and everything that can be said has been said.

Delaherche was brought up in a good school. A native of Beauvais, living in a district where pottery has always been held in honour on account of the special soil which abounds in the Department of the Oise, he educated himself by studying on the spot a fine collection of Beauvais work owned by one of his uncles. The influence of Bernard Palissy is still seen in the neighborhood of Beauvais, especially at Savigny, where he left several characteristic traditions in the art of the place. At this spot they still make a rough pottery of a very interesting kind, such as the enormous salting-jars, which in simplicity of shape and in material recall the pottery of the ancients.

28. Jean Cazin: Stoneware. London, 1872. H. 8⅞″ (22.5 cm). Collection Musée National de Céramique, Sèvres. Photograph: Garth Clark.

Delaherche's first efforts date from 1883, but it was not until 1889 that he would allow them to be shown publicly. At the Universal Exhibition he had a show case containing a collection of enamelled and fired stonework, which called forth the admiration of all art lovers.

At that time he was working in Paris, in the Vaugirard quarter, with earth which he procured from the Oise; now, however, he has established himself in the immediate neighbourhood of Beauvais, and set up his ovens there. He spends the greater part of the year amid this beautiful Picardy scenery, working steadily and alone, far from the cliques of Paris and all its petty tendencies. And every year fresh shapes, fresh patterns, are added to his collection of works, which now number not less than eight hundred, every one of them quite original and individual, and fashioned by his own hands.

Delaherche impresses one with his strong will, his untiring patience, and his unerring knowledge of his art. He has devoted himself to it entirely, and it is no wonder he has acquired such knowledge and such skill.

"The art of pottery," he remarked to me while showing me over his workshops one lovely day in late summer, when all the landscape seen through the windows was flooded in golden light, "the art of pottery is a jealous art, demanding absolute fidelity. One must work, and seek and find unceasingly, and finding is most difficult of all, for one's discoveries must be made wittingly, with intention. It will not do to leave one's work to chance, as so many do. We are grappling with a blind power—fire; of all the elements perhaps the most powerful and most formidable, and we have to subdue and master it, and not let it conquer us. To this object all the potter's efforts must tend. Despite all the worker's care, and no matter how deep may be his knowledge of the processes of all sorts taught by experience, I defy him, whoever he be, to be able to know beforehand, at the moment when he puts his works into the oven, what exact results will have been obtained when he brings them out again. Do I mean by this that we are working absolutely in the dark? Happily this is by no means the case; but almost always we meet with results unforeseen, surprising, and very often most interesting; and this is our best school. It behoves us to make use of the unexpected, for each time the oven is heated there are fresh lessons to be learnt by the attentive observer. The danger lies in letting oneself be fascinated by these surprises, and thinking they will suffice of themselves to give this or that piece of work the ornamentation desired. But to be satisfied with results obtained in this haphazard way is to bring this admirable art down to the lowest level. Some of the pieces," continued M. Delaherche, "which I have broken up, as being unworthy of holding a place among my productions and of bearing my signature, were really remarkable: the action of the fire had taken all sorts of rich and fanciful colourings,

and I had often to resist the importunities of collectors who were enthusiastic over the effects produced. But that's not art.

"The remark of *père* Ingrès still applies with as much force to the potter as to the painter or to the sculptor: 'Even if you have a hundred thousand francs' worth of ability, buy two sous' worth more!' For art consists in achieving as nearly as may be the effects one has conceived and hoped for, by dint of slow and scrupulous study and observation, ever-increasing experience, and deeper and deeper penetration into Nature's mysteries.

"It is indeed an exciting moment when the work is taken from the oven. You have pictured, for instance, a splendid combination of colours for your amphora; you wished the *coulée* of the glazing on your vase to stop at two-thirds of its height; or on another piece you wanted to see a coating of rich enamel. But in one case it has all gone black; in another the drops have flowed too low; in a third the bottom has blistered, and is all over dull pustules; or all the materials have run into one another in the fusion; all is incoherence and disorder; the vitrified matter has distributed itself badly, and the earthenware reappears in patches!

"But, on the other hand, how boundless the domain of the process! What miracles these twelve hundred degrees of heat can perform! And what joy, what triumph, when one succeeds in bringing to perfection a beautiful piece of pottery, complete and satisfactory in its smallest details as in its entirety! I can assure you one's trouble is fully repaid, for the tints of the finest colourists can never equal the splendour, the brilliant variety, the deep, rich sumptuousness of some of these enamels."

No one who loves and appreciates the art of pottery will consider M. Delaherche guilty of exaggeration or professional vanity in thus proclaiming aloud the virtues of his art.

As a decorator Delaherche has the rare merit of extreme sobriety and simplicity of style. A leaf of thistle or clover, a wild-rose blossom, or a few peacock's feathers arranged in a wreath or *en arabesque* in two parallel rows around the neck or middle of a large vase, for instance, or on the brim of a goblet or water-jug—this is all he allows himself in the way of ornamentation. For my own part I prefer pottery devoid of all line work and decorative ornament, relying for its richness and beauty on the charm of the vitrified material, on the various effects of the fusion on the enamels, and on the oxydations.

As may be seen, one of the dominant characteristics of Delaherche's work is its saneness. It is firm and full of power. He has no fancy for any but normal harmonies of colour, if one may so express it; in other words, he ignores—and very wisely so—the complexities and subtleties which resolve themselves so easily

29. Taxile Doat: Porcelain form. Sèvres, 1900. H. 7⅞″ (20 cm).
Collection Alain Lesieutre, Paris. Photograph: Garth Clark.

into mere "Byzantinism." He loves the rich robust forms akin to nature, those which spring sanely, normally, I had almost written naturally, from the potter's fingers.

To adorn all he touches, this is the *raison d'être* of every artist. The blacksmith, the illuminator, the cabinet-maker of the Middle Ages put his whole conception of the beautiful into his productions, whether it was the iron-work of a box or a candlestick, an ornamental letter or a piece of furniture. There is as much beauty in a Greek vase as in the sublimest statue; and the man who to-day makes a stoneware pot, adorned with all the magic of the fire and radiant in the rich splendour of its material, holds in the eyes of all who really understand what art means, a place of equality beside the masters of the brush and the chisel.

30. Auguste Delaherche: Stoneware vase. Paris, 1889. H. 9″ (22.8 cm). Collection Galerie du Luxembourg, Paris. Photograph: Garth Clark.

The Anglo-Oriental Influence

Towards a Standard

Bernard Leach

"We live in dire need of a unifying culture out of which fresh traditions can grow. The potter's problem is at root the universal problem and it is difficult to see how any solution aiming at less than the full interplay of East and West can provide either humanity, or the individual potter, with a sound foundation for a worldwide culture."

Bernard Leach, the potter and writer, has become the best-known and most-honored figure in the contemporary ceramic arts. But when he published *A Potter's Book* (London: Faber & Faber, 1940), he was little known outside England and Japan, and his diligent crusading to bring about a bridging of the cultures of East and West had fallen on deaf ears for over twenty years. His determination was rewarded as *A Potter's Book* rapidly became the most popular publication of this century on the ceramic arts. It was more than a simple potter's manual. Leach blended technical information with the discussion of history, aesthetics, and purpose. The opening chapter, "Towards a Standard," is of particular significance, dealing with the philosophical role of the potter and suggesting an aesthetic that was not based on Western dualism, but on a gentle monistic view of beauty, springing from life itself.

Towards a Standard

Very few people in this country think of the making of pottery as an art, and amongst those few the great majority have no criterion of aesthetic values which would enable them to distinguish between the genuinely good and the meretricious. Even more unfortunate is the position of the average potter, who with-

59

out some standard of fitness and beauty derived from tradition cannot be expected to produce, not necessarily masterpieces, but even intrinsically sound work.

The potter is no longer a peasant or journeyman as in the past, nor can he be any longer described as an industrial worker: he is by force of circumstances an artist-craftsman, working for the most part alone or with a few assistants. Factories have practically driven folk art out of England; it survives only in out of the way corners even in Europe, and the artist-craftsman, since the day of William Morris, has been the chief means of defense against the materialism of industry and its insensibility to beauty.

Here at the very beginning it should be made clear that the work of the

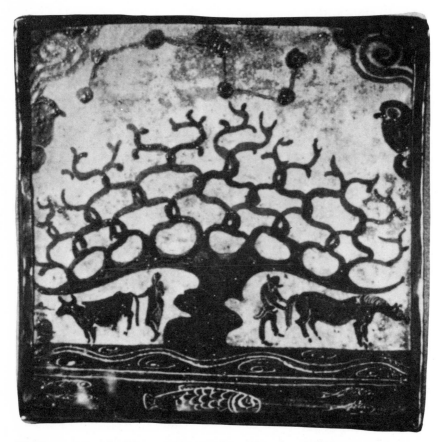

31. Bernard Leach: Tile, painted slip decoration. Leach Pottery, St. Ives, Cornwall, 1923. H. 7⅞″ (20 cm).

individual potter or potter-artist, who performs all or nearly all the processes of production with his own hands, belongs to one aesthetic category, and the finished result of the operations of industrialized manufacture, or mass production, to another and quite different category. In the work of the potter-artist, who throws his own pots, there is a unity of design and execution, a cooperation of hand and undivided personality, for designer and craftsman are one, that has no counterpart in the work of the designer for mass production, whose office is to make drawings or models of utensils, often to be cast or molded in parts and subsequently assembled. The art of the craftsman, to use Herbert Read's terminology, is intuitive and humanistic (one hand one brain); that of the designer for reduplication, rational, abstract, and tectonic, the work of the engineer or constructor rather than that of the "artist." Each method has its own aesthetic significance. Examples of both can be good or bad. The distinction between them lies in the relegation of the actual making not merely to other hands than those of the designer but to power-driven machines. The products of the latter can never possess the same intimate qualities as the former, but to deny them the possibility of excellence of design in terms of what mechanical reproduction can do is both blind and obstinate. A motorcar such as a Rolls-Royce Phantom achieves a kind of perfection although its appeal is mainly intellectual and material. There I think we come to the crux of the matter: good handcraftsmanship is directly subject to the prime source of human activity, whereas machine crafts, even at their best, are activated at one remove—by the intellect. No doubt the work of the intuitive craftsman would be considered by most people to be of a higher, more personal, order of beauty; nevertheless, industrial pottery at its best, done from the drawings of a constructor who is an artist, can certainly have an intuitive element.[1] The trouble, however, is that at a conservative estimate about nine-tenths of the industrial pottery produced in England no less than in other countries is hopelessly bad in both form and decoration. With the exception of a few traditional shapes and patterns for tableware, and others designed by the best designers available today and painted by the best available artists (none of whom is a potter), turned out notably by the Wedgwood and Royal Worcester and Minton factories and by the Makin and Gray firms in Hanley, and excluding also a few purely functional and utilitarian designs, some of which are also traditional, such as Doulton's acid jars, we meet everywhere with bad forms and banal, debased, pretentious decoration—qualities that are perhaps most conspicuous in "fancy vases," flowerpots and other ornamental

[1] "Whenever the final product of the machine is designed or determined by anyone sensitive to formal values, that product can and does become an abstract work of art in the subtler sense of the term."—Read, *Art and Industry*, p. 37.

pieces, in which we find a crudity of color combined with cheapness and in-
appropriateness of decoration and tawdriness of form that must be seen to be
believed. And although the mechanical processes are indeed marvelous, as for
example the automatic glazing, cleaning, measuring, and stamping of many
millions per month of bathroom tiles, fired in a single nonstop tunnel kiln, the
mere fact of their being mass-produced is no reason why these tiles should be as
cheaply designed and as dull and miserable in color as it is possible for tiles to be;
nor in the case of hollow ware is the casting of shapes so exactly and so quickly
and with such perfect pastes an adequate excuse for dead shapes, dead clay, dead
lithographed printing or the labored painting of dead patterns. Indeed the more
elaborate and expensive the decoration the more niggling and lifeless it is, and
the nearer it approaches the long-deceased fashion of naturalism of the nine-
teenth century, when close attention to detail and the careful painting of pic-
tures upon porcelain in enamel colors was considered the summit of ceramic
art—"applied" art with a vengeance! On the other hand, if the bulk of the
pottery turned out in England today is mass-produced and of inferior form and
decoration, its inferiority is not so much due to the manner of its production—
for mass-produced wares can not only be of fine quality of body[2] and beautiful
in form, if designed by the right men—but for various extrinsic reasons, chief of
which is the failure of the manufacturer to interest himself in good design. The
want of artistic initiative on the part of the manufacturers must be ascribed to
the general lowering of taste under conditions of competitive industrialism. The
public is ever increasingly out of touch with the making of articles of everyday
use, and although its entrepreneurs, the buyers and salesmen of trade, are con-
tinually caught out in their underestimation of what people like they cannot be
entirely blamed for catering to safe markets. Even if, as Pevsner says, "one
cannot condemn an industrialist too severely because he does not jump at every
suggested artistic improvement," and it "would be absurd to suggest to the pro-
ducer that he ought to ruin himself for the community," there is nevertheless
no reason why he should not work as far as possible towards replacing bad forms
and decorations with good, and realize, in spite of the cheerful assurances of
buyers and travelers, that he must cater to bad taste, that one of the chief reasons
why "the public (apart from a few hopelessly insensitive individuals) likes"
tawdry utensils is because as a rule it can get no others. Apart from the initial
expense of new molds, and provided a competent designer is available, there is

[2] ". . . pottery manufacturers know that mass production can in ceramics, at least as
regards the quality of the body, help greatly towards improvements. The reason is that more
efficient kilns can be used and better conditions of firing attained."—Comp. Nikolaus Pevsner,
An Enquiry into Industrial Art in England (1937), pp. 191, 83.

no apparent ground for believing that good commercial pottery should be any more expensive to make than bad.

It is obvious that the standards of the world's best pottery, for example, those of the T'ang and Sung periods in China and the best of the Ming, Korean celadons and Ri-cho, early Japanese tea-master's wares,[3] early Persian, Syrian, Hispano-Moresque, German Bellarmines, some Delft and English slipware, cannot well be applied to industrial work, for such pottery was a completely unified human expression. It had not been mechanized. Yet there is no doubt that much can be learned by the industrial potter or designer from the wares especially of the Sung and early Ming dynasties. The Chinese potters' use of natural colors and textures in clays, the quality of their glazes (e.g., the Ying-ching and Tz'ou Chou families), the beauty and vitality of their well-balanced and proportioned forms, could be a constant source of inspiration to the designer for mass production no less than to the craftsman.

It is no discredit to the scientific and utilitarian advances of the English pottery industry to say that the beauty to which the Sung potters attained was far beyond the highest that from its beginnings in Josiah Wedgwood the English factories ever aimed at. The two traditions and methods of production are radically different, and the intuitive, organic qualities of Sung pottery can never be completely expressed by the rational and tectonic methods of big industry. Concentration upon mechanical production and utilitarian and functional qualities is today necessary and justified, and as already said there is no reason to suppose that factory-made utilitarian wares may not by reason of their precision, their pleasing lines and perfection of technique, added to complete adaptation to use, have a great beauty of their own. Even during the course of the last two centuries molded English tea ware of admirable design has been made, and often its decoration, especially the "Japan" and other conventionalized set patterns of the late eighteenth and early nineteenth centuries, has been, if not great art, at least possessed of much charm. It would be surprising if equally good patterns could not be turned out by able designers today.

It is quite otherwise with the studio potter. He is indeed constrained to look to the best of the earlier periods for inspiration and may, so far as stoneware and porcelain are concerned, accept the Sung standard without hesitation. As it is, there are a few English craftsman potters today who do accept it, and their work

[3] I.e., pottery approved of by the Japanese tea-masters, adepts in the *Cha-no-yu*, or tea-ceremony, who have for several centuries been the foremost art critics in Japan and have counted among their numbers many creative artists of the first rank. For an account of the spirit of the *Cha-no-yu*, see *The Book of Tea* by Okakura Kakuzo, also A. L. Sadler, *Cha-no-yu* (London, 1934).

is incomparably the best that is now being turned out.[4] Others go back to an outmoded "arts and crafts" tradition, which seems to have had its origin in France in the last quarter of the nineteenth century and to have been largely influenced by modern Japanese designs, which became fashionable soon after the Paris Exhibition of 1867. Its characteristic features are weakness of form, especially of lip and foot, and, except in the case of the salt-glazed wares of the Martin Brothers (much of which was also influenced by Japanese design), crudely colored glazes in which all aesthetic quality is lost in technique, as always happens when the means are mistaken for the end. It is easy to understand the impression made on potters by the discovery, first in France by Chaplet and later in England by William Burton, of how to make the brilliant high-temperature single color and flambé glazes of the Ching period in China; but in the absence of tradition, again technique triumphed over art and eccentricity and weakness over strength. The attempted revival of lustre painting under Pre-Raphaelite influence by William de Morgan led as one might expect to nothing fresh and vital in form, or for that matter in decoration. Nor does the example of the Doulton company in preserving the English salt-glazed tradition seem to have had any influence on studio potters, beyond the Martins and, possibly, William Gordon, who was recently making good salted porcelain at Chesterfield.

In the absence of some agreement, however inarticulate, as to a common standard, one may hope to find an occasional work of genius in the free or so-called fine arts (frequently then only the outcome of pain and poverty and life-long obscurity); but in applied art, which depends upon collaboration in the workshop and constant sales to a public, there is even less hope. Indeed, amongst some at least of the free arts there does exist what one may call a classic standard, according to which the work of today, especially in literature and music, is compared with the great work of the past. That the criterion of beauty is a living thing and constantly in flux is true, but here at least there is a continuous if ever changing consensus of opinion as to what may be called great achievement. In

[4] There has never been a European stoneware tradition except that of the Rhenish salt-glazed wares. "Accepting the Sung standard" is a very different thing from imitating particular Sung pieces. It means the use so far as possible of natural materials in the endeavor to obtain the best quality of body and glaze; in throwing and in a striving towards unity, spontaneity, and simplicity of form, and in general the subordination of all attempts at technical cleverness to straightforward, unselfconscious workmanship. A strict adherence to Chinese standards, howsoever fine, cannot be advocated, for no matter what the source and power of a stimulus, what we make of it is the only thing that counts. We are not the Chinese of a thousand years ago, and the underlying racial and social and economic conditions which produced the Sung traditions in art will never be repeated; but that is no reason why we should not draw all the inspiration we can from the Sung potters.

regard to pottery such a criterion can hardly be said ever to have entered the consciousness of Western man. In the East it has long been in existence, especially in Japan, where the aesthetic sensibility of educated people has been stimulated by the ablest of critics for some three hundred or more years. As space will only allow me to speak briefly of this great aesthetic cult and its unrivaled standard of artistic appreciation, I cannot do better than give a more or less condensed and paraphrased extract from an essay on popular, or folk, arts and crafts by Soetsu Yanagi, the intellectual leader of the Japanese craft movement of today:

> I have many occasions to call at the residences of well-known art collectors, but I find too often that the articles of everyday use in their homes are far from being artistic, to say the least. They often leave me with a sad suspicion as to how much these collectors really appreciate beauty.
>
> To me the greatest thing is to live beauty in our daily life and to crowd every moment with things of beauty. It is then, and then only, that the art of the people as a whole is endowed with its richest significance. For its products are those made by a great many craftsmen for the mass of the people, and the moment this art declines the life of the nation is removed far away from beauty. So long as beauty abides in only a few articles created by a few geniuses, the Kingdom of Beauty is nowhere near realization.
>
> Fortunately, in Japan, handicraft objects have been treasured through the channel of ceremonial tea. *Cha-no-yu* in the last analysis is a means of harmonizing life and beauty. . . . It may be thought of as an aesthetics of the practical arts. In all its appurtenances, whether it be in the architecture, the garden, or the utensils, the first principle is utility and the adornment of life with refinement. Not beauty for beauty's own sake, but beauty answering all immediate needs of life—that is the essence of ceremonial tea. . . .
>
> One may ask, what then is the nature of the beauty which has been discovered by these tea-masters? . . . In the first place it is non-individualistic. . . . As in medieval Europe art meant adherence to tradition, so in the East all works of arts or crafts were governed equally by common principles. . . . Some of the most famous tea bowls were originally the simplest of utensils in popular use in Korea or China; many of them were the rice bowls of Korean peasants. But the amazingly keen eye of the *Cha-no-yu* master has discovered in these odd, neglected pieces a unique beauty; for what most appeals to him are the things originally made for everyday use. In brief, *Cha-no-yu* may be defined as an aesthetics of actual living, in which

utility is the first principle of beauty. And that is why such great significance has been given to certain articles necessary for everyday life. . . .

The next important aspect of the works of people's art is that they are simple and unassuming. Here the quality of extravagance that is always associated with expensive art objects is wholly absent, and any surplus of decorativeness is objectionable. . . . Simplicity may be thought of as characteristic of cheap things, but it must be remembered that it is a quality that harmonizes well with beauty. That which is truly beautiful is often simple and restrained. . . . I am told that St. Francis of Assisi advocated what he called "Holy Poverty." A thing possessed in some manner of the virtue of poverty has an indescribable beauty. Indeed, Beauty and Humility border upon each other. What is so appealing in the art of the people is this very quality . . . beauty accompanied by the nobleness of poverty. The Japanese people have a special word *shibui* to express this ideal beauty. . . . It is impossible to translate it satisfactorily into one English term, *austere, subdued, restrained;* these words come nearest. Etymologically, *shibui* means "astringent," and is used to describe profound, unassuming and quiet feeling. The mere fact that we have such an adjective would not call for second thought, but what does call for special note is the fact that this adjective is the final criterion for the highest form of beauty. It is, morever, an ordinary word, and is repeated continually in our casual conversation. It is in itself unusual that a whole nation should share a standard word for aesthetic appraisal. Here in this criterion of ours for the best and most beautiful may be observed the fundamental principle of the aesthetic tastes of the Japanese people. . . . If you have traveled much in rural Japan you must have come across one of these stone monuments, with the inscription *Sangai Banrei To*, at a crossroad or in a deserted corner. The inscription means "a monument to the unknown, departed souls of the million people of the world." This monument is an expression of the Buddhist's compassion for the countless number of forgotten and uncared-for souls. I am one of those whose prayer it is to erect such monuments in the Kingdom of Beauty.

Thus from a Buddhist background, ethically much akin to the medieval Christianity on which the neo-Thomists have based their attitude towards art, Mr. Yanagi seems to me in these arresting and moving sentences to have thrown down a challenge not only to his Japanese contemporaries but to us as well—a challenge to our overaccentuated individualism. For one may indeed look back with an acute sense of loss to those periods when the communal element, with

its native religious, psychological, and aesthetic basis, was all-powerful as an ennobling and transmuting influence and source of life.

A potter's traditions are part of a nation's cultural inheritance and in our time we are faced with the breakdown of the Christian inspiration in art. We live in dire need of a unifying culture out of which fresh traditions can grow. The potter's problem is at root the universal problem and it is difficult to see how any solution aiming at less than the full interplay of East and West can provide either humanity, or the individual potter, with a sound foundation for a worldwide culture. Liberal democracy, which served as a basis for the development of industrialism, provides us today with a vague humanism as insufficient to inspire art as either the economics of Karl Marx or the totalitarian conception of national life, but at least it continues to supply an environment in which the individual is left comparatively free.

Our need of a criterion in pottery is apparent and seems to be provided by the work of the T'ang and Sung potters which during the last twenty years has been widely accepted as the noblest achievement in ceramics. But the successful assimilation of strange stimuli requires a healthy organism, and it remains to be seen whether there is enough vitality in Europe to absorb from early Chinese pottery even more than we did during the eighteenth and nineteenth centuries from late Chinese porcelain. At the moment it is difficult to believe that the general arrogance of our materialism and the particular self-sufficiency of the pottery trade will permit the subtler scale of early oriental values to be perceived, except by artists and some sensitive people of leisure. Influences from alien cultures either upon art or industry must pass through an organic assimilation before they can become part and parcel of our growth. This happens, moreover, only when they supply an inherent need, and is usually inaugurated by the enthusiasm and profound conviction of men who have themselves succeeded in making the synthesis. The superficial imitation of early Chinese shapes, patterns, colors, and technique signify nothing unless new life emerges from the fresh combination. The temptation for the individual potter is to stand back with the paralysis of frustration in face of such a sea of change, but we cannot afford to wait until the tide of a new culture rises.

The necessity for a psychological and aesthetic common foundation in any workshop group of craftsmen cannot be exaggerated, if the resulting crafts are to have any vitality. That vitality is the expression of the spirit and culture of the workers. In factories the principle objectives are bound to be sales and dividends and aesthetic considerations must remain secondary. The class of goods may be high, and the management considerate and even humanitarian, but neither the

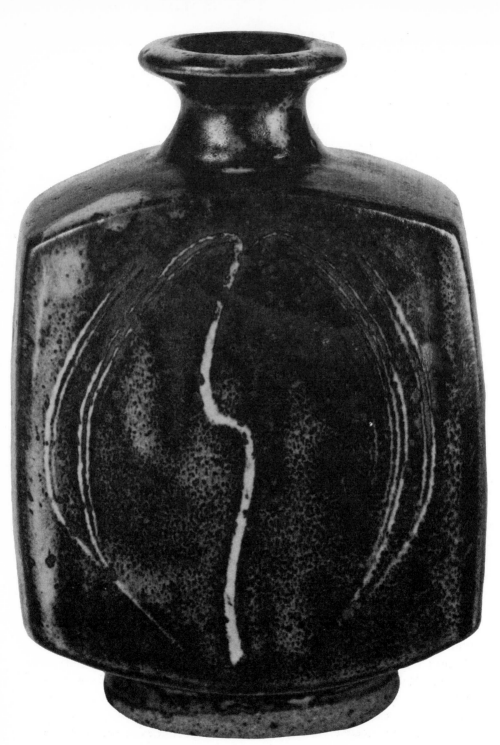

32. Bernard Leach: Press-molded stoneware bottle. Leach Pottery, St. Ives, Cornwall, 1956. H. 7½″ (19 cm). Collection Fred and Mary Marer, Los Angeles. Photograph: Paul Soldner.

creative side of the lives of the workers nor the character of their products as human expressions of perfection can be given the same degree of freedom which we rightly expect in handwork. The essential activity in a factory is the mass production of the sheer necessities of life and the function of the handworker on the other hand is more generally human.

The problem is made increasingly difficult for the reason that the people who are attracted today by the handcrafts are no longer the simpleminded peasantry, who from generation to generation worked on in the protective unconsciousness of tradition, but mainly self-conscious art students. They come to me year after year from the Royal College, or the Central School, or Camberwell, for longer or shorter, usually shorter, periods of apprenticeship. As soon as they have picked up enough knowledge, or what they think is enough, off they go to start potting on a studio scale for themselves. Very few have proved themselves to be artists. And what of the others, those thousands who pass through these schools and then either disappear from sight or continue to produce bad work. Again, in the past tradition would have developed and used their more moderate talents; in our own one cannot escape the sense of a great wastage.

In crafts the age-old traditions of handwork, which enabled humble English artisans to take their part in such truly human activities as the making of medieval tiles and pitchers and culminated in magnificent cooperation like Chartres Cathedral, have long since crumbled away. The small establishments of the Tofts and other slipware potters were succeeded by the factories of the Wedgwoods and the Spodes, and in a short space of time the standard of craftsmanship, which had been built up by the labor of centuries, the intimate feeling for material and form, and the common, homely, almost family workshop life had given way to specialization and the inevitable development of mass production. For that no individual can be praised or blamed: like many another institution it arose in response to a human need, moving parallel on the one hand with the slow progress of economic democracy, and on the other with an unprecedented rise in the population. But although we have now reached a point where for the first time in history we are able to produce enough and more than enough for all, the trouble from the artist's or craftsman's, or for that matter any sane person's point of view, is not only that the problem of equitable distribution is still unsolved, but that so many of the things we have thus contrived to make are inhuman.

In the field of ceramics the responsibility for the all-pervading bad taste of the last century and the very probable ninety percent bad taste of today lies mainly with machine production and the accompanying indifference to aesthetic considerations of individual industrialists and their influence on the sensibility of

the public.[5] Yet although industrialists will as time goes on become more and more conscious of the desirability of, if not the necessity for, good form and decoration, it is also plain that during the last twenty-five years a far-reaching change in aesthetic judgment has come about, not only in England, but literally all over the civilized world. A new type of craftsman, called individual, studio, or creative, has emerged, and a new idea of pottery is being worked out by him as a result of an immensely broadened outlook. Another wave of inspiration has come to us from the Far East, and out of the tomb-mounds of long-dead Koreans and Chinese, looted and disturbed by the encroachment of Western commercialism, has arisen a new appreciation of ceramic beauty.

It is just about fifty years ago that Carriès, a young French sculptor, began to make stoneware based upon old Japanese models. He has been followed by a number of potters in Paris, such as Delaherche, Decoeur, Cazin, and many others, whose work has been inspired by the simplicity and restraint of the Sung potters. In Holland, Germany, Austria, Scandinavia, America, Japan, and England there has been a similar response to the same stimulus, and factory products are being more and more influenced by them. One need only mention Sèvres and Copenhagen. Amongst all these individual efforts to my mind the Japanese and English are the best.

Pots, like all other forms of art, are human expressions: pleasure, pain, or indifference before them depends upon their natures, and their natures are inevitably projections of the minds of their creators. It is unfortunate that as a consequence of its divorce from life, the "applied" no less than the "fine" art of our time, more than in any other age, suffers from excessive self-consciousness, or what is often called pose, a very different thing from the unconscious, inherent, personal, and race character which has distinguished all the great periods of creative art. It is also important to remember that, although pottery is made to be used, this fact in no wise simplifies the problem of artistic expression; there can be no fulness or complete realization of utility without beauty, refinement, and charm, for the simple reason that their absence must in the long in be intolerable to both maker and consumer. We desire not only food but also the enjoyment and zest of eating. The continued production of utilities without delight in making and using is bound to produce only boredom and to end in sterility. And the greater part of what passes for pleasure in the form and decoration and color of pottery for the people today is so banal, so false and ridiculous

[5] This is not to say that any better taste was shown in the work of the late nineteenth- and early twentieth-century hand potters in England up to fifteen or twenty years ago, or by many of them even now; but it is probable that the example set by industrialism and the strain of getting away from it was largely responsible even for their demoralization.

in the confusion of mechanical perfection with beauty, as to be in itself alone an indictment of our popular half culture.

The art forms of a community are the crystallizations of its culture (which may indeed be a very different thing from its civilization), and pottery traditions are no exception to the rule. In the T'ang period it is not difficult to recognize the Chinese genius for synthesis, here reinterpreting Greek and Buddhist ideology in terms of contemporary need, and combining these elements within the native framework of Taoist and Confucian concepts, thus fundamentally modi-

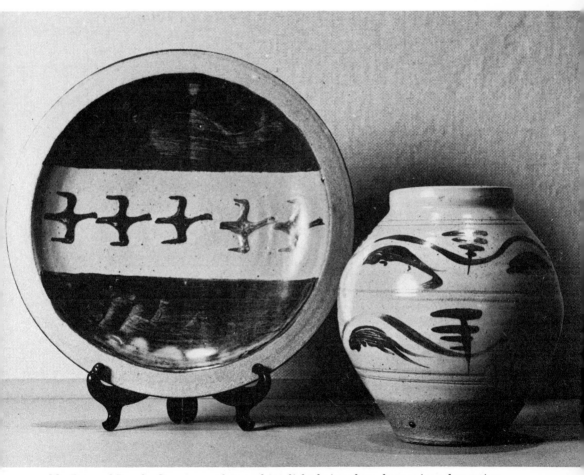

33. Bernard Leach: Stoneware plate and jar, light beige glaze, brown iron decoration. Leach Pottery, St. Ives, Cornwall, c. 1956–1957. H. (maximum) 14¾″ (37.5 cm). Collection Everson Museum of Art, Syracuse, New York. Photograph: Everson Museum of Art.

fying and extending the boundaries of their ideas of beauty and truth. In the greatest period, that of the Sung dynasty, all these different influences are welded together in one, for unification was then supreme. Until the beginning of the industrial era, analogous processes of synthesis had always been at work amongst ourselves, but since that time the cultural background has lost much of its assimilating force, and the ideas we have adopted and used have been molded into conformity with a conception of life in which imagination has been subordinated to invention and beauty to the requirements of trade. In our time technique, the means to an end, has become an end in itself, and has thus justified Chinese criticism of us as a civilization "outside in."

Since the last quarter of the nineteenth century, the reaction started by William Morris has been taking place mainly outside industry and has culminated in what I have called the individual, or artist, craftsman. Beginning in protest against the irresponsible use of power, it came to an end in pseudo-medieval crafts little related to national work and life. Thence has arisen the affirmation of the mechanical age in art—functionalism. This, through let us say, Picasso,[6] le Corbusier, and Gropius of the Bauhaus, is having its effect on all crafts. A movement which however based by its initiators on a new and dynamic concept of three-dimensional form tends amongst those who attempt to carry the idea into industry to an overintellectual effort to discover norms of orderliness and utility. Such a process limits the enjoyment of work to the designer and overlooks the irregular and irrational element in all fine activity including the making of pottery. Herein lies the significance of the artist-craftsman as distinct from the factory designer. Almost alone amongst workmen does he exercise the responsibility of making things for full human use—objects which are projections of men—alive in themselves. To him the question of standard is of vital importance, and through his work to industry, and through industry to everyone. He is faced with a broken tradition and, what is even more serious, with a culture in rapid process of change. Our sensibility to beauty is ministered to for the most part only by the work of a handful of men of genius, for the history of all nations with a developing industrialism shows that the unconscious, intuitive craftsman breaks down under the strain of transition from hand and tool to industrial machinery. His horse sense and creative vigor, his capacity to assimilate new methods and new ideas became perverted. Only the artist and craftsman of unusual perception and strength of character stands a chance of

[6] It is worth recording that Picasso himself, perhaps the most creative artist alive, has written, "decorative art bears no resemblance to easel painting, to the production of a picture. One is utilitarian, the other a noble play. An armchair means the back against which one leans. It is a utensil. It is not art." *Creative Art* (June 1930).

selecting what is best from the welter of ideas which rolls in upon him today. As soon as the craftsman becomes individual and detached from his tradition he stands on the same footing as the artist. This may not signify much when one thinks of the number of artists in relation to the number of paintings done each year which will appeal with any conviction to men a century hence! But the important question is how in our disintegrating times individual potters are to discover their particular kind of truth, in other words, their highest standard, and further, by what means it can be passed on to other artist-potters to the end that humanistic work of true merit, especially for domestic use, may be produced.

I can still remember vividly how twenty-five years ago I stood before the magnificent examples of the pottery of the Sung dynasty in the Tokyo Museum wondering how an individual potter of today could possibly appropriate to himself a beauty so impersonal, so inevitable—the patient unassuming outcome of centuries of tradition gradually developing through the experience of material and increasing complexity of need, and the sublimated emotion of a long succession of Chinese or Korean workers. I was abashed. I know now that it is a task beyond the power of any one man, and what makes the matter still worse, far from there being any unity of purpose and faith, at the present moment there is such an obsession with the individual point of view among English craftsmen, that one often hears them ridicule the very idea of a new communal standard. Independence once achieved is very precious, but an exaggerated pride in its possession stands bluntly in the way of concurrence in either aim or action, and the pride is only too often merely that of an artist on a dunghill. Since World War I, however, there have been at least some signs of change, in science, in philosophy, in politics, even in the worldwide acceptance by the younger artists of a more or less common geometric abstract. But even this new common factor has been accompanied by a growing awareness of emptiness and sterility.

We craftsmen, who have been called artist, have the whole world to draw upon for incentive beauty. It is difficult enough to keep one's head in this maelstrom, to live truly and work sanely without that sustaining and steadying power of tradition, which guided all applied art in the past. In my own particular case the problem has been conditioned by my having been born in China and educated in England. I have had for this reason the two extremes of culture to draw upon, and it was this which caused me to return to Japan, where the synthesis of East and West has gone farthest. Living there among the younger men, I have with them learned to press forward in the hope of binding together those elements from the ends of the earth which are now giving form to the art of the coming age. I may tend to overstress the significance of East and West to one

another, yet if we consider how much we owe to the East in the field of ceramics alone, and how recent a thing is Western recognition of the supreme beauty of the work of the early Chinese, perhaps I may be forgiven for the sake of the first-hand knowledge which I have been able to gather both of the spirit and manner in which that work was produced.

The manner, or technique, will be dealt with in the following chapters: here at the outset I am endeavoring to lay hold of a spirit and a standard which applies to both East and West. What we want to know is how to recognize the good or bad qualities in any given pot, and we are at least able to say that one should look first for the nature of the pot and know it for an expression of the potter in the background. He may be an unknown peasant or he may be a Staite Murray. In the former case his period and its culture and his national character-istics will play a more important role than his personality; in the latter, the chances are that personality will predominate. In either case sincerity is what matters, and according to the degree in which the vital force of the potter and

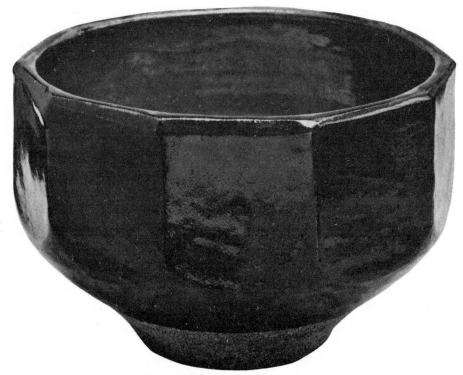

34. Bernard Leach: Cut stoneware bowl.
Leach Pottery, St. Ives, Cornwall, 1965. H. 4$^{15}/_{16}$″ (12.5 cm).

that of his culture behind him flow through the processes of making, the resulting pot will have life in it or not.

I have often sought for some method of suggesting to people who have not had the experience of making pottery a means of approach to the recognition of what is good, based upon common human experience rather than upon aesthetic hairsplitting. A distinguished Japanese potter, Mr. Kawai of Kyoto, when asked how people are to recognize good work, answered simply, "With their bodies"; by which he meant, with the mind acting directly through the senses, taking in form, texture, pattern, and color, and referring the sharp immediate impressions to personal experience of use and beauty combined. But as pottery is made for uses with which we are all familiar, the difficulty probably lies less in one's ability to recognize proper adaptation of form to function than in other directions, primarily perhaps in unfamiliarity with the nature of the raw material, clay, and its natural possibilities and limitations, and also in uncertainty as to the more imponderable qualities of vitality and relative excellence of form, both of which are indispensable constituents of beauty. It must always be remembered that the dissociation of use and beauty is a purely arbitrary thing. It is true that pots exist that are useful and not beautiful, and others that are beautiful and impractical; but neither of these extremes can be considered normal: the normal is a balanced combination of the two. Thus in looking for the best approach to pottery it seems reasonable to expect that beauty will emerge from a fusion of the individual character and culture of the potter with the nature of his materials—clay, pigment, glaze—and his management of the fire, and that consequently we may hope to find in good pots those innate qualities which we most admire in people. It is for this reason that I consider the mood, or nature, of a pot to be of first importance. It represents our instinctive total reaction to either man or pot, and although there is no guarantee that our judgment is true for others, it is at least essentially honest and as likely to be true as any judgment we are capable of making at that particular phase of our development. It is far better to run the risk of making an occasional blunder than to attempt cold-blooded analyses based upon other people's theories. Judgment in art cannot be other than intuitive and founded upon sense experience, on what Kawai calls "the body." No process of reasoning can be a substitute for or widen the range of our intuitive knowledge.

This does not mean that we cannot use our common sense in examining the qualities in a pot which give us its character, such as form, texture, decoration, and glaze, for analytic reasoning is important enough as a support to intuition. Beginning with the color and texture of the clay, one must ask, apart from its technical suitability, whether it is well related to the thrown or molded shape

created by the potter and to the purpose for which the pot is intended—what, for example, is appropriate for a porous unglazed water jug is utterly unsuitable for an acid jar. Does its fired character give pleasure to the eye as well as to the touch; its texture contrast pleasingly with the glaze? Has it where exposed to the flame turned to a dull brick red which contrasts happily with the heavy jade green of a celadon? Does it show an interesting granular surface under an otherwise lifeless porcelain glaze? Has its plasticity been such as to encourage the thrower to his best efforts, for the form cannot be dissociated from its material. The shape of a pot cannot be dissociated from the way it has been made, one may throw fifty pots in an hour, on the same model, which only vary in fractions of an inch, and yet only half a dozen of them may possess that right relationship of parts which gives vitality—life flowing for a few moments perfectly through the hands of the potter.

Apart from the basic clay, the form of the pot is of the first importance, and the first thing we must look for is, as already indicated, proper adaptation to use and suitability to material. Without these we cannot expect to find beauty in any of its modes, nobility, austerity, strength, breadth, subtlety, warmth—qualities which apply equally to our judgments of human and ceramic values. Nor do these qualities arise from human characteristics alone, but from a common recognition of forms, whether man-made or natural, which we associate with them. Of all forms we know best our own and attach to it the greatest degree of evocative emotion; next come animal, plant, and mineral forms; lastly, and mainly in our own time, geometric abstracts, largely the inventions of man's brain. It is not without reason that important parts of pots should be known as foot, belly, shoulder, neck, and lip, or that curve and angle should often be thought of as male or female. Beauty of ceramic form, which is at once subjective and objective, is obtained in much the same manner as in abstract (rather than representational) sculpture. It is subjective in that the innate character of the potter, his stock and his tradition live afresh in his work; objective in so far as his selection is drawn from the background of universal human experience.

Subordinate to form but intimately connected with it is the problem of decoration, and the question arises whether the increased orchestration adds to the total effect or not. Decoration will be treated more fully later on, here it is enough to say that, although some of the very finest pots are quite plain, it is nevertheless of the greatest significance. Many a good piece has been spoiled by a weak or tasteless design, printed or applied in one way or another: not only must the pattern be good in itself and freely executed, but it must combine with and improve the form and harmonize with the natural variations of both color and texture of body and glaze.

76

35. Bernard Leach: Tall glazed bottle with painted decoration. Leach Pottery, St. Ives, Cornwall, 1960. H. 13¹³⁄₁₆″ (35 cm).

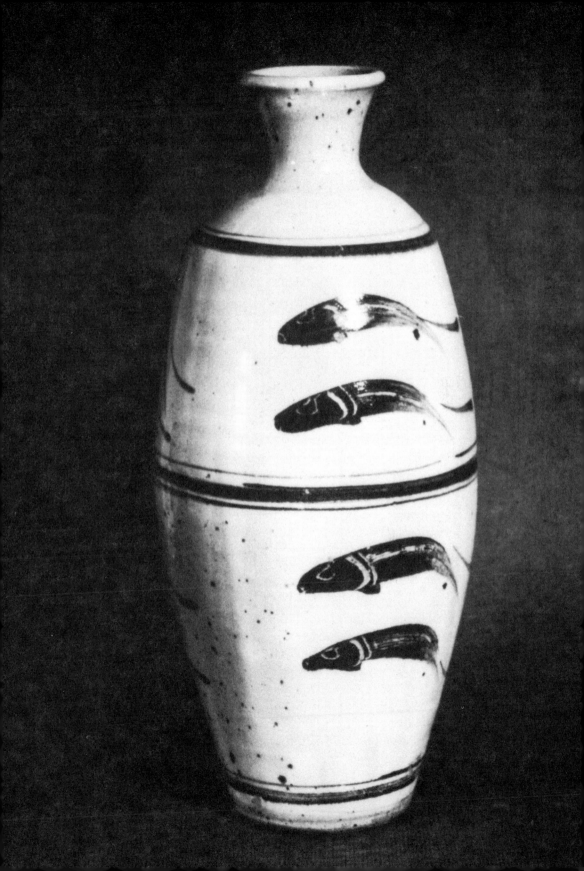

36. Bernard Leach: Lidded bowl.
Leach Pottery, St. Ives, Cornwall,
1965. H. 10¹³⁄₁₆″ (27.5 cm).
Collection Seamus and Mary
O'Brien, Addlestead, England.
Photograph: Garth Clark.

The upshot of the argument is that a pot in order to be good should be a genuine expression of life. It implies sincerity on the part of the potter and truth in the conception and execution of the work. By this reasoning we are thrown back upon the oldest of questions, but there is no escaping fundamental issues in discussing problems of art at a period of breakup and change. Art is an epitome of life experience, and in searching for a standard in pottery elastic enough to cover both past and present, we are compelled to look far afield and to examine the principles upon which the best pots of East and West have been based. In a broad way the difference between the old potters and the new is between unconsciousness within a single culture and individual consciousness of all cultures. And to this one can only add that until a life synthesis is reached by humanity the individual potter can only hope to deepen and widen his consciousness in anticipation and contribution towards that end.

The method by which a pot is formed determines its general character, whether hand modeled or built up out of coils or slices, or freely thrown on the wheel, or thrown in a mold, or cast entirely in a mold—each process conditions

the interpretation of the original idea, and each has a limited range of right usage, from the easy flowing application of which follows the sense of satisfaction and adequacy of technique. It is for this reason that the industrial practice of rigidly separating designer on paper from maker in clay is responsible for much of the deadness of commercial pottery, for it is a waste of opportunity as well as a straining of technique to make molded pots as like thrown pots as possible. The beauty of each method lies in using that method honestly, for what it is worth, not in imitating other quite different processes.[7]

The range of plastic beauty achieved in primitive pottery made chiefly by the hands of women without a wheel and with tools only of wood or stone, basketry, textiles, leaves of trees, or stitched animal hides is immense. The whole world seems to have contributed to it during thousands of prehistoric years: Minoan, archaic Greek, African, North and South American, pots of the Black Earth Region, and Neolithic China, pigmented but unglazed, often so fine that one might be tempted to surrender all claim for the supremacy of eleventh- and twelfth-century China, were it not for the fact that the general cultural and technical achievements of the Sung Chinese were so much greater. For this reason I shall deal in this book for the most part with wheel-thrown forms, which reached their greatest perfection round about that period.

A pot thrown on a good wheel with responsive clay, but not too soapy in texture, is impressed and expressed, urged and pulled and coaxed through a series of rhythmic movements, which like those of a dance are all related and interdependent. The spinning wet clay must be kept dead true to the center of the wheel while it is being hollowed and drawn up, expanded and contracted into a living embodiment of the potter's intention. The preconceived shape will include the mark of each part of the process of throwing, the ribs left by the fingers, the upward thrust of the cylinder from the wheel head to the major curve of the belly, the fullness or leanness of that curve, the pause and turn on the shoulder, often accentuated with ridge or collar, where convex movement changes to concave, the neck tapering to the lip with a concluding accent and conciseness of finish. Many of the noblest and most spontaneous pots are com-

[7] Every designer either on paper or of model parts should have firsthand experience not only of the processes of manufacture, but also of the limitations no less than the potentialities of his materials. What is obviously needed is a new type of designer who knows both approaches to pottery and can therefore keep industry in touch with fresh artistic expression in the studio. Without such an alliance in the near future between artist-craftsman and factory, it is difficult to conceive how pots could be made in Staffordshire which would be even respectable in the scale of beauty the world has known. The tendency to employ sculptors and painters of reputation to make designs for the industry is useful up to a point, but it gives no guarantee that these artists know and feel their medium, nor that the factories and their reduplicating processes will do justice to the designs. The link is not close enough.

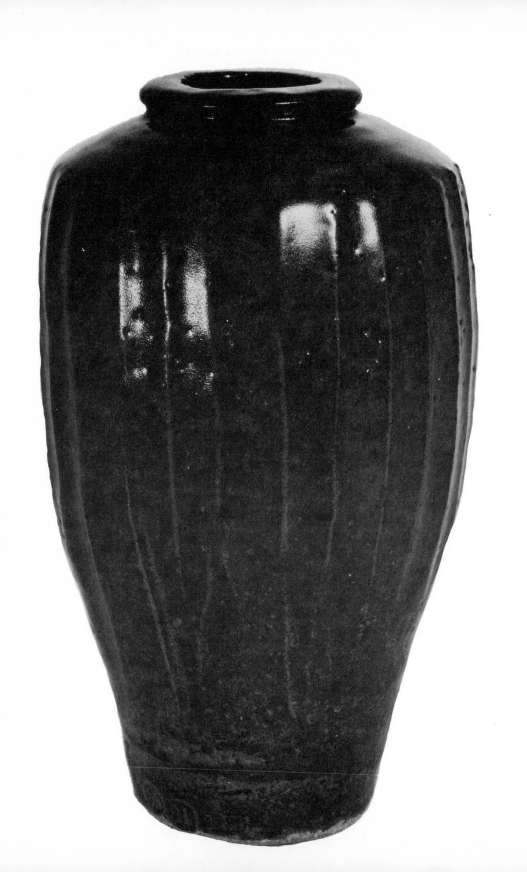

plete at this point, but others, especially such as are to have a foot-ring or beveled lip, need to be pared on the wheel when half dry. This cutting off of shavings gives a different and sharper quality of finish: the difference between modeling and carving; and the two surfaces must be brought into harmony with one another.

The foot, upon which the pot stands, should be reasonably wide for stability, but over and beyond that its angles and proportion should relate to the lip, to which the eye instinctively leaps. The cutting of the foot does not end with the profile; the inside of the ring is nearly always hollowed out in the East. Stoneware pots are seldom glazed over the bottom, and the exposed clay tells how thoroughly the potter felt the contrast between the profile with its necessary concluding foot and the perfect curve of the pot through it.

There are many types of foot-cutting well understood by oriental potters and often associated with certain kinds of vessel or with certain localities, in which refinement has been worked out by a long process of trial and error into a fixed tradition.

It is interesting to see an Oriental pick up a pot for examination, and presently carefully turn it over to look at the clay and the form and cutting of the foot. He inspects it as carefully as a banker a doubtful signature—in fact, he is looking for the bona fides of the author. There in the most naked but hidden part of the work he expects to come into closest touch with the character and perception of its maker. He looks to see how far and how well the pot has been dipped, in what relation the texture and color of the clay stand to the glaze, whether the foot has the right width, depth, angle, undercut, bevels, and general feeling to carry and complete the form above it. Nothing can be concealed there, and much of his final pleasure lies in the satisfaction of knowing that this last examination and scrutiny has been passed with honor.

As for the shapes of pots and good proportions in different types, it is impossible to do more than offer a few general suggestions. Artists of many races have believed that are are fundamental laws of proportion and composition, and I too believe it; for what we call laws are no more than generalizations founded on our sense experience, but when the attempt is made to reduce such generalizations to mathematical formulae, it is difficult to believe that they can be applied in practice without robbing the craftsman's work of its vitality. No formula, however accurate, can take the place of direct perception.

Here, for example, are a few of the constructional ideas that I have found useful:

1. The ends of lines are important; the middles take care of themselves.

37. Bernard Leach: Tall fluted pot, tenmoku glaze.
Leach Pottery, St. Ives, Cornwall, 1970. H. 12⅝″ (32 cm).

2. Lines are forces, and the points at which they change or cross are significant and call for emphasis.

3. Vertical lines are of growth, horizontal lines are of rest, diagonal lines are of change.

4. Straight line and curve, square and circle, cube and sphere are the potter's polarities, which he works into a rhythm of form under one clear concept.

5. Curves for beauty, angles for strength.

6. A small foot for grace, a broad one for stability.

7. Enduring forms are full of quiet assurance. Overstatement is worse than understatement.

8. Technique is a means to an end. It is no end in itself. If the end is achieved, and a fine pot comes out of the kiln, let us not be hypercritical about fortuitous blemishes. Some of the most beautiful pots in the world are full of technical imperfections. On the other hand, the Japanese have often gone too far and made pots with deliberate imperfections and overstatements of technical characteristics. This is nothing more than a kind of intellectual snobbery, rather to be expected from groups of second-rate tea-masters, and a very different thing from the sanded foot of Ming porcelains or the Korean foot-ring, spur-marked with quartz, whose virtue was the virtue of necessity. There was no question of pose about it. But there comes a time when the accidentals of potting have to be considered consciously as such, and that is the position today.

Round the question of accidentals and incidentals in pottery making revolve some of the chief difficulties we encounter in reaching a new idea of standard. After the symmetries and microscopic precision of mass production these two words seem such mouthfuls to swallow. But if T'ang or Sung pottery is accepted as the highest achievement in ceramics, they will have to be swallowed. Eastern and Western thought alike regard man and his work as very inadequate and variable affairs, and an oriental art lover eyes any very perfect piece of technique with the suspicion that it contains little depth of meaning. In all the greatest pottery of the world the natural limitations of both the material and the maker are accepted without question. In China the clays are often coarse and usually exposed, the glazes are thick, and crackled, and run, and occasionally skip, the brushwork is vigorous and calligraphic, not realistic and "finished," the throwing and molding are frank, and accidental kiln effects are frequent.

Apologies for these "imperfections" by authorities like the late Mr. Joseph Burton on the ground that they were incidental to primitive handwork amuse oriental writers on art, who feel that such expressions of opinion merely expose

38. Bernard Leach: Stoneware vase, iron wax-resist decoration. Leach Pottery, St. Ives, Cornwall, 1973. H. 8⅞″ (22.5 cm). Photograph: Courtesy Leach Pottery, St. Ives, Cornwall.

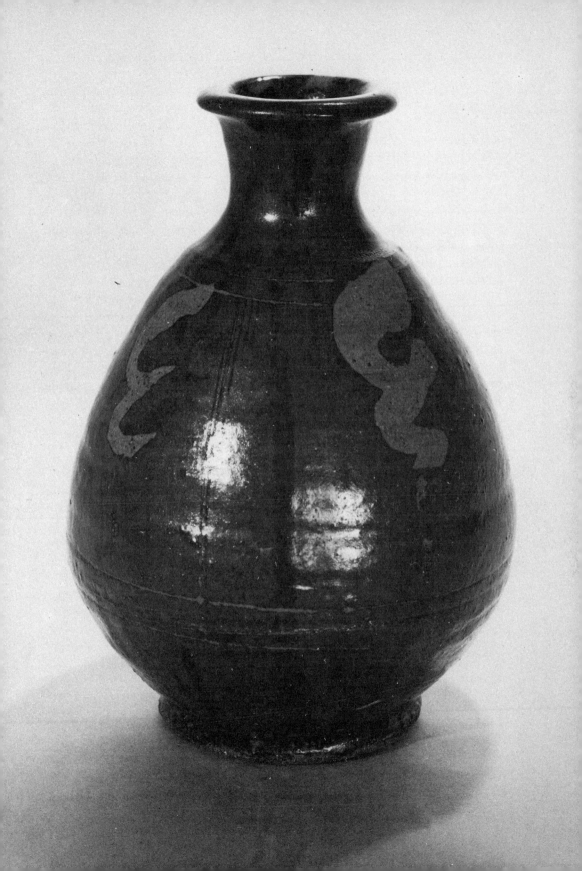

the critic's lack of insight. The Far Eastern point of view is that all these qualities can be used and that they are incidental to nature rather than accidental to man.

A more recent dictum occasionally heard is to the effect that where irregularities occur the potter "has not realized his intentions." It should not be forgotten, however, that within the potter's intentions are included all sorts of variations depending on the nature and manner of use of his materials and ranging from the fortuitous and often highly effective skipping of a glaze to wide differences in its color and quality, and that so long as they do not involve structural weaknesses or by their eccentricity detract from the beauty of the pot, they are acceptable to him. It is the uniformity of perfection that kills. On the other hand, if a pot is spoiled by blistering or cracking, it is spoiled, and there is no doubt about it.

During the long Victorian period "perfect finish" came to mean two things, either great realistic detail and meticulous surface finish or a concealing of the means by which the end had been achieved. Even so great a rebel as Whistler proclaimed the latter idea in print if not in paint. An unprejudiced survey of pre-industrial pottery, especially Far Eastern, must lead to the conclusion either that its makers were first-class bunglers or that we have got our values upside down. But at the same time, if feeling in this matter is indeed changing, in spite of the emphasis on technical precision necessitated by mechanically made products, nevertheless, the way in which craftsmen rightly make use of "accidentals" and "incidentals" has inevitably been lost sight of. Technique has become so complex and so hidden away from common sight that we no longer know good clay, good throwing, turning, or brushwork, or good firing when we see them. Nor are we constantly reminded through doing things by hand, how from each part of a craftsman's job of any real interest variations emerge, which must be dealt with on the spur of the moment. The closest analogy is that of the kitchen, with which a pottery has so much in common. Many of the problems touched on in this chapter will appear more familiar if translated into terms of good home cooking, for despite individual preferences we all know something from experience about good and bad food. But today the average man or woman judges pots by a Victorian trade standard and food apparently by none at all. And although a few people turn to books, museums, and collectors for enlightenment, there are few good books save technical,[8] and the acquisitive impulse of the collector is responsible for many false values. Rarity is no guarantee of beauty, and the cunning search for it is only a hindrance to appreciation of beauty as normality.

[8] Exceptions must be made in the case of Dora Billington's short but informative volume, *The Art of the Potter* (Oxford University Press, 1937), and as a handbook for the student, Geo. J. Cox's *Pottery for Artists, Craftsmen and Teachers* (Macmillan, 1926).

The extent to which quite ordinary people react to the changing beauty of a shape on the potter's wheel has been a continual revelation to me of their latent desire, and often capacity, to make good things, to use them or at the very least to learn to know them. To make a thing oneself is the nearest way to understanding; but although our newer education is insistent upon this counterpoise to theoretic learning, there are hardly any schools or teachers in this country who are introducing boys and girls to the kind of making which involves real beauty. The sort of thing that goes by the name of Art and Craft in most schools, including many art schools, the next generation could very well do without.

So far as pottery is concerned, school training is a doubtful method in any case. It does not bring students into contact with the actual conditions of the craft either as hand or machine work. At best they receive no more than a half training as individual potters. The number who have come to me from well-known schools without even an elementary knowledge of clays, of throwing, of glazes and their composition, of kilns and their construction and use—the very foundations of the craft—reveals a state of affairs which could not be tolerated in any other subject.

In childhood a natural process of rehearsal and growth through experience is constant, but educationalists do not take this sufficiently into account in the teaching of pottery. I often see electric kilns and power wheels installed in schools, and clay, pigments, and glazes bought ready-made. This is beginning at the end, and is a loss of opportunity and a waste of money. Children and students learn far more by reexperiencing, as far as possible, the evolution of the potter's craft from its primitive origins. They enjoy finding and digging their own clay, building their own kilns, and making their own colors and glazes as potters used to do before the machine age. Shoji Hamada recounted to me once how when he was a boy in a Japanese village he took part as a matter of course in making half the things used by the villagers with the consequence that he grew up knowing out of his body the nature of wood, of cotton and silk, of metal and clay and foodstuffs. Local tradition was still pure enough to provide a standard of form, pattern, and color which embodied that deeper wisdom of beauty in articles of daily use which we have almost lost. Such a child could never be entirely deadened by mechanical and monetary values. Only with the enthusiasm engendered by such personal experience is there any likelihood of a generation growing up capable of appreciating and demanding beauty in our domestic pottery. Until that time comes, the individual potter, together with other artist craftsmen, is bound to remain outside the normal flow of a healthy national life.

Belief and Hope

Bernard Leach

"A potter is one of the few people left who uses his natural faculties of heart, head, and hand in balance—the whole man. His is a way of life. Good pots require the ardor of a vocation and the devotion of a lifetime. Hamada, whom I regard as the best balanced and truest potter I have known, said recently that he had struggled uphill to capture certain qualities of old pots and failed to satisfy himself and he had come to the conclusion that good pots were made with ease, 'like a man walking down a mountain in a cool breeze.' "

"Belief and Hope" is Bernard Leach's personal credo. It was first published in *Bernard Leach: Fifty Years A Potter* (1961), the catalogue of a major retrospective of his work organized by the Arts Council of Great Britain. It continues the theme of his earlier writings, and restates the importance of process. However, Leach sees process not simply in terms of pure craft but as a total effort where the artist must strive for purification of self, as a man develops soundness of judgment as a craftsman.

Belief and Hope

All my life I have been a courier between East and West. I believe in the interplay and marriage of the two complementary branches of human culture as the prelude to the unity and maturity of man. I believe that from this century forward a potter must be an artist and that nonindustrial pots will be judged as works of art. Today, and practically only from today, the concept of form, pattern, texture, and color in a nonindustrial pot springs to life in a single man's brain. Thus the question as to whether a potter is an artist or not becomes vital.

So far, too few of the potters have been artists and too few of the artists

(including Picasso) have been potters. The disciplines of fire and clay have been absent. We potters of today stand alone without the close support of generations of craftsmen behind us; therefore, as with fellow artists in what are called the "fine arts," we need a like power of digestion to assimilate the influx of ideas from "40,000 years of art." Within a hundred years the craftsman has had to widen his vision from the village to the horizons of East and West and that, apart from economics, is the reason why peasant art is dead or dying all over the world and also why so much of our work is ill digested. We are no longer simpleminded peasants, we inherit all, and we stand alone.

We are at grips, East and West. We have to decide which is to rule—the imagination or the intellect, the inner or the outer. The individual potter has to decide what his standards are and to make his pots worthy of them from concept, through all the processes of clay and glaze, to the final test by fire. In the nobility and universality of the best T'ang and Sung pots discerning minds have recognized the highest achievement and therein a criterion of beauty for the modern potter has been established. But since the potter belongs to our time and aspires to the position of a creative artist, he is divided in allegiance between contemporary movements in our own art and this challenge from the classic periods of the East.

I hope that out of our total inheritance, we are moving toward balance. Integration, as I conceive it, is the state in which a man attains a natural interrelatedness of his inner and outer capacities. In the paraphrased words of Confucius: The wise man is he who in his maturity can make natural use of the gifts with which he was born.

A potter is one of the few people left who uses his natural faculties of heart, head, and hand in balance—the whole man. His is a way of life. Good pots require the ardor of a vocation and the devotion of a lifetime. Hamada, whom I regard as the best balanced and truest potter I have known, said recently that he had struggled uphill to capture certain qualities of old pots and failed to satisfy himself and he had come to the conclusion that good pots were made with ease, "like a man walking down a mountain in a cool breeze."

A potter on his wheel is doing two things at the same time: he is making hollow wares to stand upon a level surface for the common usage of the home, and he is exploring space. His endeavor is determined in one respect by use, but in other ways by a never-ending search for perfection of form. Between the subtle opposition and interplay of centrifugal and gravitational force, between straight and curve (ultimately of sphere and cylinder, the hints of which can be seen between the foot and lip of every pot), are hidden all the potter's experience of beauty. Under his hands the clay responds to emotion and thought from a long

past, to his own intuition of the lovely and the true, accurately recording the stages of his own inward development. The pot is the man: his virtues and his vices are shown therein; no disguise is possible. The virtues of a pot are derived from the familiar virtues of life. They can be seen by the naked eye of anyone sensitive to form, color, and texture who is reasonably experienced in the language of clay—that language, and even rules, which the innate sense of fitness has extracted from experience in every quarter of the globe. Now we are bringing them all together into broad principles if not to precise rules. Rules ask to be broken if they are not of our own making but principles, if they are deep and wide enough, can be suggestive and helpful. Whether we put them into words or not, we are aware of them and, from this angle or that, individually as well as historically, they form the invisible core of standard and tradition. The pot is the man, he a focal point in his race, and it in turn is held together by traditions embedded in a culture. In our day the threads have been loosened and a creative mind finds itself alone with the responsibility of discovering its own meaning and pattern out of the warp and weft of all traditions and all cultures. Without achieving integration or wholeness, he cannot encompass the extended vision and extract from it a true synthesis. The quality which appears to me fundamental in all pots is life in one or more of its modes: inner harmony, nobility, purity, strength, breadth, and generosity, or even exquisiteness and charm. But it is one thing to make a list of virtues in man and pot and another to interpret them in the counterpoint of convex and concave, hard and soft, growth and rest, for this is the breathing of the Universal in the particular.

Industry and the Studio Potter

Stoneware Pottery

Michael Cardew

"Good design in pottery is the product of a tension or 'dialectic' between the demands of pure utility and those of pure beauty, and only a long experience and continual struggle enable you to achieve a successful fusion of the two."

Michael Cardew is an internationally known potter and the author of *Pioneer Pottery* (London: Longmans, 1969), one of the classics of ceramic literature. "Industry and the Studio Potter" is one of his earlier writings and was published in *Crafts* (2, no. 1, 1942), the magazine of the Red Rose Guild, England. It is what Cardew calls " a period piece," reflecting his optimism at the time that studio-potter and industry could collaborate successfully. The article was written during Cardew's first visit to Africa, while he was pottery instructor at the Gold Coast's (now Ghana) Achimota College, near Accra. There he was attempting to set up a small industrial pottery to supply the ceramic needs of occupied West Africa. Since then his views have altered, and Cardew tends to agree with William Staite Murray's observation that "one cannot make love by proxy." Nonetheless the article remains instructive and a reminder of a new role that several studio-potters were attempting to establish in the late 1930s and early 1940s.

The second short statement, "Stoneware Pottery," was written while Cardew was in Lagos, taking on his post of pottery officer to the Nigerian government. It appeared as the introduction to a catalogue of an exhibition of stoneware pots at the Berkeley Galleries, London. "Stoneware Pottery" is what Katherine Pleydell-Bouverie, a lifelong

friend of Cardew, and one of the pioneer artist-potters in England, calls his "fighting manifesto."

Industry and the Studio Potter

Should studio potters, abandoning their isolation, descend into the industrial arena and take an active part in the designing of mass-produced pots? The answer, I think, can only be *yes*. The question is certainly full of difficulties, but it becomes more and more urgent every year, for the potter, for the industry, and for the public in general.

First, the difficulties: while it is fairly obvious that some, at any rate, of the potters are willing and anxious to cooperate in industry (if industry were willing to ask for their services) there are also potters who will not.

I think this attitude is rapidly becoming out of date among younger potters; but it is sometimes due to the fact that the craftsman potter does not know enough about Staffordshire at first hand, and often only meets, from Staffordshire, the people who are chiefly interested in "the selling side"—travelers, sales managers, directors, etc. In any case, there is a good deal of arrogance and other products of the inferiority complex to be broken down on both sides. The most important obstacle on the industrial side is that the industrialists will not have the studio potters because they think that their technique is inferior to their own, that their prices are fantastic, and their designs fundamentally unsuitable for purposes of utility. Some of these objections are justified, but not all of them.

But the position is urgent and serious, not only for the salvation of the studio potters, but for the sake of the industry itself. The pottery industry desperately needs new designs—not from a commercial point of view, but because "Art goes by seasons, like Nature," and the industry is still trying to live on the designs of the eighteenth and early nineteenth centuries, from mere want of anything new that is also good. And the modern school of studio potters can certainly give them that, and thereby fertilize design in the industry, if both could agree to collaborate.

The actual position today is very unsatisfactory. Some progressive firms are aware of the need for good modern designs, but the only thing they have been able to do, so far, is to call in from outside various people who know very little about pottery—architects, painters, and people who call themselves "designers for

industry." The results have been instructive. They prove, I think, only one thing, that you can only get good designs for pottery from potters, because they are the only people who understand the art by experience and with their whole personality.

A long and thorough apprenticeship to the handicraft of any industry is the only sufficient training for a designer for that industry. No one should design for mass production unless he has spent several years successfully designing and making single pieces with his own hands. There are at least two good reasons to support these apparently sweeping statements. First, a good design in pottery is the product of a tension or "dialectic" between the demands of pure utility and those of pure beauty, and only a long experience and continual struggle enable you to achieve a successful fusion of the two. Beauty in manufacture is not achieved automatically (as the Functionalists "vainly talk") by paying rigid

39. Michael Cardew: Slipware. Winchcombe, England, c. 1932. D. 9¹³⁄₁₆″ (25 cm). Private collection. Photograph: Garth Clark.

attention to use and convenience only; it is achieved by a balance and a synthesis of use and beauty; and this involves hard work and many failures on the way. This "dialectical" principle applies equally to all applied art and all architecture.

Second, there is the enormous responsibility of the designer for mass production. A bad design in handicraft will only reach a limited number of finished articles, and the failure can soon be canceled. But a bad design for mass production may result in immense losses to the firm producing it and worse still, it will, if "released," be an artistic injury to thousands and perhaps millions.

But a handicraft potter, provided that he really is a creator, is less likely to make such mistakes because he spends his whole working life making responsible choices about the shapes of things and deciding to make any given vessel thus, rather than thus. In this way he really comes to know which shapes are good, whereas the man "from above" only fancies he knows.

This points to a serious weakness in the theory of Gropius, which was that

40. Michael Cardew: Slipware.
Winchcombe, England, c. 1935.
H. 5^{15}⁄$_{16}$″ (15 cm).
Private collection.
Photograph: Garth Clark.

41. Michael Cardew: Slipware.
Winchcombe, England, c. 1937. H. 13¹³⁄₁₆″ (35 cm).
Private collection. Photograph: Garth Clark.

this training in handicraft can be provided by the art schools. "Craft classes must be regarded as laboratories for experimenting with materials and basic processes; they can no longer be an aim in themselves as William Morris and C. R. Ashbee . . . had preached; but they are of vital and indispensable advantage in conveying to the designer a live understanding of the natural will of a material which does not reveal itself except to those who shape it with their own hands." The modern disciple of William Morris must answer that all this is very good, as far as it goes, but it does not go nearly far enough. It is not true of pottery (and I cannot believe it is true of many other arts or industries) that a year or two, or even longer, spent in even the best of art schools is enough to make a good industrial designer, and it is difficult to resist the temptation of citing as proof of this the actual designs produced by the students at the Bauhaus.

The excellent designs on which the greatness of the Staffordshire industry has been based were for the most part evolved by potters of the seventeenth and eighteenth centuries, men who worked all their lives on a handicraft basis. Those designs are a synthesis of traditional throwers' shapes, inherited from the Middle Ages, with the ideas of convenience and refinement acquired in the eighteenth century. Staffordshire today has nothing to take the place of this great impetus, which has now spent itself, and cannot apparently be renewed from within the industry. The springs from which it came have been systematically diverted and stopped up. The only source left today from which a new inspiration can come is the small band of "artist" potters.

But one should guard against any shallow optimism about the possible results of this cooperation between potters and industrialists. Reform of the shapes, improvement of the style of decoration, all this is a treatment of symptoms rather than of causes. The real revolution will not come until the men of Staffordshire make it for themselves by achieving a new idea of what pots should be.

In the meantime, a cooperation even of this limited sort is still to be desired, for at least three reasons: it might prove to be the beginning of such a revolution within the industry; it would at least mitigate the results of pure industrialism in pottery; and it would be valuable experience for the artist potters, by keeping them in touch with contemporary realities and the requirements of a greater public.

The chief reason for thinking that the results would not be really satisfactory is that the factory system is based on the existence of the operative as opposed to the workman; on the assumption that there is such a thing as "pure craftsmanship," that is, craftsmanship into which no element of originality ("art") enters. Thus Pevsner uses the example of the engraver of paintings: "When the engraver has faithfully carried out the artist's intention, his task is complete"—that is, he is not called on for originality. But, in fact, all good engravers did have originality; and it always did, often unconsciously, creep into their engravings, however much they may have tried to keep it out. In other words, the engraver, like the interpreter of music, is a true craftsman, and there is in reality no such thing as this supposed "pure craftsmanship."

As long as human craftsmanship is necessary in factories, and in the pottery industry it is very unlikely that it can ever be entirely superseded by machinery, there will always be the hope that the germ of "art," which is necessarily always alive at the root of "craftsmanship," may emerge at last into consciousness and repudiate the false ideal of servile obedience.

The factory system is thus found to be based on a foundation which does not exist, and it follows that sooner or later the system will have to be very much

modified; which leads again to the conclusion that a really satisfactory revolution in pottery can only come when the workers in the factories are ready to make it. There is one other course open to the studio potter, provided he has the opportunity and the necessary energy and enterprise. This is to increase his own production so that his workshop becomes a factory, but a factory of a new and more enlightened kind. The objection to the "studio" scale of work is either that the pots are too expensive for any but a very small public, or else that he condemns himself and his family to a life of more than medieval poverty and hardship. (I am not considering the mere dilettante, but only those who make their living by their work.)

Such a factory would necessarily grow rather slowly, because most of the workers would have to begin young, as apprentices. Pottery being an art that essentially involves repetition and a sort of standardization, experience would gradually show how much mechanization could be introduced without doing violence to the human craftsmanship of the workers.

This program would admittedly be full of dangers, but that is not a reason for refusing to undertake it. Our general problem is the craftsman's place in modern society; and this, if it can be done, would be the most fruitful solution of it.

Stoneware Pottery

The potter has an interesting life. He starts by thinking he wants to express something in clay, but after a time (if he is any good) the clay takes charge and expresses something through him. Perhaps in other arts it is different, but it always seems to me that the potter is only about "one percent" a free agent—the other ninety-nine percent is predetermined by technical facts—the process and materials he uses.

It is a right and proper state of affairs—the technical processes and materials are not a category distinct and separate from the expression the artist makes from them. On the contrary, they are themselves part and parcel of the meaning which he can only express by endlessly studying their structure and the minutest subtleties of their behaviour: finding out what the material wants to say is the only way to say anything through the material. A good potter loves clay disinterestedly, for its own character, not because it is an obedient mirror for his own personal ideas, however interesting they may be.

42. Michael Cardew: Stoneware, dark celadon glaze. Vume Dugame, Ghana, 1946–1947. H. 6⅛″ (15.5 cm). Private collection. Photograph: Garth Clark.

Someone has defined vulgarity in art as the means of expression outrunning the content to be expressed—technique outrunning inspiration. It seems to me that this state of affairs produces not vulgarity but something far worse, the "ghastly good taste" which is the characteristic product of our education.

But the whole antithesis between Technique and Inspiration (or Design, to use the more sedate expression fashionable at present) is an unreal one. It is only the cold and lazy habit of abstract thought which would separate them, when they are in reality as much one as the inner and outer faces of a crystal surface.

The same bad habit of making abstractions and then treating them as if they were realities accounts for another fallacy—what may be called the "Art in Industry" fallacy. Honest Thinkers are continually throwing it out but it keeps on creeping back again.

The fallacy is, that there is a "department" or category called Utility, and another called Art. Utility is for Utensils, Art is for Delectation—"a kind of noble play" and all that talk.

Those who think this fill both their departments with objects of horror. They will fill the world with Well-Designed Utilities, but the essential meaning of works of art will always (though they will never know it) elude them.

96

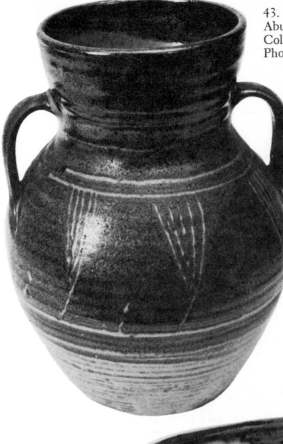

43. Michael Cardew: Stoneware.
Abuja, Nigeria, 1957. H. 12″ (30.5 cm).
Collection Bill Ismay, Wakefield, England.
Photograph: Garth Clark.

44. Michael Cardew: Stoneware.
Wenford Bridge, England, 1949. H. 6¹¹⁄₁₆″ (17 cm).
Private collection.
Photograph: Garth Clark.

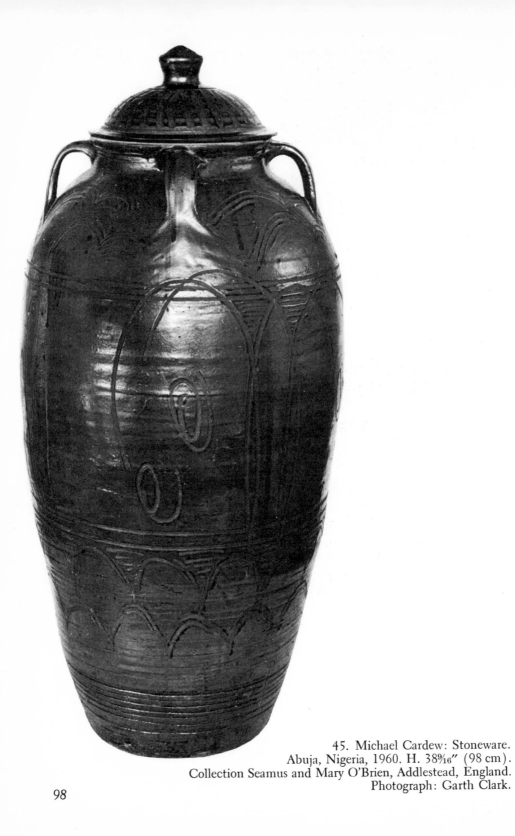

45. Michael Cardew: Stoneware.
Abuja, Nigeria, 1960. H. 38⁹⁄₁₆″ (98 cm).
Collection Seamus and Mary O'Brien, Addlestead, England.
Photograph: Garth Clark.

The Sun's Light, when he unfolds it
Depends on the Organ that beholds it.

This mass-produced drain-pipe will not receive the same kind of individual care that a ceremonial loving-cup receives. But if the drain-pipe is good (i.e., efficient), it means that the clay has been treated right. Well, then it will be beautiful (if you are able to see it).

If the clay of the ceremonial cup has not been treated right, it will be horrible, however much loving care has been lavished upon it (the more care, the more horror). You cannot, by making use of Design, impose beauty on the objects of Utility. It is their birthright. If they are not born right, nothing can help them.

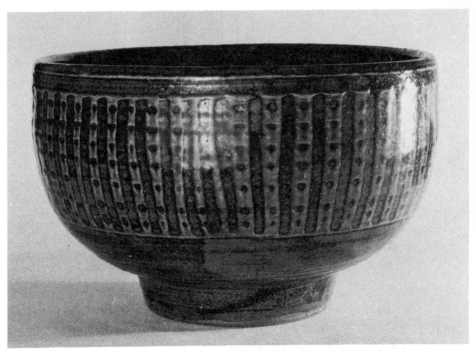

46. Michael Cardew: Stoneware. Wenford Bridge, England, 1975. D. 11¹³⁄₁₆″ (30 cm). Private collection. Photograph: Garth Clark.

Potters and Amateur Potters

Michael Cardew

"So more and more people like to become potters, or at least part-time or amateur potters. Most people at first choose to do it the easy way: You buy the clay ready-mixed in plastic packets, you get ready-prepared glazes, you buy a prefabricated kiln. Then you only have to learn how to do the *making* part—and goodness knows, even then, there are plenty of difficulties. But if you remain at that stage, your pots will be only partly yours. Their character is conditioned by that of the clay, the glaze, and the way they are fired."

Potters and Amateur Potters was first published in 1972 as a monograph by the National Council on Education for the Ceramic Arts, and was also published under the same title later that year in *Ceramic Quarterly* (no. 10). In the essay Michael Cardew advises a mixture of conservatism and adventure for the potter, arguing that only through a thorough knowledge and competence in the more formal areas of the craft can he be free to create pots that are "being brought to birth dangerously."

Potters and Amateur Potters

I have just been reading an article by Thelma McCormick of York University, Toronto, called: "Folk Culture and the Mass Media." Her conclusion seems to be that Folk Art, which of course included handcraft pottery, has, in the phrase of André Malraux, ceased to exist because the "folk" no longer exist, and

she is trying to substitute for it a modern equivalent which she calls "amateur culture."

There evidently was a time in our past when folk culture included everyone (except, perhaps, a small elite group at the top): when it was really true as Eric Gill used to say: "an artist is not a special kind of man, but every man is a special kind of artist." True folk art in which everyone is a participator is either dead or dying. Most of us have become passive recipients of *popular culture,* which is spoon-fed to us by impersonal corporations.

Meanwhile, the culture of small minorities, the intellectual elite, becomes more and more specialized and less and less accessible to the ordinary mortal in the street.

In the department of *elite culture* which is called "science" the tendency to specialization is inevitable, though it is to some extent mitigated for us by the efforts of *popular science writers* who help us to a kind of second-hand understanding of what the real scientists are saying. But in the department called *art* the situation is altogether more difficult.

All artists have this firm persuasion (and a firm persuasion is generally a true persuasion) that something that is essentially *subjective* can be communicated, not through words, but through *the thing itself.* But, if you are like me, an outsider, you usually get the feeling that the subjectivity is there and the *thing itself* is there but the communication is lacking—you don't get the message—you don't know what it means. Maybe our children or our grandchildren will be better able to understand it. Living art was never understood in its own day, but when it is safely sterilized and stabilized by becoming the art of the past—then at last, we recognize it and call it "Great."

Yet I cannot help feeling that that is not quite the whole story. There was surely never a time when living art was so esoteric, so confined to the in-groups, as it is today. Am I therefore trying to say that there is no great art being produced now? On the contrary: Art is indestructible; it just takes different forms in different ages. The best art being produced today is that of the engineers; they are our great creative artists. Their works of art are the highways, airports, cranes, bridges, airplanes, and of course, buildings that we see all around us. Like all creative artists, they are using their skill, their technical expertise, to *make*— that is to say, realize—the things they have seen or half-seen in their mind, and by realizing them, to communicate them. And we, the general public, are also participators, not merely by looking at them, but mainly by using them.

But these great works of public art don't exactly lend themselves to individual make-it-yourself enterprise. Pottery, on the other hand, is something which is immediate and sensual and calls for a specially personal kind of skill.

So it satisfies our hunger for skill, a natural, healthy kind of hunger, seeing that without skill we are unable to create or communicate our creation. Skill is the channel along which your creative juices can flow.

So more and more people like to become potters, or at least part-time or amateur potters. Most people at first choose to do it the easy way: You buy the clay ready-mixed in plastic packets, you get ready-prepared glazes, you buy a prefabricated kiln. Then you only have to learn how to do the *making* part—and goodness knows, even then, there are plenty of difficulties. But if you remain at that stage, your pots will be only partly yours. Their character is conditioned by that of the clay, the glaze, and the way they are fired. And since all these things —clays, glazes, and kilns—are prefabricated and standardized, the pots will be less satisfying than you expected, partly because making them will not be so much fun nor will it be so exciting or dangerous as it ought to be. They won't be as good as they have a right to be. If they are deprived of half their personality by all these shortcuts, a sensitive potter, feeling that there is something missing, will probably try to replace it by what I call "a deliberately willed injection of personality." But it's a mistake, because the something which is missing—call it character or personality or originality or whatever you prefer—is in fact a very mysterious and elusive thing, which cannot be pinned down and captured by a direct assault. The only chance of catching it is by stalking it and taking it by surprise; you have to approach the mystery by an indirect road. This indirect road is skill, or craftsmanship—not only manual control, dexterity, efficiency, and all those things, but also expertise, learning how to overcome all sorts of technical difficulties and all the various obstacles which nature puts in the way of art. And this in turn involves you in all kinds of excursions into the more theoretical aspects of pottery and ceramics, excursions which are never ending; the more you find out about the nature of clay, or what goes on inside kilns, the more you find you need to know. And so you can exercise your intellectuality in a sphere where it is relevant, science; and are better able to keep it from interfering in a sphere where it is irrelevant, namely, the creative act.

In using your skill in this way you also become more critical of the quality of your own performances and you find you have to be always taking risks and always living dangerously. And this is something of a paradox, because, in becoming more skillful and more expert, you think you should be making pots more successfully and more safely, but as soon as you rest content with being safe and successful, your pots begin to be static and begin to be dead. They will only stay alive if they are always being brought to birth dangerously.

All of this may sound alarming to a beginner, but it doesn't all happen at

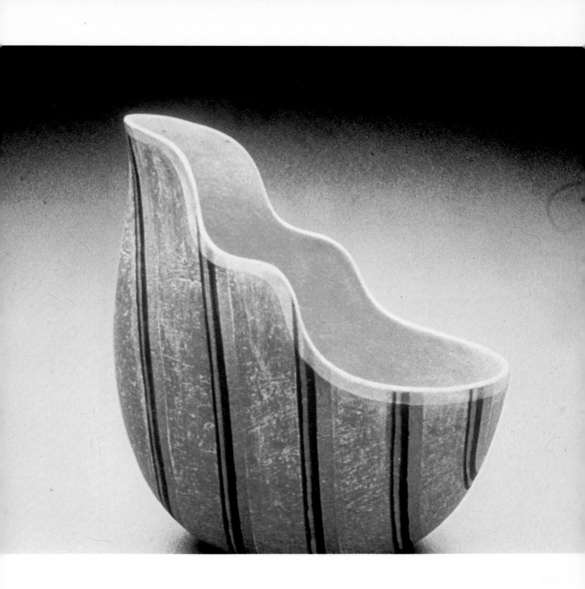

Plate 1. Elizabeth Fritch: Stoneware vessel, engobe decoration. London, c. 1975. H. 6⅞″ (17.5 cm). Private collection. Photograph: Crafts Advisory Committee, London.

Plate 2 (above). Anthony Caro: *Con Can Castle*. Syracuse, New York, 1975.
23⅝" x 21¹¹⁄₁₆" x 9⅞" (60 cm x 55 cm x 25 cm). Courtesy Everson Museum of
Art, Syracuse, New York. Photograph: Jane Courtney Frisse.

Plate 3 (opposite, above). Edward Burne-Jones: Tile panel, earthenware.
Morris, Faulkner and Co., London, 1975. L. 9⅞" (25 cm). Collection John and
Kate Catleugh, Richmond, London. Photograph: Garth Clark.

Plate 4 (opposite, below). William de Morgan: Earthenware tiles, painted
decoration. Chelsea, England, c. 1872. 6⅛" x 6⅛" (15.5 cm²). Collection Jerry
Posner, San Francisco, California. Photograph: Tom Hartman.

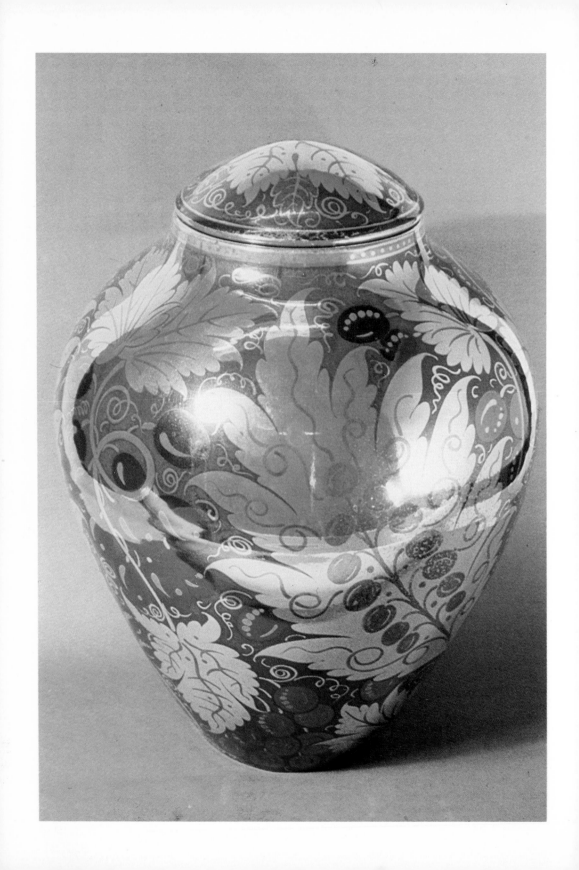

Plate 5 (opposite). William de Morgan: Covered jar, lustre decoration. Fulham, England, c. 1895. H. 10¹³⁄₁₆″ (27.5 cm). Collection Victoria and Albert Museum, London.

Plate 6 (above, left). Robert Wallace Martin: Stoneware, salt-glazed tobacco jar. Martin Brothers Pottery, Southall, England, c. 1890. H. 9⅞″ (25 cm). Collection John and Kate Catleugh, Richmond, London. Photograph: Garth Clark.

Plate 7 (above, right). Edwin Beer Fishley: Harvest jug, sgraffito decoration, galena glaze. Fremington Pottery, Devon, England, c. 1900. H. 12⅝″ (32 cm). Collection Victoria and Albert Museum, London. Photograph: Garth Clark.

Plate 8 (below). Emile Lessore: *The Repose*. Detail of faïence plate. Wedgwood, England, 1874. L. 11⁷⁄₁₆″ (29 cm). Collection Jerry D. Durham. Photograph: Tom Hartman.

Plate 9 (opposite, left). Ernest Chaplet: Stoneware pitcher. Paris, 1974. H. 11¹³⁄₁₆″ (30 cm). Collection Garth and Lynne Clark. Photograph: Garth Clark.

Plate 10 (opposite, right). Jean Carriès: Mask, stoneware. Saint Amand en Puisaye, France, c. 1892. H. 8⁷⁄₈″ (22.5 cm). Collection Alain Lesieutre, Paris. Photograph: Garth Clark.

Plate 11 (above). Michael Cardew: Jug, earthenware, sgraffito decoration. Winchcombe, England, c. 1935. H. 11¹³⁄₁₆″ (30 cm). Collection of the artist. Photograph: Garth Clark.

Plate 12 (opposite, above). Michael Cardew: Bowl, stoneware. Wenford Bridge, England, 1975. H. 10¹³⁄₁₆″ (27.5 cm). Private collection. Photograph: Garth Clark.

Plate 13 (opposite, below). Bernard Leach: Stoneware vase. Leach Pottery, St. Ives, England, 1956. H. 11⁷⁄₁₆″ (29 cm). Collection Everson Museum of Art, Syracuse, New York. Photograph: Garth Clark.

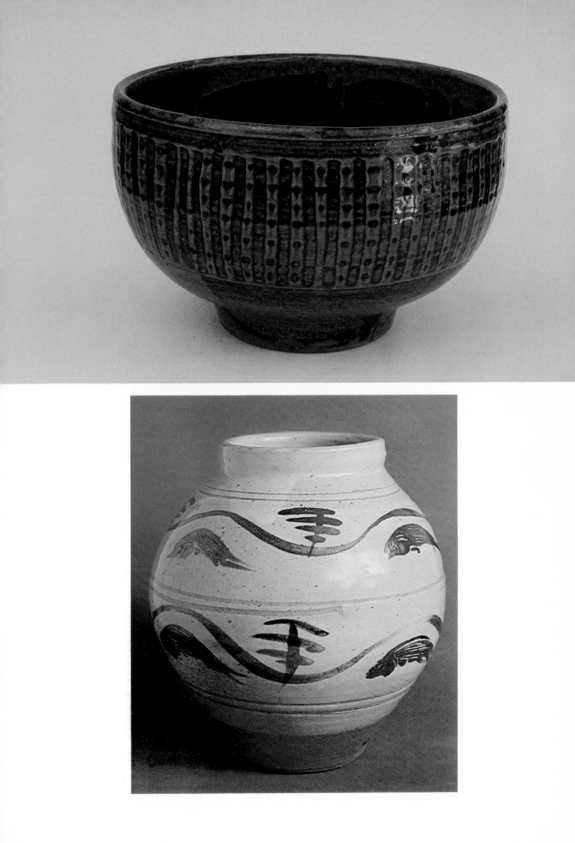

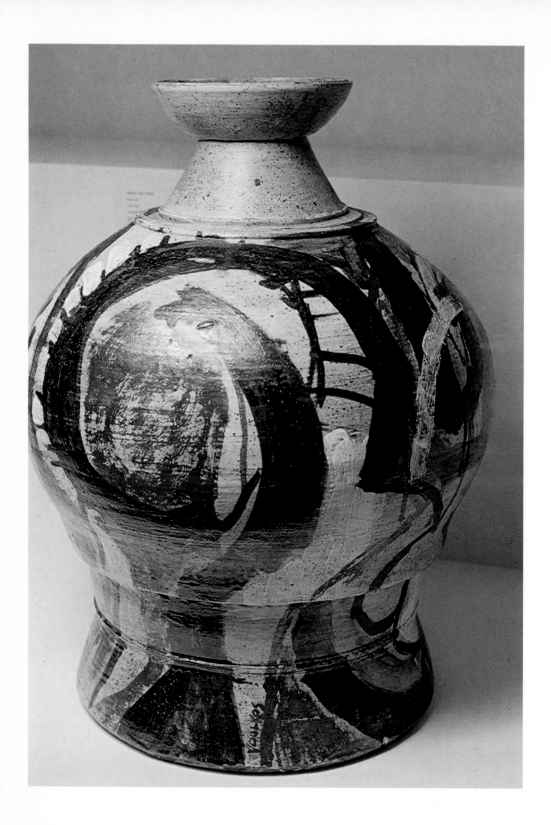

Plate 14 (opposite). Peter Voulkos: Stoneware. Los Angeles, 1957–1958. H. 23⅝″ (60 cm). Collection Everson Museum of Art, Syracuse, New York. Photograph: Garth Clark.

Plate 15 (above). Peter Voulkos: Platter, stoneware. Berkeley, California, 1963. L. 14¾″ (37.5 cm). Collection Fred and Mary Marer, Los Angeles. Photograph: Sharon Hare/Doug Humble.

Plate 16 (below). Michael Frimkess: Plate, stoneware. Los Angeles, 1960. D. 18¾″ (47.5 cm). Collection Fred and Mary Marer, Los Angeles. Photograph: Sharon Hare/Doug Humble.

Plate 17 (opposite). Ron Nagle: Cup, earthenware, wood. San Francisco, 1969. H. of box 4⅝″ (11.7 cm). Collection Professor and Mrs. R. Joseph Monsen, Seattle, Washington. Photograph: Dudley, Hardin and Yang. Courtesy San Francisco Museum of Modern Art.

Plate 18 (below). John Mason: Stoneware plate. Los Angeles, 1964–1965. 2¹⁵/₁₆″ x 12¼″ x 14¾″ (7.5 cm x 31.2 cm x 37.5 cm). Collection Professor and Mrs. R. Joseph Monsen, Seattle, Washington. Photograph: Dudley, Hardin and Yang. Courtesy San Francisco Museum of Modern Art.

Plate 19 (opposite, above). Richard Shaw: *Couch with Landscape*. Earthenware, acrylic paint. San Francisco, 1965. 29½" (75 cm). Private collection. Photograph: Courtesy the artist.

Plate 20 (opposite, below). Ron Nagle: *Cup*, earthenware with china paints. San Francisco, 1976. H. 3" (7.6 cm). Photograph courtesy Quay Gallery, San Francisco.

Plate 21 (below). Kenneth Price: *Untitled Cup*, earthenware. Taos, New Mexico, 1974. H. 4" (10.1 cm). Private collection. Photograph: Kenneth Price.

Plate 22 (bottom). Peter Voulkos: Platter, stoneware. Berkeley, California, 1973. 14¾" (37.5 cm). Collection Fred and Mary Marer, Los Angeles. Photograph: Sharon Hare/Doug Humble.

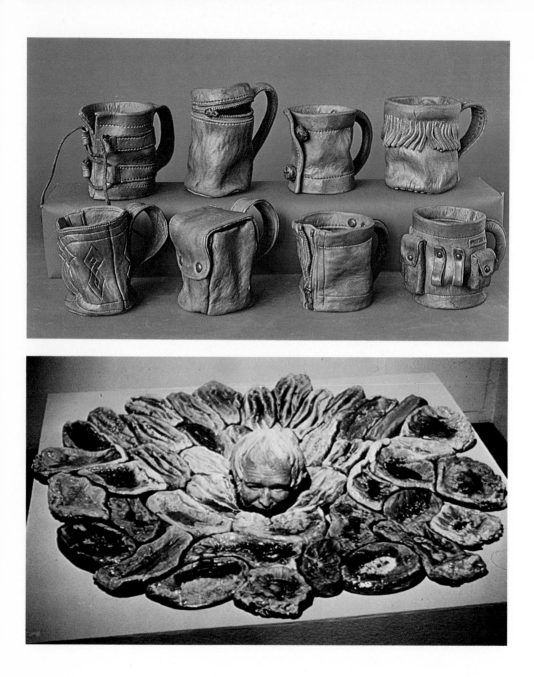

Plate 23 (above). Marilyn Levine: Stoneware cups. Berkeley, California, 1974. 4¹⁵⁄₁₆″ (12.5 cm). Photograph: Courtesy Hansen Fuller Gallery, San Francisco.

Plate 24 (below). Robert ("Bob") Arneson: *Stream-a-Head*, glazed earthenware. Davis, California, 1974. W. 70″ (177.8 cm). Photograph: Courtesy Hansen Fuller Gallery, San Francisco.

once. You find yourself acquiring the knowledge and the skill and self-criticism bit by bit, as and when you feel the need for it, in just the same way as professional potters do and always did. Becoming more and more involved in all this, you gradually find that it is not so necessary to give the pots those gratuitous but superfluous "personality-touches" which previously seemed to be called for, because the pots themselves are becoming more personal and at the same time more universal. They no longer need their eccentricities because they have begun to acquire something better; they begin to look easy and natural instead of strained and contrived.

Learning to make pots is like learning to write. When as children we were being taught to write, they didn't tell us the great thing to aim at was to make the writing "express our personality"; personality is something too big and too mysterious to be treated that way. They taught us skill, or craftsmanship, that is, to make our writing legible. But while you are learning to write legibly, your handwriting becomes yours and only yours. Legibility is not going to rob it of its personality; on the contrary, it makes it possible for your personality to flower and be seen; your handwriting is you and nobody else can imitate it exactly.

The best way to impart character and personality to pots is to turn your attention to other matters; to make them with as much concentration as you are capable of, to enlarge your skill over as wide a range as possible, to get to know your materials by living with them, trying to understand them, and finding out little by little—not with your head but with your body—how they want to be treated; in fact, to treat them with proper respect as we would a friend. Then, nothing can stop your personality from appearing in your pots. They will be as individual and unmistakable as your handwriting. But the handwriting has to be legible; if it isn't the message—the meaning—will not be communicated.

Pots made in this way will begin to be, in a sense, works of art—very humble works of art perhaps—but at this present moment of our evolution they will be important and significant; significant for several reasons: because they come right into our homes and into our daily lives, in fact some of them come right up to our lips many times a day; and because you and I, and many other people, are capable, if we set ourselves to work in the right way, of producing that small kind of art. And so it becomes a shared art in which many kinds of people can participate. And above all, because making pottery is curiously effective as a producer of human happiness, and because in this way we can recover our right to be creative. Everyone has an instinct to create; and like any other instinct, if we can't give it a channel along which it can flow, it will go mean and sour and destructive. We must learn to be happy or perish; if the human race cannot find a way to release its creative instinct, there is no hope for us—we shall end by

destroying ourselves out of sheer spite and frustration of our own inability to be happy.

What I have been trying to say is this: If we potters who used to be part of a universal folk culture are now to be classified according to Thelma McCormick as part of what she wants us to call "amateur culture," then some of the things which she describes as essentials of culture will need to be criticized or modified. "Amateur culture," she says, "is the reverse of professional culture; no rigorous discipline is required, self-indulgence need not be restrained, self-realization is more important than reaching standards; what is expected is that the experience will be rewarding in itself; levels of achievement do not exceed the levels required for personal satisfaction."

But my experience has been that there is not much personal satisfaction to be gotten from an activity unless you are prepared to do some work for it, usually a good deal more work than you bargained for at the beginning, and that the kind of self-realization which is worth having can only be obtained through continual training and concentration. In the crafts today we rightly place much emphasis on social and individual therapy. But the therapy won't work except through skill, and skill requires concentration. It is chiefly the concentration which has the therapeutic value.

Amateur, professional—how I hate these rigid categories. Amateur just means you love it; professional merely means you are good enough at it to earn your living that way. But a good professional, if he stays alive, will never lose the spark and the freshness, even some of the clumsiness, coming from his probably amateur beginnings. And the amateur is always being drawn on irresistibly by glimpses of things that at the beginning he never thought would be within his range.

Some Thoughts on Attitudes

Harry Davis

"When the potter succumbs to economic dictates, or when he assumes the role of manager and expects uninterrupted repetition of his ideas by paid assistants, the game is lost. Repetition then very quickly ceases to be interpretation, and reinterpretation, and yields only a cliché. This is obviously an inevitable outcome, and the evidence that this is so is lamentably abundant."

Harry Davis is a potter and an early apprentice of Bernard Leach. After making pottery in England, Africa, and New Zealand, he moved to Izuchaca, a remote village in Peru, where he set up a cooperative pottery with the villagers. He is a well-known figure in America and Europe through his frequent lecture tours to raise funds for this venture. "Some Thoughts on Attitudes" was published in *Ceramic Review*, no. 11 (1971) and is the summary of a lecture that Davis had given earlier that year to the Commonwealth Institute in London. The summary deals with the broader issues of the craftsman's integrity in his society.

Some Thoughts on Attitudes

This statement was prompted by a request at a recent lecture to talk about my ideas on the subject of decoration on pots. My answer to such a question takes me at once into subjective considerations which do not lend themselves to elucidation by formula. The subjective and personal element so essentially basic to good decoration applies of course equally to form and to color. It is difficult and perhaps unwise to expound formulae in this field—such attempts too often

result in expressions devoid of meaning—but I believe it is possible and valuable to analyze attitudes which condition the subjective, and this is what I have attempted to do.

It is easy to talk about technology and scientific principles. To do so even helps one to understand them better as one is talking about something measurable and definite. To talk about aesthetics and things creative is a very different matter. Here one is dealing with subjective evaluations and indefinable subtleties. A technological process can be precisely defined and carried through stage by stage to a predictable result. A creative process on the contrary can only be defined with difficulty, and any attempt to follow it through stage by stage with conscious deliberation will be self-defeating.

A work of art might be defined as the outcome of a wealth of subjective experience, evoked and influenced by a circumstance and finally given expression. In the subconscious mind of the artist there exists an immense reservoir of recorded experiences. Before him is material to be worked and in his conscious mind there exists at best an uncertain concept of what he will do with that material. Once at work upon it his course will be governed by many variables, and each move will be the outcome of what we call a spontaneous decision. Among these variables will be factors such as a sensitive response to properties in the material—the particular degree of skill or the lack of it, which he may muster at any given moment—the chance effects of light and shade on the material and the vague conscious intent in his mind. All these coalesce to stimulate a subconscious reaction which provokes a decision to act. The decision, the intention, the action, and the skill with which they are put into effect are all so intimately involved with one another, and follow in such rapid sequence that they seem to be one—a spontaneous act of imagination—an act expressive of the whole man.

All this underlines the fact that the creative processes require, even for the talented, a great deal of continuous involvement and a background of prolonged dedication, but one should remember that, in spite of the explicit nature of technology, it is not entirely irreconcilable with these highly subjective processes. In fact it is folly to suppose, as purists often do, that these two can or should be kept apart. This is particularly so in the case of the potter. The conscious intellectual grasp of what will happen to materials during the heat treatment cannot be allowed to recede for very long. It is important to keep in mind the fact that pigments and surfaces on which they are being applied have no resemblance to their final appearance at the time of application. The matter is further complicated and rendered less predictable by the fact that during the firing the potter will have to exercise other skills and make yet further decisions. These will be conscious intellectual decisions, and there will be time in which to weigh the

pros and cons. There won't be the same element of fast-moving spontaneity, but the outcome can influence the aesthetic quality of the result very considerably. Although these decisions are of a conscious and intellectual nature, the outcome, especially in reducing conditions, is only precise within more or less predictable limits, and error is never quite out of the question. However, this is not altogether to be deplored because total predictability, which does often seem technologically possible, invariably leads to monotonous and unattractive results.

The notion that what we call spontaneous creativity is the fruit of a well-stocked subconscious and a devoted and long involvement is interestingly endorsed in A. Koestler's *Act of Creation*. The recurring theme common to so many creative minds stressed by Koestler is the one in which many years of intense dedication and total involvement precede the creative flash. This implies a subconscious stockpiling of ideas and experiences, and it seems as though the subconscious mind is like a fully programed computer. It is stocked with a thousand variations of experience which give rise to a response triggered by the circumstances of a given situation. This response, when a group of related ideas fall fortuitously into place, is sometimes called an inspiration. This may lead to a grouping of forms and colors or of sounds as occurs in the arts, or to the solution of a problem which resolves something previously unresolved, which then becomes what is called an invention or a breakthrough in scientific understanding.

A rather different situation arises in the case of what we call the traditional craftsmen, and this is particularly relevant in the case of pottery. Assuming that the craftsman is working in circumstances not excessively dominated by commercial considerations, most of the factors conducive to creative work will operate, but some will be governed by habit, or in other words, by that which is traditionally acceptable. Basically the expressed idea will tend to be something which was the fruit of someone else's imagination or the collective imagination of predecessors long since dead. The outcome may well be something very beautiful with a highly acceptable vitality based on a new factor which I have not yet mentioned. This is the element of interpretation, which enters into most of the visual arts and has links with the role of the musician. One does not question the artistic viability of interpretative expression in the field of music, nor that of an overlap when it occurs, between the originator or composer, and the interpreter or musician. Something very similar can take place in the visual arts, and it is possible, as in the case of the composer, to be both originator and interpreter. On by no means every occasion when an artist sits down in front of his material does the whole battery of creative forces come into play. One outstanding piece of work may well give rise to numerous interpretative variations. The

sum of such variations can be what is referred to as the style of a particular artist over a given period, a style which characterizes his work until some radically different idea is triggered by some new and fortuitous coalescence of subjective and objective circumstances.

The coalescence of these interrelated and interacting factors should also be considered in yet another situation. Here only some, or even only one, of these factors is allowed to operate. To put it at its worst, a quite nonsubjective approach governed by economics can be made to do proxy for all factors except that of skill. When this happens the conscious intent, as I have called it, can be that of some other person—to wit, that of the boss, and for obvious reasons spontaneity and imagination can no longer function.

This brings one to that knife-edge of a hazardous situation which the potter has to face when he is involved in doing repetitive work. Even for the independent potter the danger of turning a viable interpretation of what was once his own creative expression into a hackneyed cliché is never very far away. Economic circumstances exert a continuous pressure in this direction; and nothing but an alert consciousness of this hazard and a will to contrive situations and methods of working conducive to vitality will hold it at bay.

When the potter succumbs to economic dictates, or when he assumes the role of manager and expects uninterrupted repetition of his ideas by paid assistants, the game is lost. Repetition then very quickly ceases to be interpretation, and reinterpretation, and yields only a cliché. This is obviously an inevitable outcome, and the evidence that this is so is lamentably abundant.

Whatever the level of activity, the element of vitality hangs in the last resort on an attitude of mind, and an ordering of priorities. Pablo Casals has stated somewhere his belief that "the capacity to care is the most significantly human quality"; and this I think is the human capacity most vital to the right ordering of priorities. A proper ordering of priorities is after all a matter of doing things for the right reasons. A right reason is one chosen from a group of possible reasons for doing something, and this might also be called the best reason. When economics dictate the reason, the outcome is what John Dewey calls an act of postponed living, and art is very much a postulation of life. One who creates is in the complete sense alive. There are of course good secondary reasons as well, but that of good business is perhaps the last one that should be given priority. If it is not, then a vainglorious seeking after fame—that arch temptress of the arts—certainly is.

It is important to be conscious of the significance of a rejection of better motives. I always feel that one should never reject a good reason for doing something or making something on the grounds that it would not pay. It is perhaps

advisable to be aware that it might not pay, but one should not let that stop one. Do it and count the costs afterwards. Do it again, I say, even if it was not profitable, and scout around in the meantime for some contributary aspect of the practice which will bring solvency without cost in creative terms.

Reflections on Freedom and Ceramics

Bob Rogers

"If we really accept the diversity and freedom of modern ceramics, then we should give up all discussion about the relative merits of different *kinds* of work. This does not mean that we should give up criticism. On the contrary, I think we could do with much more vigorous criticism, but it should be criticism based on a plurality of standards and a flexibility of approach which is open to whatever qualities are present in work of every kind, a criticism which can draw on the experience of a rich variety of ceramics—functional, decorative and sculptural, past and present."

"Reflections on Freedom and Ceramics" (*Ceramic Review*, no. 32, 1975) is the continuation of an illustrated lecture, "Discipline and Freedom in the Crafts," that Bob Rogers, head of Three Dimensional Design for Loughborough College in England, gave to the Craftsmen Potters Association in July 1974. In this essay he directed his interests more pointedly to the concerns of those who worked in clay, arguing for a tearing down of rigid genres in ceramics in favor of its development as a more personal, reflective art that would draw its strength from its own traditions.

Reflections on Freedom and Ceramics

There are three important ways in which potters (and other artist-craftsmen) are freer today than they have ever been. First, they are not confined to the style of a particular locality or period, as most of their predecessors have been. Not only is the world shrinking geographically into McLuhan's "global village," where we are all simultaneously aware of what is going on everywhere else, it is also shrinking historically. As Bernard Leach said in that thoughtful first chapter of A *Potter's Book*, "we are being born today, whether as occidentals or orientals, as inheritors of total human experience. This involves a new assessment of values which is orbital for the first time in human history." Museums, photographs, books and magazines, travel, and international exhibitions have made the pottery of the past as accessible and as immediately present to our senses as pots which were produced yesterday. As a result of this the modern potter is as likely to be inspired and influenced by ancient Chinese, African, pre-Columbian American, or eighteenth-century English potters as he is by his own contemporaries and countrymen.

Second, the modern potter is freer technically. He can choose from an enormous range of materials, techniques, and equipment, and he has access to expert technical advice on every aspect of his work. If he fires by gas, oil, wood, or electricity, builds his forms by hand or throws them on a wheel, operates his wheel by electricity or kicks it round, or pushes it round with a stick (as Hamada does), then he does so not from necessity but from choice.

And third, there is practically no limit to the range of images, symbols, and motifs which today's potters may use. Because they do not inherit any generally accepted ones, they may take them from where they like. Christianity, Zen Buddhism astrology, political and social satire, Greek mythology, pop, pornography—anything goes.

Freedom for artists and craftsmen is not an unmixed blessing. Within the more limited horizons of the artists and craftsmen of the past, all sorts of questions and decisions which can be agonizing for modern potters did not arise or have to be made. Above all, there was not the pressure that there is today to find one's own approach, to be original and individual. "The personality of the artist does not aways appear," writes Emile Mâle in *The Gothic Image*, "but countless generations of men speak through his mouth, and the individual, even when mediocre, is lifted by the genius of these Christian centuries." Soetsu Yanagi,

in *The Unknown Craftsman,* makes a similar point about the work of such anonymous craftsmen as the ancient Chinese village potters, who simply accepted an existing tradition. Of course, the external constraints and traditional disciplines did not entirely exclude individual expression. In all the great traditions of ceramics there has been room for a personal contribution, for fantasy and a sense of fun, but always within a framework of accepted practices which for the most part were unchallenged because they were taken for granted. No such framework exists for the modern potter. He has to establish his own boundaries and impose his own disciplines. Every aspect of his work, from the most trivial to the most fundamental, is open to choice and is a matter of personal responsibility. Whether the decisions are hard or easy, or consciously taken or slipped into by degrees, they have to be made. This can be a great strain, and at its worst it can have a paralyzing effect. It is part of the price we pay for freedom. Only the most extroverted, single-minded, and deeply convinced, or else hopelessly blinkered potters can keep pressing on cheerfully down one road without ever looking back. Often the most mature and apparently assured and successful potters suffer from bouts of self-questioning, reappraisal, and wondering whether they have taken the right road.

It is this freedom to develop one's own style, techniques, and imagery which has led to the most noticeable feature of recent ceramics—its enormous diversity. This was certainly a prominent aspect of the large, mixed "International Ceramics 1972" exhibition at The Victoria and Albert Museum, but it is equally obvious in the succession of smaller shows in London and provincial galleries and is, as one might expect, most glaringly apparent in the diploma shows of students who are just passing out from art colleges. Potters with vastly different temperaments and outlooks are now free to seek ways of working that are congenial to them and they are producing a tremendous variety of functional, decorative, and sculptural ceramics. Many people find this kaleidoscopic variety chaotic and undisciplined, and they see it as a sign of sickness in our society. Irritated by the rapid changes of fashion and the frequent triviality and absurdity that our kind of freedom gives rise to, they yearn nostalgically for a more ordered state of affairs in a more coherent society with a continuous tradition.

In 1940 Bernard Leach said "we live in dire need of a unifying culture out of which fresh traditions can grow," but he recognized that "liberal democracy . . . continues to provide an environment in which the individual is left comparatively free." And Bernard Leach, more than anyone else, has done all he can to foster just such a growing tradition. But although he has many followers, this unifying culture with its fresh traditions appears now, thirty-five years later, to be farther off than ever. I think it is time we gave up making the mistake of

either expecting it or hoping for it. We are not likely to develop a coherent tradition in the way that the Greeks, Egyptians, and African tribes did. Modern technological society is not like that. Our most deeply held beliefs and attitudes, at least in liberal democratic Britain, are not and never can be reflected in any particular style or tradition. It is in the variety itself that they are reflected. It is no mere paradox to say that our tradition is one of no traditions, of continuing variations and diversity. Individualism in creative work is the natural corollary of individual freedom in our society. We are not likely to get a unified tradition in any historical sense unless our kind of society is changed radically and some kind of unity is imposed on us by a repressive political, social, or religious dogmatism. In my view, even though there may be much in it that we object to, we should rejoice in the diversity of our arts and crafts and both encourage and defend it for all we are worth, for it is a sign not of social sickness but of health.

Studio potters who concentrate on functional wares often give the impression that they are more "serious" than decorative or sculptural potters. In particular they take an unaccountable pride in producing things which are actually used, and in being "traditional." What is often ignored is that to opt for producing handmade functional wares is as much a free personal choice as any other option and is no more justifiable in social, moral, or aesthetic terms than any other. First of all, such work is not in any real sense traditional. There is no living tradition which modern potters can follow directly and unselfconsciously in the way that ancient potters did. Nobody in an advanced society today is part of a tradition, although he may very well be a conscious and deliberate traditionalist developing a style of his own based on an amalgam of, say, medieval, ancient Chinese, and eighteenth-century English styles. Delightful though it often is, this kind of eclectic traditionalism is not a tradition in any real sense. Moreover, this kind of pottery is a luxury product which has created its own market of sophisticated buyers. It is not determined so much by the needs of modern people for usable pots as by the desire of the potter for a particular life-style and absorbing occupation. In other words, although he often will not admit it, he does his work for more or less the same reasons as an artist does his. Producing a handmade jug or casserole in the way that most of our best potters do is rather like writing a sonnet. It is to choose to work to a given basic form with fairly strict rules and to measure one's achievement against a long history of similar products. Some people function better under these conditions. Ultimately it is of course only the work itself that counts, and it will be judged much as a work of art is judged. To think that the main thing about a really good handmade functional pot is that one can put milk in it or pour out tea from it is like thinking that the main thing about a painting is that it fills a blank on the dining

room wall. Once it is admitted that we can look at studio pottery as an art form, it becomes possible to apply appropriate aesthetic standards to it. We can appreciate the new developments, the clever variations on old themes, the sensitive exploitation of set forms. And we can sort out what is merely derivative pastiche from what is honestly personal and new.

If we really accept the diversity and freedom of modern ceramics, then we should give up all discussion about the relative merits of different *kinds* of work. This does not mean that we should give up criticism. On the contrary, I think we could do with much more vigorous criticism, but it should be criticism based on a plurality of standards and a flexibility of approach which is open to whatever qualities are present in work of every kind, a criticism which can draw on the experience of a rich variety of ceramics—functional, decorative, and sculptural, past and present. The main branches of ceramics came into being at about the same time and have flourished side by side throughout history. The history of sculptural ceramics is immensely rich, and it is against a background of Mayan, Peruvian, Tang, Tanagra, the Della Robbias, and all the work of the post-Renaissance period that the modern products should be assessed. The decorative, nonfunctional branch of ceramics is equally rich. I mention this mainly because I have met people who seem to regard these two branches of the art of ceramics as modern deviations from some orthodox traditionalism. As someone once said to me, "They are not real potters."

It is in education that the problems of freedom arise in their acutest form. Given so many possible approaches, what does one teach? Art colleges are often accused of encouraging a belief that the "traditional disciplines of the craft" are unimportant and that the novelty of the *idea* is all that matters. Now it is certainly true that there is a strong swing away from traditionalist, functional studio pottery. The constraints and limitations which the functional potter has to accept make his innovations and personal qualities somewhat quiet and unobtrusive. Handmade jugs, like Chinamen, tend to look much the same until you become really acquainted with them. Moreover, the central place of the wheel in studio pottery creates a problem. It is only after a great deal of determined practice that a thrower becomes proficient enough to achieve the kind of subtleties and refinements which make so much difference to the quality of thrown wares. Learning to throw is an act of faith, like learning Latin or Greek. Only after long hard work do you get the rewards. The satisfactions to be got from repetitive throwing seem somewhat esoteric to the uninitiated. They do not seem to appeal to many students today. This is a pity because many students could certainly benefit from a really close and sympathetic study of the careful consideration that first-rate studio potters give to every detail of their work.

114

The main reason why students are finding sculptural and decorative ceramics more exciting is that they seem to offer much greater opportunities for personal expression and the development of new ideas. The climate outside the colleges and the wider opportunities available inside them have brought about this movement, which the teachers could not stop even if they wanted to. There would be no point in imposing a standard course on all students, even if the teachers could agree on one, which is unlikely. The right approach for a particular student emerges only as the dialogue between him and his teacher develops. In the end it does not really matter whether a student sees himself as an exponent of Art Deco or Art Nouveau, or prefers functional, decorative, or sculptural ceramics, or turns to Tibetan art, William Morris, or nature for his inspiration. What matters is whether he allows his teachers to help him to develop the skills, sensibilities, and imagination that will enable him to produce work that is personal and of high aesthetic quality in whatever style or technique he chooses.

The Buddhist Idea of Beauty

Soetsu Yanagi

"Rather than attribute the quality of work to the personal ability of the potters, we must conclude that it was the world in which they lived that not only protected them but also contributed to their success. Abundant natural resources, a long tradition, repetition of effort required for production in quantity, and the fact that the articles were being made for daily use all combined to assist the potters, who, for their part, meekly accepted those conditions with both body and soul as they spent long hours at the kilns. Should a craftsman of modest talent try to resist these forces and stand on his own two feet, he would be bound to meet with difficulty and, as a result, to lose his path or fall by the wayside before reaching his destination. Such a man has but one choice to make: he must rely submissively on a Greater Power."

Soetsu Yanagi was the founder of the folk movement in Japan and a strong influence, through his close friend Bernard Leach in the West. Yanagi's views are apparent in Leach's A *Potter's Book*, which first introduced concepts of Buddhist aesthetics to the Western potter. In 1952, Leach invited Yanagi to England for the Dartington Conference of Potters and Weavers, where he read two major papers on the Buddhist idea of beauty, from which this extract was derived. Following the conference, Leach, the potter Shoji Hamada, and Yanagi toured the United States lecturing on the issues that had emerged from Dartington. Their tour took them throughout the United States, with a particularly memorable stop for an "International Symposium" at the Black Mountain School in North Carolina. Yanagi's essay "The Buddhist Idea of Beauty" is an excerpt of the chapter by the same name in *The Unknown Craftsman* (Tokyo: Kodansha International, 1972), an adaptation of Yanagi's

writings by Bernard Leach.

In illustrating the article, I have selected a group of traditional works by Japanese potters who have played an important role in the Japanese folk art movement.

The Buddhist Idea of Beauty

There is a tremendous difference between the nature of God as conceived by Christians and that of the Buddha as conceived by Buddhists. God is an absolute being, distinct from that finite being called man; God is creator, man created. It is thus a fundamental characteristic of Christian philosophy to perceive the existence of God as independent from man. Some link, consequently, is required to connect these two different entities, and this link is to be found in the person of Jesus Christ. The cross symbolizes the belief that Jesus performed his difficult task at the cost of his life.

The Buddha, on the other hand, is not a creator: as is suggested by his name, he is a man who has achieved Enlightenment. Every human being, according to Buddhism, may become a Buddha; everyone is primordially qualified to do so. Of those who have achieved Buddhahood, Shakyamuni is the perfect example; all adherents of Buddhism, therefore, aspire to follow in his footsteps. Conceiving of no god apart from man, Buddhists instead suppose the existence of the Law (Logos). Although the Law may sometimes be referred to anthropomorphically, its character is far different from that of the Christian God: the manifestation of the Law is the essential property of man. Thus, by the Buddha may be understood a man in whom the Law has been realized.

What, then, is Enlightenment? It is the state of being free from all duality. Sometimes the term *Oneness* is used, but *Non-dual Entirety (funi)* is a more satisfactory term because Oneness is likely to be construed as the opposite of duality and hence understood in relative terms. Buddha is the name applied to a person who has achieved this Non-duality; Buddha is not the creator as opposed to the created but rather is the whole, the integrity that is beyond any such distinction. Since the creator presupposes the created, the concept remains dualistic in nature, while Buddhahood is the "state" in which that which creates and that which is created are undifferentiated. The Undifferentiated, the Non-dual, is assumed to be the inherent nature of man; all Buddhist discipline, therefore, has as its goal the achievement of this Non-dual Entirety. To be in the Non-dual

state forever is the meaning of the expression "entering into Nirvana," which is the same as "attaining Buddhahood."

Buddhism, then, is not theism, but neither would it be proper to describe it as atheism, for it perceives Law in the world where there is no opposition between existence and nonexistence. Again, Buddhism is neither monotheism nor polytheism, since it does not allow the entertainment of such dualistic conceptions as "one" and "many." Although some would pronounce Buddhism to be a kind of pantheism, that too would be incorrect, because Buddhism assumes no such special entity as a God. Against this assertion the argument might be advanced that Buddhism has so many deities that the mere enumeration of their names is a difficult task: Buddhism, therefore, must be polytheistic. But this argument may be refuted by the fact that the deities are merely manifestations of the immeasurable glory of the Law: they may be likened to the beams of the sun, radiating in all directions.

In Buddhist discipline, the central problem, the problem of primary importance as well as of greatest urgency, is how to eradicate man's two most representative forms of dualism—the opposition between life and death and the opposition between one's self and others; and every effort in Buddhism is directed to the solution of this problem. Terror, suffering, conflict, enmity, resentment, lust—all these are the result of man's confinement to the dualistic world. For this reason the different Buddhist sects all teach the principle of "The Gate of the Law to the Non-dual." Different points of view and dissimilar methods of exposition have given rise to numerous Buddhist sects, but all agree in amplifying the theme of Non-dual Entirety. This inherent nature of man's may be compared to his homeland; Buddhism, then, is both nostalgic remembrance as well as the way home. The man who has found the way and succeeded in returning home may be glorified by the name of Buddha. Enlightenment becomes synonymous with the realization of Non-dual Entirety, with abiding in undifferentiated integrity.

Once there was a man seeking the way to Enlightenment who visited a priest named Kanzan. "What did you come for?" asked the priest, for that is always the first question a Buddhist priest asks. "I am puzzled," replied the man, "by the problem of life and death, so I have come to seek your instruction." The priest's answer was: "Here is a place where there is neither life nor death. You might as well go home." This may, at first, seem to be an extremely impolite and unkind reply, but the fact is that the priest was trying to make clear once and for all that the world of Buddhism is a world beyond all such dualistic distinctions as that between life and death. His answer, kindly meant, was a warning

that so long as life and death are conceived of as two opposing phases of existence, truth is not to be grasped.

Another illustrative anecdote concerns the great Chinese Zen monk Kuei-shan, who sought to explain the meaning of everything by making use of the circle as a symbol. One day, while engaged in training his disciples, he drew a circle on the ground, saying: "If you step into this circle, I will strike you. If you stand outside it, I will strike you just the same. What are you going to do?" By this seeming paradox, the monk hoped to show that so long as a man persists in the dualistic realm of "in" and "out," he cannot possibly attain Buddhahood.

What, the reader may ask, has this to do with the Buddhist idea of beauty? My answer is that it is an essential preamble, for I do not propose to introduce the subject of Buddhist aesthetics, since nothing of the sort has ever been cultivated as an independent branch of learning. Nor do I intend to discuss beauty as expressed through the medium of Buddhist art. My object is to clarify what interpretation of the world of beauty is possible from the Buddhist point of view and to explain the Buddhist basis on which the nature of beauty as it is pursued in the Orient chiefly depends.

Let us look at a beautiful piece of pottery. Its provenance does not concern us. If the article is beautiful, we may say that it has achieved Buddhahood, for it is not man alone that may become a Buddha. A beautiful artifact may be defined as one that reposes peacefully where it aspires to be. A man who achieves Buddhahood has entered the realm that lies beyond that of duality; by the same token, beauty is that which has been liberated—or freed—from duality.

Freedom is a word that is now being used rather too carelessly, and Buddhists prefer the word *muge* (literally, "liberation," "being free from impediment"), which refers to the absence of that impediment or restriction arising from relativity. It means the state of liberation from all duality, a state where there is nothing to restrict or be restricted. Beauty, then, ought to be understood as the beauty of liberation or freedom from impediment. It should be noted that true freedom is not fettered even by the idea of freedom. In this sense, liberalism cannot be said to realize the true meaning of freedom, because it is enthralled by principle. Even less does freedom mean selfish or lawless behavior. True freedom must mean liberation from both one's self and others: it must not be in bondage to itself nor may it be restricted by others. Everything that is beautiful is, in one sense or another, a manifestation of this sort of freedom.

If beauty is the antithesis of ugliness, however, like good and bad or high and low, then it can only be conceived of relatively; but from the Buddhists'

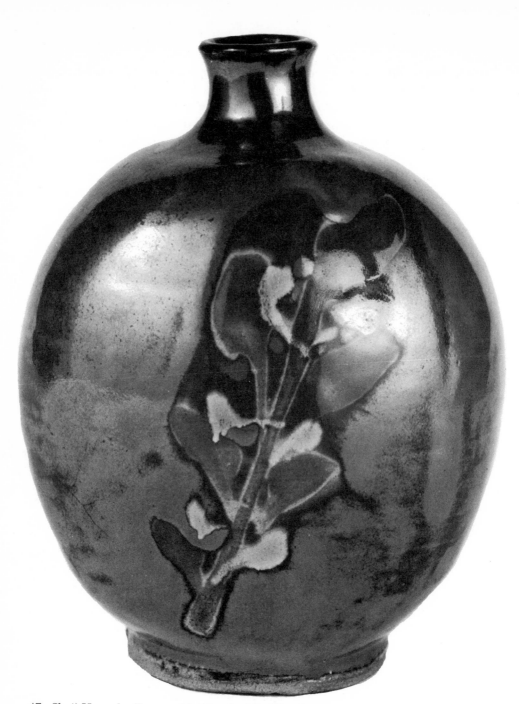

47. Shoji Hamada: Press-molded bottle. Mashiko, Japan,
c. 1956. H. 9⁵⁄₁₆″ (23.7 cm). Collection Fred and Mary Marer,
Los Angeles. Photograph: Paul Soldner.

point of view, the "beauty" that simply stands opposed to ugliness is not true beauty. It is no more than a relativistic, dualistic idea. True beauty exists in the realm where there is no distinction between the beautiful and the ugly, a realm that is described as "prior to beauty and ugliness" or as a state where "beauty and ugliness are as yet unseparated." There can be no true beauty, then, outside that realm where beauty and ugliness have not yet begun to conflict with each other. In the *Muryoju-kyo* ("Sutra of Eternal Life"), the following statement is attributed to the Buddha:

> If in the land of the Buddha there remains the distinction between the beautiful and the ugly, I do not desire to be a Buddha of such a land.

Opposition between the beautiful and the ugly is unknown in the land of the Buddha; it lies beyond any such distinction, for dualism is alien to Buddhahood: here the concept of the beautiful as opposed to the ugly and that of the ugly as opposed to the beautiful both disappear.

Beyond dualism, every object—by whomever or in whatever manner it is made—finds salvation. We need not, therefore, lie helplessly enmeshed in the conflict between the beautiful and the ugly. Once the Buddhahood beyond beauty and ugliness is attained, any work by any craftsman becomes a Buddha. In our temporal world, conflict between the beautiful and the ugly goes on incessantly and can never be finally resolved. Yet only when this resolution occurs, we are told, is everyone to be saved. Therefore we are constantly instructed to revert to the stage that precedes the distinction between beauty and ugliness, good and bad, and other apparent antitheses.

In Buddhism, this idea of the Undifferentiated plays a role of the utmost importance. Since it does not concern itself with a preference for the beautiful over the ugly but rather pertains to the realm that precedes the birth of opposition between the two, it does not permit a situation in which either the ugly or, by the same token, the beautiful exists. Here there is neither: here everything is an integrity that is unique, that is itself, that is without distinction. Here, in the Buddhist idea, is the realm where art must abide. In the words of Kabir, the Indian mystic poet (1482–1512):

> The unstruck drum of Eternity is sounded within me.
> The dance of God goes on without hands and feet.
> The Harp of God is played without fingers, it is heard without ears:
> for He is the ear, and He is the hearer.

In this profound piece of religious poetry, Kabir is telling us that the sound of a "struck drum" would be dualistic and therefore could not constitute God's

music. So long as the man who strikes the drum and the drum that is struck are two different beings, true music can never be born.

In John 7:58 there is the statement "Verily, verily, I say unto you, 'Before Abraham was, I am.'" Most remarkable in this quotation is the juxtaposition of the preposition "before" and the verb "am." Clearly, this "before" is not used temporally; if it were, the verb should be "I have been," not "I am." The present tense is employed here to denote not the mere present but the Eternal Now, that Now that does not depend upon either the dualistic past or future but rather is the present that partakes of eternity. Thus, an object is truly beautiful because it belongs to the Eternal Now.

All art movements tend to the pursuit of novelty, but the true essence of beauty can exist only where the distinction between the old and the new has been eliminated. The Sung dynasty pottery of China reveals a beauty that is forever new, that is still alive today. It is like a fountainhead from which one may draw water a thousand times and still find fresh water springing forth. Its beauty belongs, in the words of Jesus, to the realm of "I am," not to that of "I have been," "I was," or "I shall be." A man who considers Sung ware to be "old-fashioned," who brands it a thing of the past, is himself superannuated. Passing time cannot affect an object that is truly beautiful. All that there is, is the Eternal Now.

Two Ways

Not a single piece of Sung ware, as everyone knows, bears the signature of its maker: the potter never signed his work, however beautiful it may have been. One explanation that has been put forward is that in those days the custom of signing a work was still unknown. The true explanation, however, may be simpler still. Sung craftsmen were not self-conscious artists, they were not learned men, they were mere craftsmen making articles for daily use; most of them were probably extremely poor and had to work hard from morning till night, most also were probably badly educated and uninformed. They were not privileged people who could choose to work only when they were in a creative mood. Yet, despite all this, potters in Korea as well as in China were able to produce objects of consummate beauty, such as Sung ware and Koryo celadons: works of art that have endured through the ages.

What is more, these works of art were apparently produced with the greatest of ease, nor were they the production of merely a few potters. There were, in fact, a great many craftsmen who could produce, each and every one of them, works of equal merit. Even highly accomplished artists nowadays find that a

48. Toyo Kaneshige: Bottle,
Bizen tradition. Japan, 1956. H. 7⅞″ (20 cm).
Collection Fred and Mary Marer, Los Angeles.
Photograph: Paul Soldner.

tremendous amount of effort and practice, of meditation and ingenuity is essential in order to create a work of real value, with the result that only a few artists of more than ordinary talent succeed. But Sung and Koryo pottery was produced by no such known and individual geniuses. Can the mystery be explained in Buddhist terms?

I think it can, for Buddhism teaches that there are two ways of becoming a Buddha: one is called the "Way of Self-Power" (self-reliance; *jiriki-do*); the other, the "Way of Other Power" (reliance on an external power or grace; *tariki-do*). The latter may be compared to going to sea in a sailboat; the former, to walking on land. On land one very often has to traverse rugged paths, cross muddy pools, and overcome similar obstacles, time and again getting lost, growing tired, and undergoing many other trials. For that reason, it is also called the "Way of Hardship" (*nangyo-do*), and it is the way of artists and others who believe themselves to be possessed of greatness, who want to find it out and make use of it. To do this, they are willing to rely on their own individual strength;

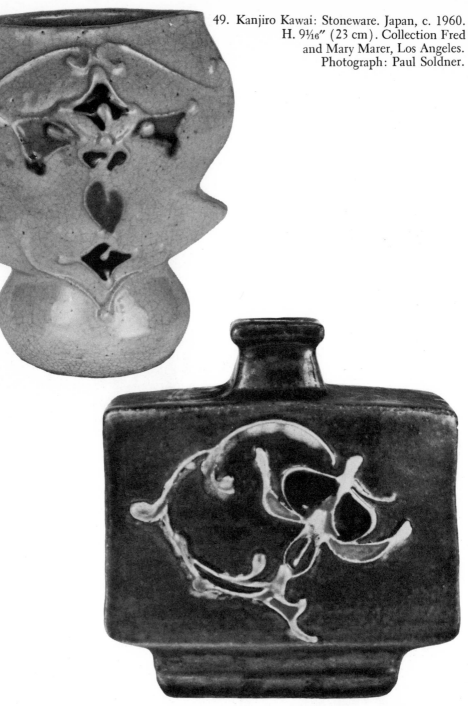

49. Kanjiro Kawai: Stoneware. Japan, c. 1960.
H. 9¹/₁₆″ (23 cm). Collection Fred
and Mary Marer, Los Angeles.
Photograph: Paul Soldner.

50. Kanjiro Kawai: Stoneware.
Japan, c. 1960. H. 9¼″ (23.5 cm).
Collection Fred and Mary Marer, Los Angeles.
Photograph: Paul Soldner.

but only those of extraordinary calibre, or genius, can complete this arduous trip.

Obviously, not all living people can be geniuses: the number of geniuses appearing in any given generation is extremely small. Thus, there are a great many people of ordinary ability living in the world, with a few geniuses among them. Are the masses doomed to simple obliteration? Is there no salvation for them? Buddhism states very explicitly that the mass of the people may also become Buddhas. The sects that emphasize that those not endowed with genius are equally to be granted the bliss of reaching their destination are called *tariki-shu* (sects of reliance on an external power), and their way is called the "Easy Way" (*igyo-do*), since everyone is to arrive safely and unfailingly. A ship entering harbor with swelling sails is not doing so on its own but has surrendered to the great power of the wind. In a similar way, the mass of the people, even those devoid of talents, may be carried to their goal with the help of a great external power: they complete their journey with ease. Those who take the hard way seek their own greatness; those who follow the easy way surrender themselves, reflecting on their own smallness.

The beauty of China's Sung pottery, then, is an instance of the goal attained by following the Easy Way, the way of reliance on grace. Rather than attribute the quality of work to the personal ability of the potters, we must conclude that it was the world in which they lived that not only protected them but also contributed to their success. Abundant natural resources, a long tradition, repetition of effort required for production in quantity, and the fact that the articles were being made for daily use all combined to assist the potters, who, for their part, meekly accepted those conditions with both body and soul as they spent long hours at the kilns. Should a craftsman of modest talent try to resist these forces and stand on his own two feet, he would be bound to meet with difficulty and, as a result, to lose his path or fall by the wayside before reaching his destination. Such a man has but one choice to make: he must rely submissively on a Greater Power.

It is a noteworthy fact that, when the way of grace is followed, very little difference results in the beauty of the final productions, no matter who the maker may be and no matter what it may be that he is making. What minor individual differences there may be are reduced to nothing by the external power. The opposite is true when the way of self-reliance is followed, for there the personality of the maker, his individual taste, and the nature of his talent dictate what the final result will be. Needless to say, even with Sung ware made in the way of grace, there are slight differences in the quality of individual pieces, but significantly not a single one is found to have deviated positively from the right course. Putting it in Buddhist terms, we may say that every piece of Sung ware has the

look of having attained Buddhahood. What a sad comparison is made by present-day industrial design!

Another noteworthy fact is that Sung ware is not a manifestation of the individual personality of the maker: that lies submerged beneath the surface, while the article itself stands out. Sung potters were working in a world where identity is not of importance. In that world, no effort is made to express individuality through the medium of things; on the contrary, the aim is to produce things through the medium of man. The beauty created there is the beauty of artifacts, not of man. If there is beauty also on the side of man, it is assuredly the beauty of the submissiveness with which he has placed himself at the mercy of the great external power.

The fact that much Sung ware is decorated with superbly drawn pictures inevitably suggests that there must have been a large number of first-rate artists at work, for the technique of the brushstrokes and the rendering of the figures are both remarkable. The further fact that we never encounter a design that may be called ugly or distasteful suggests also that many of the Sung potters themselves must have been highly gifted artists. Such conclusions would be wholly erroneous. In Tz'u-chou, for example, where this type of ware was produced in great quantity, the task of drawing pictures on pottery was almost always relegated to young boys. No famous painters of the day were hired to work for the kilns. The job was performed by boys around the age of ten, children of poor families, many of whom no doubt disliked the work and had to be forced by their parents to do it. Occasionally, as they worked, their eyes would be blinded by tears. Others of the children were probably what we would now call juvenile delinquents, quarrelsome and naughty. Most of the children were illiterate; the Chinese characters that we sometimes see written in the pictures would, then, have been meaningless to the young writers. Like all children, they laughed and sang sometimes as they worked; at other times, they fought, but, no matter what kind of children they may have been, no matter what kind of pictures or characters they drew, the result was invariably one of marvelous beauty.

Obviously, this was not because each of the children was endowed with rare talent. If the hand of genius was needed, how could such a large number of boys have drawn equally good pictures? The answer may have lain partly in the nature of the materials used, but chiefly it lay in the endless repetition that was demanded of the children. The easy use of the brush and the boldness of the composition resulted from the fact that each child had to draw the same picture hundreds of times a day. This repetition produced an amazing dexterity and a quickness of hand that must have been miraculous to watch. Hesitation had no

126

place in it; neither had anxiety or ambition. Oblivious to all these, the children worked with total disengagement.

The repetitive monotony that today would be regarded with horror; the hard work that the young boys were forced to accept as their inevitable destiny: these two factors possessed the compensatory quality of imparting beauty to the work. The obligation to draw the same picture hundreds of times a day will make a painter forget what he is drawing; he will be liberated from the dualistic opposition of dexterity and clumsiness; no longer will he need to consider the distinction between beauty and ugliness: all that he will do is move his brush quickly and unhesitatingly, without even being aware of what he is drawing. The children of Tz'u-chou may have been thinking of chrysanthemums while drawing bamboo plants; more remarkable still, they actually drew animals they had never seen and they inscribed characters they could not read. Such factors had no inhibiting effect on them. They forgot themselves as they worked, or perhaps it would be more correct to say that they worked in a world so free they were able to forget themselves.

It was precisely here, in this submissive reliance on tradition, that the beauty of their accomplishment was promised. Tradition, the accumulation of the experience and wisdom of many generations, is what Buddhists call the Given Power—an aggregate power that in all cases transcends the individuals. Illiterate craftsmen may, as individuals, be small and weak, but, supported by this Given Power of tradition, they are able to produce work of astonishing merit with the utmost ease. The importance of tradition in the work of the craftsman can hardly be exaggerated.

Once we realize that a piece of Sung pottery is not the product of some individual genius but rather of the nonindividualistic power of tradition, we understand that its beauty is not personal and there is no need, therefore, to question who its maker was. To the craftsman, tradition is both the savior and the benefactor. When he follows it, the distinction between talented and untalented individuals all but disappears: any craftsman can unfailingly produce a beautiful work of art. But if he loses sight of the long tradition behind him, his work can only be that of a bumbling incompetent.

Tradition never asks who is enlisting its help. We have hitherto been considering only pottery, but the rule holds true for other branches of practical art as well. In Coptic textiles, which are one of the great marvels of textile making, we see the hands not of a small number of geniuses but of a great many unlettered women working indefatigably according to tradition. We may do well to ask ourselves how many individual artists in more recent times have been

51. Shoji Hamada: Double vessel with wax-resist decoration. St. Ives, Cornwall, 1931–1932. 5″ (12.7 cm). Collection Michael Cardew, Wenford Bridge, England. Photograph: Garth Clark.

able to produce work more beautiful than Coptic textiles. We then realize that without the way of grace many beautiful objects would never have been created; to regard beauty as the prerogative of genius alone is too narrow a view.

One day, in the province of Mikawa in Japan, a woman named Osono, who had been deeply instructed in the doctrine of the Other Power, was standing in front of the temple, earnestly discussing with her friends the problem of faith. A priest, passing by, patted her on the shoulder and said, "What are you talking so intently about? We may die at any moment. How can you be so heedless?" Osono replied, "Is Buddha Amitabha ever heedless?" The priest was much impressed by her answer, for he understood that what she was saying was, in effect: "A trivial woman like me is easily distracted, but Buddha Amitabha is ever on the alert for my sake, so I feel no apprehension."

Just as Osono had surrendered herself utterly to the power of Buddha Amitabha, many craftsmen give themselves up, once and for all, to tradition. If they entertained the slightest doubt about that power, their work would come to a standstill, for they are but poor creatures, hardly worth a second thought. Yet the power of tradition enables them to accomplish great work. It is not they but tradition that bears the burden. Such craftsmen do not put their signatures to what they create, but Buddha Amitabha signs his name in large characters— although our mortal eyes cannot see it. Nevertheless, anyone who admires Sung pottery or Coptic textiles is admiring, without knowing it, the Buddha's signature. Anyone who is moved by the beauty of folkcraft is in reality being moved by the invisible power that lies beneath the surface.

III

Postwar America: The Liberation of Clay

The New
Ceramic Presence

Rose Slivka

"In the past, pottery form, limited and predetermined by function, with a few outstanding exceptions, has served the freer expressive interests of surface. Today classical form has been subjected and even discarded in the interests of surface—an energetic, baroque clay surface with itself the 'canvas.' The paint, the 'canvas,' and the structure of the 'canvas: are a unity of clay.' "

Rose Slivka is editor of *Craft Horizons*, a magazine published by the American Crafts Council, New York. She was appointed in 1959 and soon established a reputation for *Craft Horizons* as one of the most progressive, adventurous art magazines of the 1960s. Her essay "The New Ceramic Presence" (*Craft Horizons*, no. 4, 1961) was the first acknowledgment and definition of the Abstract Expressionist energies that had begun to reshape the contemporary ceramic aesthetic in America.

The New Ceramic Presence

American ceramics—exuberant, bold, irreverent—has excited admiration and controversy among craftsmen in every field both here and abroad. The most populated, aggressively experimental, and mutable area of craft expression, it is symptomatic of the vitality of United States crafts with its serious, personal, evocative purposes.

As in the other arts, ceramics, also, has broken new ground and challenged past traditions, suggested new meanings and possibilities to old functions and habits of seeing, and has won the startled attention of a world unprepared for the

unexpected. (At the second International Ceramic Exhibitions at Ostend, Belgium, in 1959, the United States exhibit, circulated abroad for the last two years, became the focus of the show.) To attempt some insight into what is happening—for it is a happening, peculiar to our time and to American art as a whole—to probe the complex sources of our ceramics and its vigorous new forms is the aim of this investigation.

What is there in the historical and philosophic fabric of America that engendered the unique mood of our expression?

America, the only nation in the history of the modern world to be formed out of an idea rather than geographic circumstance or racial motivations—the country compelled by the electrifying and still new idea of personal freedom that cut through geographic, racial, and economic lines to impel people everywhere in unparalleled scope, rate, and number—was a philosophic product of the Age of Reason and the economic spawn of the Industrial Revolution. In the two hundred years of our short history, our expanding frontier kept us absorbed in the problems of practical function and pressured us to solve them in a hurry. We have, as a result, become the most developed national intelligence in satisfying functional needs for the mass (in a massive country), with availability an ideal. The rapidity, the scale, and the intense involvement in mechanization have been unprecedented. If there is, in fact, any one pervasive element in the American climate, it is that of the machine—its power, its speed, its strength, its force, its energy, its productivity, its violence.

Not unified by blood or national origin (everyone is from someplace else), or a sense of place (with many generations of a family history identified with one place, as in Europe), we are a restless people. A nation of immigrants with a continuing history of migration, we are obsessed by the need for arrival—a pursuit that eludes us. And so, we are always on the go. (Our writers—Walt Whitman, Herman Melville, Thomas Wolfe, and, most recently, Jack Kerouac—have struggled for a literary art form to express this.) Having solved our need for mobility by mechanical means, we love engineering and performance and the materials and tools by which we have achieved them.

In our involvement with practical matters, we were too busy really to cultivate the idea of beauty. Beauty as such—the classical precepts of harmonious completion, of perfection, of balance—is still a Western European idea, and it is entirely possible that it is not the aesthetic urgency of an artist functioning in an American climate—a climate that not only has been infused with the dynamics of machine technology, but with the action of men—ruggedly individual and vernacular men (the pioneer, the cowboy) with a genius for improvisation. Our environment, our temperament, our creative tensions do not seem to encourage

132

the making of beauty as such, but rather the act of beauty as creative adventure—energy at work—tools and materials finding each other—machines in movement—power and speed—always incomplete, always in process.

As far back as 1870, a Shaker spokesman declared that Shaker architecture ignored "architectural effect and beauty of design" because what people called "beautiful" was "absurd and abnormal."[1] It had been stated by others before and was restated many times since, including the declaration in the 1920s by famous architect Raymond M. Hood: "This beauty stuff is all the bunk."[2] A typical American attitude, it may well have expressed the beginning of a new American aesthetic rather than gross lack of appreciation for the old one.

This is the ebullient, unprecedented environment of the art that, particularly in the fifteen years since World War II, has asserted itself on every level.

First manifested in painting—the freest of the arts from the disciplines of material or function—it projected such a presence of energy, new ideas, and methods that it released a chain reaction all over the world, and for the first time we saw the influence of American painting abroad. But nowhere has the impact of contemporary American painting been greater than here at home. Feeding on itself, it has multiplied and grown in vitality and daring to penetrate every field of creative activity.

Pottery, of course, has always served as a vehicle for painting, so this in itself is nothing new. The painted pottery of Greece strictly followed the precepts of the painting of the time in style and quality, while that of Japan was often freer and in advance of its other media of painting, even anticipating abstract modern approaches. Contemporary painting, however, has expanded the vocabulary of abstract decoration and given fresh meaning to the accidental effects of dipped, dripped, poured, and brushed glazes and slips on the pot in the round.

But its greatest and most far-reaching effect in ceramics has been the new emphasis it gave to the excitement of surface qualities—texture, color, form—and to the artistic validity of spontaneous creative events during the actual working process—to everything that happens to the clay while the pot is being made.[3] Clay, perhaps more than any other material, undergoes a fabulous creative transformation—from a palpable substance to a stonelike, self-supporting structure—the self-recorded history of which is burned and frozen into itself by fire.

[1] John Kouwenhoven's documented study of American aesthetics, *Made in America* (Newton Centre, Mass.: Charles T. Branford Co., 1948).

[2] *Ibid.*

[3] The writer does not wish this article to be interpreted as a statement of special partisanship for those potters working with the new forms and motivations. It is an attempt to treat a direction of work which, with its provocative attitudes, has evoked strong response—for it as well as against it. Our partisanship is for creative work in all its variety. We recognize that pottery has as many faces as the people who make it.

52. John Mason: *Gray Wall*, stoneware. Los Angeles, 1960.
L. 13′6¼″ (4.12 m). Photograph: Frank J. Thomas.

More than in any other form of art, there is a tradition of the "accident" in ceramics—the unpremeditated, fortuitous event that may take place out of the potter's control, in the interaction between the living forces of clay and fire that may exercise mysterious wills of their own. The fact that the validity of the "accident" is a conscious precept in modern painting and sculpture is a vital link between the practice of pottery and the fine arts today. By giving the inherent nature of the material greater freedom to assert its possibilities—possibilities generated by the individual, personal quality of the artist's specific handling —the artist underscores the multiplicity of life (the life of materials and his

own), the events and changes that take place during his creative act.

Painting shares with ceramics the joys and the need for spontaneity in which the will to create and the idea culminate and find simultaneous expression in the physical process of the act. Working with a sense of immediacy is natural and necessary to the process of working with clay. It is plastic only when it is wet and it must be worked quickly or it dries, hardens, and changes into a rigid material.

The painter, moreover, having expanded the vistas of his material, physically treats paint as if it were clay—a soft, wet, viscous substance responsive to the

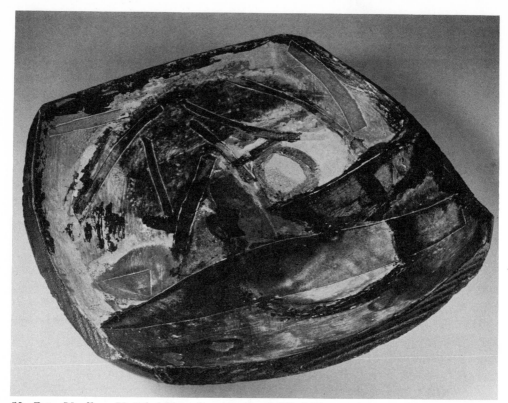

53. Peter Voulkos: *Untitled Plate*. Los Angeles, 1957. 14¾" × 15¾" (37.5 cm × 40 cm).
Photograph: Courtesy Quay Gallery, San Francisco, California.

direction and force of the hand and to the touch, directly or with tool; it can be dripped, poured, brushed, squeezed, thrown, pinched, scratched, scraped, modeled—treated as both fluid and solid. Like the potter, he even incorporates foreign materials—such as sand, glass, coffee grounds, crushed stone, etc.—with paint as the binder, to emphasize texture and surface quality beyond color. (We are aware that the application of paint as color, with its inherent qualities and dependency for a supporting structure by adhesion to a plane in another material, makes a fundamental difference between the two arts—between it and all other practices of the plastic arts. We are not trying to simplify or equate. We are pointing to those common denominators that have profoundly affected and influenced the new movement in pottery.) It is corollary that the potter today treats clay as if it were paint. A fusion of the act and attitudes of contemporary painting with the material of clay and the techniques of pottery (the potter's hand if not always his wheel is there), it has resulted in a new formal gesture that imposes on sculpture.

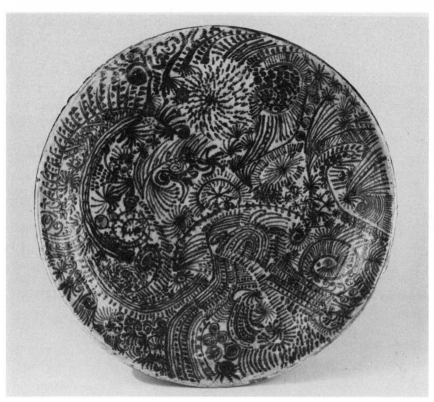

54. Henry Takemoto: Stoneware plate. Los Angeles, 1960. D. 15¾″ (40 cm). Collection Fred and Mary Marer, Los Angeles. Photograph: Paul Soldner.

In the past, pottery form, limited and predetermined by function, with a few outstanding exceptions, has served the freer expressive interests of surface. Today, the classical form has been subjected and even discarded in the interests of surface—an energetic, baroque clay surface with itself the formal "canvas." The paint, the "canvas," and the structure of the "canvas" are a unity of clay.

There are three extensions of clay as paint in contemporary pottery:

1. the pot form is used as a "canvas";

2. the clay itself is used as paint three-dimensionally—with tactility, color, and actual form;

3. form and surface are used to oppose each other rather than complement each other in their traditional harmonious relationship—with color breaking into and defining, creating, destroying form.

This has led the potter into pushing the limits of painting on the pot into new areas of plastic expression: sculptured painting, with the painted surface in control of the form. The potter manipulates the clay itself as if it were paint—he

slashes, drips, scrubs down, or builds up for expressive forms and textures. Or around the basic hollow core he creates a continuum of surface planes on which to paint. In so doing, he creates a sculptural entity whose form he then obliterates with the painting. This, in turn, sets up new tensions between forms and paint. It is a reversal of the three-dimensional form painted in two. Now the two-dimensional is expressed in three—on a multiplaned, sculptured "canvas." As a result, modern ceramic expression ranges in variety from painted pottery to potted painting to sculptured painting to painted sculpture to potted sculpture to sculptured pottery. And often the distinctions are very thin or nonexistent.

The current pull of potters into sculpture—in every material and method, including welded metals, cast bronze, plaster, wood, plastics, etc.—is a phenomenon of the last five years. So great a catalyst has been American painting that the odyssey from surface to form has been made through its power. Manipulating form as far as it could go to project the excitement of surface values, the potters found even the slightest concession to function too limiting. From painter-potters, they were impelled to become painter-sculptors. Instead of form serving function, it now serves to develop the possibilities of the new painting. However, while this painting generates the creation of forms for itself—often massive in scale—it tolerates the dominance of no presence other than itself. In his new idea of a formal synthesis, the potter is inevitably pushing into space —into the direction of sculpture.

As a fusion between the two dimensional and the three dimensional, American pottery is realizing itself as a distinct art form. In developing its own hybrid expression, it is like a barometer of our aesthetic situation.

Involvement in the new handling of surface with form, however, cannot rest on traditional categorizing. The lines cross back and forth continuously. While the painter, in building and modeling his surface has reached toward the direction of sculpture, so, too, the sculptor has been independently reaching away from the conventional bounds of sculptural form toward an energy of space and the formal possibilities of an activated surface (with or without color). The hybrid nature of this expression, however, has always been within the realm of sculpture, only to be released as an entity in our time.

Sculpture, as every area of the plastic arts, is reevaluating the very idea that gave it birth—monumentality. A traditional sculptural aspiration, its values, too, have changed. The sculptor today places greater emphasis on event rather than occasion, in the force of movement and the stance of dance rather than in the power of permanence and the weight of immobility, in the metamorphosis of meanings rather than in the eternity of symbols.

Specific to the kinship between potter and sculptor is the fact that clay is a primary material for both (for the potter, the sole material; for the sculptor, one of several). Its tools and methods impose many of the same technical skills and attitudes on both. In general, potter and sculptor share a creative involvement in the actuality of material as such—its body and dimension—an experience of the physicality of an object that in scale and shape relates to the physicality of the artist's own body in a particular space.

The developments in abstract sculpture have decidedly affected the formal environment of ceramists everywhere. The decision of the sculptor to reinterpret the figure as well as all organic form through abstraction and even to project intellectually devised forms with no objective reference inevitably enlarged the formal vistas of every craftsman and designer working in three dimensions.

To pottery, sculpture has communicated its own sense of release from the tyranny of traditional tools and materials, a search for new ways of treating materials and for new forms to express new images and new ideas.

In addition to painting and sculpture, other influences that contributed decisively to the new expression in American pottery were: The bold ceramic thrust of Picasso, and Miró with Artigas, gave encouragement and stimulation to the movement that had already begun here. The Zen pottery of Japan, furthermore, with its precepts of asymmetry, imperfection (crude material simplicity), incompleteness (process), found profound sympathy in the sensibilities of American potters.

The freedom of the American potter to experiment, to risk, to make mistakes freely on a creative and quantitative level that is proportionally unequaled anywhere else has been facilitated, to a large extent, by this country's wealth and availability of tools and materials. It gave further impetus to the potter's involvement in total process—in the mastery of technology and the actual making of the object from beginning to end—in marked contrast to the artist-potters of European countries who leave the technology and execution to the peasant potter and do only the designing and finishing. Aside from the fact that we have no anonymous peasant potters in this country to do only the technical or preparatory work, the American loves his tools too much to leave that part of the fun to someone else. For him, the entire process contains creative possibilities. Intimacy with the tools and materials of his craft is a source of the artist's power.

Spontaneity, as the creative manifestation of this intimate knowledge of tools and their use on materials in pursuit of an art, has been dramatically articulated as an American identity in the art of jazz—the one medium that was born

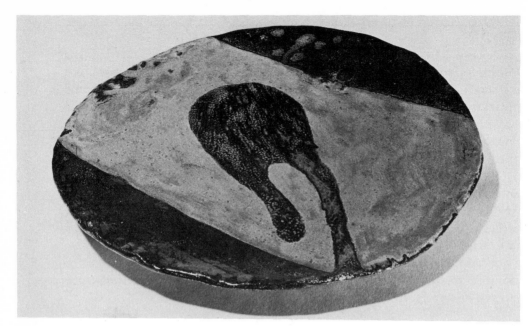

55. Kenneth Price: Plate, light green and brown stoneware. Los Angeles, 1958. D. 9¼″ (23.5 cm). Collection Happy Price, Taos, New Mexico. Photograph: Frank J. Thomas.

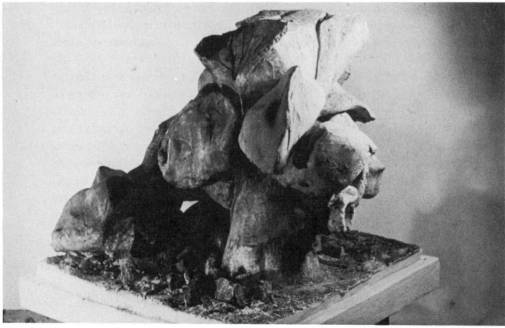

56. Jerry Rothman: Stoneware. Los Angeles, 1961. H. 38″ (96.5 cm). Private collection.

here. Always seeking to break through expected patterns, the jazzman makes it while he is playing it. With superb mastery of his instrument and intimate identification with it, the instrumentalist creates at the same time he performs; the entire process is there for the listener to hear—he witnesses the acts of creation at the time they are happening and shares with the performer the elation of a creative act.

Crafts that functioned in the communal or regional culture of an agrarian society do not have the same meaning in the internationalized culture of an industrial society. Thus, all over the modern world, the creative potter has been reevaluating his relation to function. Certainly, the potter in the United States is no longer obliged to produce for conventional function, since the machine has given us so many containers for every conceivable variety of purposes and in every possible material—plastic, paper, glass, ceramic, fiber, metal—with such quick obsolescence and replacement rates that they make almost no demands on our sensibilities, leaving us free—easy come, easy go—from being possessed by the profusion and procession of objects that fill our lives today. We are accustomed to our functional problems being solved efficiently and economically by mechanical means; yet we are acutely aware of our particular need for the handcrafts today to satisfy aesthetic and psychological urgencies. The painter-potter, therefore, engages in a challenge of function as a formal and objective determinant; he subjects design to the plastic dynamics of interacting form and color and even avoids immediate functional association—the value by which machine-made products are defined—a value that can impede free sensory discovery of the object just as its limitations can impede his creative act. And so, the value of use becomes a secondary or even arbitrary attribute.

Then comes the inevitable question: Is it craft? In the view of this writer, as long as it is the intent of the craftsman to produce an object of craft (the execution of which he performs with the recognized tools, materials, and methods of craftsmanship), and he incorporates acknowledgment, however implied, of functional possibilities or commitments (including the function of decoration)— as long as he maintains personal control over the execution of the final product, and he assumes personal responsibility for its aesthetic and material quality—it is craft. At the point that all links with the idea of function have been severed, it leaves the field of the crafts.

Ceramics, perhaps more than any other craft, throughout its long history has produced useful objects that are considered fine art. Time has a way of overwhelming the functional values of an object that outlives the men who made and used it, with the power of its own objective presence—that life-in-

vested quality of being that transcends and energizes. When this happens, such objects are forever honored for their own sakes.

We are now groping for a new aesthetic to meet the needs of our time, or perhaps it is a new anti-aesthetic to break visual patterns that no longer suffice. The most powerful forces of our environment—electronic and atomic, inner and outer space, speed—are invisible to the naked eye. Our aesthetic tradition, involved as it has been with visual experience, does not satisfy the extension and growth of reality in our time. Our greatest sensory barrier to a new aesthetic is visual enslavement in a subvisual world. The aspect of man is no longer the center of things, and his eyes are only accessories of his own growing sense of displacement.

Throughout the arts in America we are in the presence of a quest for a deeper feeling of presence.

The American potter, isolated from the mass market, which makes no demands on his product as a material necessity, is motivated by a personal aesthetic and a personal philosophy. Lacking an American pottery tradition, he has looked to the world heritage and made it his own. For this, he has had to study and travel. Today, with his knowledge about himself, his craft, and his art—historically, contemporaneously, and geographically—cumulatively greater than ever before, the United States craftsman, a lonely, ambitious eclectic, is the most eager in search of his own identity.

All this, then, has made him most susceptible and responsive to the startling achievements of contemporary American painting and sculpture. For better or worse, he has allied himself with a plastic expression that comes from his own culture and his own time, and from an attitude toward work and its processes with which he can identify. The American potter gets inspiration from the top—from the most developed artistic, intuitive consciousness in his society. As always, the artist is led—not by the patron, not by populace, certainly not by the critic—artist is led by artist. The artist is his own culture.

Briefly, the characteristic directions of the new American pottery are: the search for a new ceramic presence, the concern with the energy and excitement of surface, and the attack on the classical, formal rendering.

Pottery, with a continuity that reaches back to the very beginnings of man, has always had a tradition for variety. If there is any one traditional characteristic of American pottery, it is this enormous variety. And if there is anything that distinguishes American plastic expression, it is the forthrightness, the fearlessness, the individuality, the aloneness of each man's search.

The Tao and Dada of Recent American Ceramic Art

Bernard Pyron

"Wet clay is flexible enough to allow the potter to express, perhaps without knowing, the subtlest of spontaneous impulses that modify his image of traditional forms. In many ways the making and appreciation of this art requires more subtle perception than painting or sculpture."

In taking a point between the Oriental ceramic aesthetic on the one hand, and the acknowledgment of the Dadaist and the liberating climate of Abstract Expressionism on the other, Bernard Pyron shows a clear appreciation of the forces that have shaped contemporary American ceramics and particularly the sculptural concerns during the late 1950s and early 1960s. "The Tao and Dada of Recent American Ceramic Art" was published in *Artforum* (March 1964).

The Tao and Dada of Recent American Ceramic Art

As a material of artistic communication, clay has an old and deep meaning for man. Not only did he use clay, along with wood, stone, and straw, for his first tools and utensils, but clay sculpture preceded stone sculpture in some cultures, and the knowledge of firing processes was necessary for the development of

bronze casting. Coyote, god of the Miwok tribe of California, modeled man in clay, and the Mesopotamian god Ea used the potter's wheel to create the first man. During the last twenty years, American studio potters have revived some of clay's meaning, first by creating pots with a quiet beauty to be used as vases and tableware, and later by giving clay a new life through abstract ceramic sculpture.

The making of functional pottery coincided with the creation of clay sculpture in the life of most primitive and semiprimitive people. In China functional pottery evolved over two thousand years to reach its highest state of refinement in a culture of sensitive artistic taste where all the richness of China's past—the ritualistic vitality of the Shang, the simplicity of the Han, the robust fullness of the T'ang, and the attitudes of Taoism, Confucianism, Buddhism, and Zen— flowered in a final tribute to man's creativity. The power, refinement, and elegance of a Sung celadon, crisp but misty with Taoist nature, owes its life to a culture where the standard of living was higher than in the past, but more important, where art, life, religion, and philosophy flowed together in a delicate balance, whether inspired by Taoist unity with the universe, orthodox Buddhism, Zen, or neo-Confucianism. Like the landscapes of Fan K'uan of the Northern Sung or the softer, more romantic and intimate Southern Sung landscapes of Ma Yuan and Hsia Kuei, a Sung pot seems to have been made by a spirit working with the spontaneity of nature herself. The potter who made a Sung vase or bowl seems to have become the clay, the fire of the kiln, and the potter's wheel, and yet expressed his own self through his hands on the wet spinning clay. But this self was the principle of nature working through him as well as the past of Chinese civilization.

It was these qualities that led the English potter Bernard Leach to adopt the Sung aesthetic as the standard for contemporary pottery. Leach became the most influential and verbal of the earlier studio potters of the twentieth century. For him the pottery of the Sung dynasty (960–1279) represented the highest attainment in ceramic history. Leach felt that Sung pots were "born, not made." They were organic, and had a quality of life that can be explained only in part by the ways the potters used their clay and glazes. The potters did not have full control over the glaze patterns; they were partly products of a natural process, the melting of the ground-rock glaze by the Tao of the kiln.

Most Sung pots were made for a particular use. For the Sung potters and for Bernard Leach, a good pot is both useful and beautiful. A good pot expresses the fact that it is a pot, existing for and by itself in space, but meant for some use. It should express the nature of its materials, clay and glaze, and the technique of throwing on a wheel. This was the pottery aesthetic that many American studio

potters absorbed during the 1940s and 1950s, largely from Leach although there were a few American studio potters working during the 1930s, such as Glen Lukens and Henry V. Poor. And, of course, Charles F. Binns, also influenced by Chinese ceramics, had been making stoneware since the early part of the century.

A functional pot can have an enormous amount of life in its form and glaze pattern. Minute differences in form, in the fingermade spiraling ribs that record the act of pottery creation, can give the form life or kill it. This perfection of form is not a matter of design, but rather of creating with the hands and with the wheel a work of beauty and utility. Wet clay is flexible enough to allow the potter to express, perhaps without knowing, the subtlest of spontaneous impulses that modify his image of traditional forms. In many ways the making and appreciation of this art requires more subtle perception than painting or sculpture.

But for many American potters the Sung aesthetic did not fit. Our urban culture did not encourage or support a total commitment to the anonymity of functional pottery. Western artists still carry much of the Renaissance negation of clay as a medium of artistic expression, and, in accord with the Western tendency for dichotomous ordering of experience, still tend to separate "fine art" from "minor art." In addition, Americans are not as bound to traditions as the Orientals. Once one has gotten the feeling of the clay, preconceived notions of "good" or traditional form can get in the way of spontaneous creation, of letting the material itself and the potter's ideas of form arising, partly unconsciously, during the act of throwing, determine the final form. Since most American studio potters were trained in art schools, they were aware of the attitude currents of contemporary painting and sculpture. Perhaps they first turned to functional pottery partly from a psychological urge to produce something useful for the public, to become involved as artists in the culture. Unfortunately, at least for those who like to eat and drink from plates, bowls, cups, and pitchers that approach works of art, too few of them could make a living by their pottery alone. They had to teach to maintain themselves and their freedom as studio potters.

Many American potters wanted to do something to the traditional pot to raise it above the level of craftsmanship. Peter Voulkos broke with traditional functional pottery and during the middle and late 1950s began making ceramic assemblages. David Weinrib went into more architectural slab constructions. A pot may, however, rise above tradition without departing radically from familiar shapes by its slight irregularities in form. Toshiko Takaezu made slight changes and additions to a wheel-thrown pot without departing radically from traditional forms. In fact, the piece shown seems to have something of the spirit of Mu-ch'i's

57. Peter Voulkos: Bowl, stoneware. Los Angeles, 1956. H. 4¹⁵⁄₁₆″ (12.5 cm). Collection Fred and Mary Marer, Los Angeles. Photograph: Paul Soldner.

famous *Persimmons*. Some younger potters have attempted expressive brushwork and amorphous but suggestive forms and others decorated plates with a kind of generalized calligraphy. The fusion of both painting and sculpture in ceramics, characteristic of many American potters, is seen clearly in the ceramic wall reliefs of John Mason, which are assemblages of thrown shapes, coils, strips, and slabs.

Most American studio potters were interested in sculpture rather than painting. They were searching for new forms, developed from the pottery processes of wheel-throwing, hand or slab-building, that were more personally expressive. The techniques of working with clay offer a much greater opportunity for the expression of momentary and unpremeditated ideas of form arising during the act of creation than conventional methods of modeling and casting in bronze, stone, and wood. Functional pottery proved to be too restricting and inhibiting for Peter Voulkos and others, as the medium of lost-wax casting in bronze proved too inhibiting for Ibram Lassaw and other metal sculptors. After absorbing the influences of oriental ceramics, Picasso, the ceramic sculpture of Miró and Arti-

58. David Weinrib: Slab pot, stoneware, unglazed outside, glazed inside. New York, 1957. H. 9½″ (24.1 cm). Collection Everson Museum of Art, Syracuse, New York. Photograph: Garth Clark.

gas, the work of contemporary metal sculptors like David Smith, New York Abstract Expressionism, and finally, perhaps, the ideas of collage and assemblage, Voulkos moved into sculpture during the middle 1950s to become one of the leaders of the recent movement toward expressionism in clay.

In Voulkos's sculpture of the middle and late 1950s one can see practically all of the qualities and attitudes that are typical of the sculpture of other American studio potters. Voulkos tends to work without a preconceived image, and his works were formed by ideas released in the process of creating. The finished work is expressive of the act of creation and generally has no concrete symbolic significance as a total form, although its individual parts may have a vague or specific felt meaning. This common attitude of painters and sculptors—the gospel according to the act—grew from the liberating method of Dada and Surrealism, which trusted the impulses of the "unconscious" to produce something of interest in the concrete act. It was reinforced by the immediacy of Zen brushwork. Existentialism may have reinforced the attitude, but it did not affirm

59. Win Ng: *Directions*, glazed
stoneware, gray, white, and brown with
orange streaks. San Francisco, 1960.
H. 35⁷⁄₁₆″ (90 cm). Collection
Everson Museum of Art, Syracuse,
New York. Photograph: Courtesy
Everson Museum of Art.

the mystery of finding an image of all life and of oneself in the momentary act.
The Zen doctrine of complete enlightenment or identity to be found in almost
any concrete experience, where the life of nature is revealed in oneself and one-
self is revealed through nature, was much more exciting.

But Zen was not totally accepted because most American artists are against
doctrines, although it was felt to offer attitudes that are missing in the overintel-
lectualized Western tradition. Except for Mark Tobey, Morris Graves, and Ibram
Lassaw, few advanced American artists fully understand and live within a unified
belief system. Zen is perhaps more popular among potters, in spite of the fact
that nearly all studio potters are academic teachers, than with painters because
the whole Far Eastern influence is much stronger in American pottery than in
painting. The attitudes of the Abstract Expressionists of the New York School
were not inspired by Wang Hsia and other "ink-flingers" of the Chinese T'ang
dynasty (618–907) who splashed ink onto the painting surface or painted in

other violent and unorthodox ways, nor by the impassioned brushwork of Shih K'o or Liang K'ai. Some of our potters have carried Zen expression in pottery beyond the somber, rough Japanese Bizen, Seto, and Shigaraki pottery, as painters have gone far beyond the most abstract landscapes of Sesshu. The affirmation of the unfinished state and of textural roughness by American potters is also part of the broader attitudes of painters and sculptors who leave the surfaces of their works ragged, sharp, rough, heavy-textured, or even sloppy.

In accord with this attitude, painters, sculptors, and potters value a work that expresses the process of painting, the process of working with molten metal, and the process of potting. A functional pot in the Sung tradition expresses, to some extent, in its form and in its fingermade lines, the process of wheel throwing. The more unfinished and cruder pots of Japanese Bizen and Shigaraki, highly valued by the Zen tea masters, are even more expressive of this process. But these pots were made by anonymous folk potters working under conditions of mass production. It is true, however, that in Japan, since the sixteenth century, the individuality of the potter has played an important role in the creation and appreciation of ceramics, and a work by Chijiro (1516–1592) or the first Kenzan (1664–1743) is highly valued because it has a great name attached to it. The individuality of these Japanese potters and the value placed on their work raised them to the status held by poets and painters, something unknown in Sung China. The work of the Japanese master did not, of course, evolve into abstract sculpture. Semiabstract and abstract ceramic sculpture was to be found only in primitive cultures until the modern work of Miró and Artigas and that of the contemporary Americans.

After experiencing some degree of perfection in more finished Sung-type pottery, many American potters seemed to want to express process even more than the Japanese. This is quite true of the work of the younger potters, and the process is certainly not limited to wheel throwing, but extends to slab-building and hand-forming methods. The slab-built sculpture by Win Ng is a successful expression of a slab-built form and in its architectural construction and subtle asymmetry vaguely echoes early Japanese Jomon ware. It is like a primitive hut, raised off the ground by successive layers of slabs, similar to the Chinese clay models of the Han tower house. The long wormlike sculptural piece of Clayton Bailey grew out of the simple hand-formed bowl, the traditional Japanese raku tea bowl. In squeezing the clay between his fingers while rapidly forming a bowl, he discovered that the clay that is pushed up between the two fingers could be left as a sort of "flying buttress" and might have a structural function as well as a decorative one. The "flying buttress" tea bowl gradually evolved into a more elongated wormlike form, with ribs of hand-formed buttresses every few inches.

It is more expressive of the hand-forming process than the Japanese tea bowl.

A large sculptural piece by Peter Voulkos is expressive of the throwing process, the slab-building process, the process of modeling with the hands or tools, and the process of simply picking up bits of scrap clay and sticking them on. Voulkos's sculpture expresses more than the process that gave it life. He juxtaposes architectural forms and organic forms that evoke more specific images with the amorphous shapes common to both nongeometric, abstract sculpture and Abstract Expressionist painting. His forms always have a primitive vitality and often hark back to the solemn and playful muses of primitive sculpture, representing creatureliness in the abstract. They are usually large, massive composites of several wheel-thrown forms and slab-built forms, sometimes pushed into shape by the hand or tool. Voulkos's way of working has much in common with the basic method of collage and assemblage. Plant and animallike forms are juxtaposed almost randomly and combined with square-shaped, or ambiguous slab and strip forms. By working without a preconceived image and by executing ideas as they arise during the process of creating, an assemblage is created out of the partly accidental fusion and contradiction of separate forms. The method of assemblage can provide a broader range of expression and can suggest a greater range of associations than more conventional sculptural forms by sacrificing older notions of unity.

Not all of Voulkos's assemblages are complex. Some are much simpler, smaller, and perhaps more successful. He does not always use aggressive animallike forms, for some of his sculptures are constructed more homogeneously as rocklike forms. Almost all have an element of playfulness and humor. Many are massive, somewhat immobile forms. They express the energy of mass, but hardly lightness. Even though clay is flexible in the forms it can take, it cannot be put together in very slender pieces as some metals can, especially if the clay construction is large. It is difficult to create space within the parts of a clay construction. Perhaps one of the reasons Peter Voulkos has recently been working in bronze, cast and then assembled with much the same spontaneity as his clay sculpture, but with greater freedom, is his respect for the limitations of clay.

Other ceramic sculptors such as Daniel Rhodes, Robert Sperry, and Clayton Bailey keep their forms relatively simple, more unified, accepting the limitations of clay. The sculpture of Rhodes is rich in texture and plantlike in an abstract way, while the attraction of animallike forms can be seen in the work of Robert Sperry and Clayton Bailey. Some of Sperry's sculptures are like totems and seem endowed with a ritualistic or magical significance.

Bailey's assemblages of "critters" are "Coonskin" beings that rise to an

60. Peter Voulkos: Untitled stoneware. Berkeley, California, 1957. *151*
H. 62" (1.55 m). Photograph: Courtesy Quay Gallery, San Francisco, California.

imaginative level from Southern Highland salt-glazed jugs. His creatures "snort" through their ceramic noses and twang like a mountaineer mouth-bow, while his blatting ceramic horns actually perform in music sessions. The appendages on these creatures—noses, mouths, breasts, and penises—all belong to Dada. They are heavy, but not as solemn as most primitive images, and are invitations to the joyous drum beat. Like the metal sculptors, Lipton and Roszak, Bailey and other ceramic sculptors invent new organic forms that are expressive of man's identification with nature, and of the fear, playfulness, sexuality, and aggression of all creatures. The sculpture of Clayton Bailey is in tune with the witty and playful side of primitive sculpture and Dada, and his forms are expressive of clay—of a twanging humor—and a childlike looseness uncommon among contemporary painters. The sculptor may find himself in nature and nature in himself through his own inventions.

Abstract Expressionist Ceramics

John Coplans

"In modern art all conventions including this hierarchy of media have been under attack. What distinguishes a work of art from that of craft is qualitative. A work of art is not concerned with the utilitarian, the rational, and the logical. Its purpose is expressive, that is, to aim new questions about the nature of existence. In short, it is concerned with the aesthetic experience in its purest form."

The American John Coplans is one of the foremost critics on contemporary art and, until recently, editor of *Artforum*. His essay "Abstract Expressionist Ceramics" is taken from the catalogue of the exhibition of the same name at the Art Gallery, University of California, Irvine (October 28–November 27, 1966), and The San Francisco Museum of Art (January 11–February 12, 1967). During the 1960s, Coplans was a keen and intuitive observer of the emerging genre of ceramic sculpture. In his writing for *Artforum*, he strongly supported the work in clay by artists out of the "Otis" school, as well as the second generation that grew out of Berkeley, where Voulkos moved in 1958.

Abstract Expressionist Ceramics

Quite neglected in most accounts of the development of recent West Coast art is the brief period during the middle 1950s (roughly from 1954, when Peter Voulkos arrived in Los Angeles, to 1958) when a group of some of the most talented and inventive artists in California shared an intense involvement in ceramics. The brilliant body of work produced during this period has remained

relatively little known, although it contains the germinal elements of the mature styles of many well-known West Coast artists. It also produced a considerably far-reaching revolution in ceramics itself and constituted the most ingenious regional adaptation of the spirit of Abstract Expressionism that has yet emerged. Undoubtedly, what has prevented this work from receiving its proper due hitherto has been the hangover of an outmoded conception of ceramics as a minor art at best, a mere "craft" at least. That Voulkos, Price, Mason, Bengston, and their associates should have fed into this medium some of their most original ideas and should have, in the process, elevated the medium itself to a new stature was a possibility simply too unlikely to be given serious consideration.

Peter Voulkos's reputation as a ceramicist of some importance preceded him to Los Angeles.[1] His presence attracted several other ceramicists, notably John Mason, Billy Al Bengston, and Kenneth Price, all of whom linked up with him. Mason, the eldest, was a contemporary of Voulkos and already a skilled ceramicist. Bengston and Price, although younger, were also considerably skilled in the medium.[2] Both were studying at Los Angeles City College and, when Voulkos joined the faculty at Otis Art Institute to start a ceramic center, they decided to join him. In speaking of those days, Bengston has remarked, ". . . we stood in awe and admiration of Voulkos's extraordinary capacity to handle clay. He was also technically superior to anyone at that time and probably still is today. He has a quite incredible touch. Something that others have to work extremely hard to obtain, he had naturally." Price adds, ". . . it was the revelation of our lives to see how Voulkos worked. He is capable of the most intense economy of energy for the amount of time he spends on a work. Yet he does more work and spends more energy than anyone else. Voulkos is capable of an almost inhuman capacity—he made fifteen pieces to everyone else's one." As a consequence of Voulkos's vitality, there developed an extremely competitive spirit. They began to regard themselves, not so much as a group with a common program, but as individual contestants. Ceramics, it should be remembered, are made in kiln loads, and the production of quantities is common. But in those years, suffused with this new spirit (and reinforced by the ideal climate of southern California), they often worked fourteen hours a day, seven days a week, making as many as a hundred pots a day. Attracted by what was going on, other

[1] Voulkos originated from Montana. He took his M.F.A. in ceramics at the California College of Arts and Crafts, returning thereafter to Montana to teach at the Archie Bray Foundation.

[2] Bengston began making ceramics in 1945 as a student at the Manual Arts High School, Los Angeles. The art department at the time taught painting and sculpture and had a life class, the students drawing from a nude female model. Included in the curriculum were ceramics, printing, bookbinding, metalworking, etc. Jackson Pollock and Philip Guston both started their careers at this school.

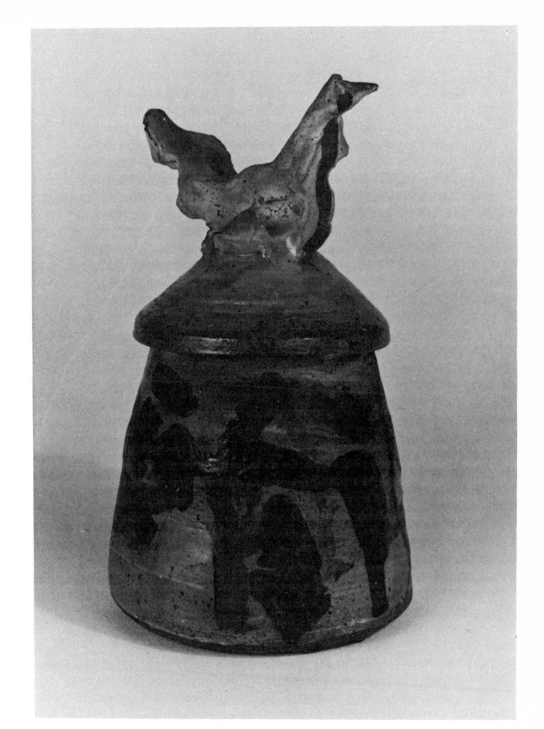

61. Peter Voulkos: Gray, green, and brown glazed stoneware. Los Angeles, 1957. H. 11⁷⁄₁₆" (29 cm). Collection Fred and Mary Marer, Los Angeles. Photograph: Paul Soldner.

ceramicists of a kindred spirit soon filtered in; for example, Malcolm McClain, Michael Frimkess, and later Henry Takemoto.

Despite Voulkos's position on the faculty at Otis, he never placed any distance between himself and his younger colleagues. He continuously worked side by side with them and, as a consequence, there was always a considerable exchange of ideas. In a similar manner to the Club in New York, but without the same aura of self-consciousness, ceramics began to draw artists of a kindred spirit together in Los Angeles. Everyone was interested in what was going on, including many painters. Craig Kauffman and Robert Irwin, for example, as a mark of their interest, each entitled a painting *Black Raku* after the Japanese ceremonial tea bowls. Price made and began to give away his coffee cups as a token of camaraderie to sympathetic artists.[3] Strictly utilitarian, each piece is highly individual; they are the prized possessions of many artists in California, who use them daily.

Given the emergence of a distinctly American style of painting, the minds of these ceramicists were freed of anxiety about the future. They were aware of what was going on in the art world outside Los Angeles, particularly in New York and San Francisco.[4] What they needed was time to mature as artists, to seek their own path free of external pressures. The pot, they felt, was no more than an idiom and could lead in any direction. They were uninterested in exhibiting and, apart from Fred Marer (who very early on began to collect their work) and Rose Slivka of *Craft Horizons*,[5] no one in the official art world (as distinct from the craft world) was either interested or quite knew what they were up to.[6] This suited their purpose at the time. Given, however, the quite revolutionary ceramics produced over these years, the arbitrary consignment of the ceramic medium to what they considered to be a twilight world, that of the crafts, later caused them considerable misgivings, and even anguish.

[3] Bengston was the first to use this form. Nagle's cups, which derive from Price, are non-utilitarian.

[4] Apart from the fact that there was considerable traffic between San Francisco and Los Angeles (Bengston, for example, studied painting under Diebenkorn in 1955 at Oakland College of Arts and Crafts), Voulkos made frequent trips to New York.

[5] *Craft Horizons* was one of the most adventurous magazines in the United States. It followed with great insight and knowledge the development of ceramics in California. A special issue in 1956 was devoted to California, and as early as 1961 it published a heavily illustrated article written by Rose Slivka on the ceramic sculpture, linking the new approach to Abstract Expressionism.

[6] The situation is aggravated by the fact that The Museum of Modern Art in New York, an extremely influential institution, apart from showing painting and sculpture, also exhibits architecture, photography and commercially designed objects. It will show a teapot as an example of fine design, but following earlier guidelines, nothing that fits into the category of the crafts. This is left to the Museum of Contemporary Crafts. Thus The Museum of Modern Art perpetuates the distinction between art and craft, but allows commercial design into an institution devoted to high art.

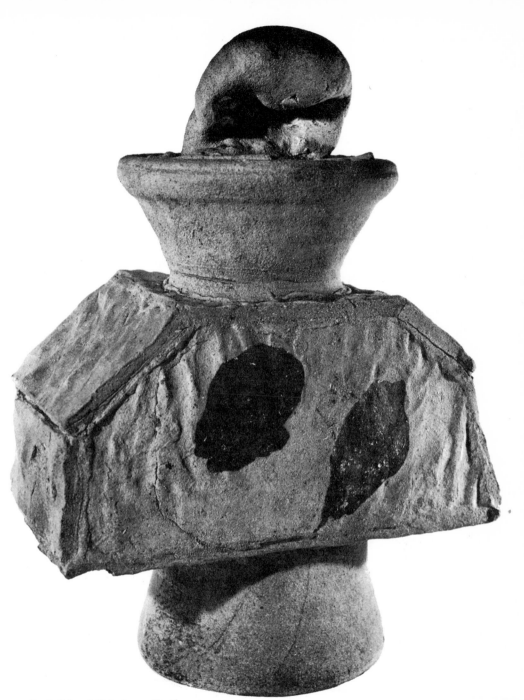

62. Michael Frimkess: Earthenware pot.
Los Angeles, 1959. H. 19⁵⁄₁₆″ (49 cm).
Collection Fred and Mary Marer, Los Angeles.
Photograph: Frank J. Thomas.

In the history of Western art, the artist has continuously struggled to divest his activities of the tainted aura of craftsmanship and the implications of being a hired hand. What he wanted and did get was intellectual and social equality within the liberal arts. Distinguishing himself by the use of certain media (for example, oil paint, bronze, and marble), he left the employment of what was considered to be the inferior media to mechanics or craftsmen. Ceramics was one of these. The artist could use any of the minor media, including ceramics, but only for the purpose of the sketch.[7] Out of this approach arose the distinction between the "fine" and the "decorative" arts.

In modern art all conventions including this hierarchy of media have been under constant attack. What distinguishes a work of art from that of craft is qualitative. A work of art is not concerned with the utilitarian, the rational, and the logical. Its purpose is expressive, that is, to aim new questions about the nature of existence. In short, it is concerned with the aesthetic experience in its purest form. To this it should be added that one of the most important qualities that distinctly separates American painting from much of pre–World War II European art is the question of aesthetic purity. Issues concerning integration with other disciplines—for example, the integration of art and science or of art and architecture—are completely antithetical to the spirit established by the Abstract Expressionist outlook.

Since medieval times Europe can hardly be conceived of as a ceramic culture, especially in comparison to China, Korea, and Japan. Despite the admiration for many of the wares from those countries and their massive importation during the sixteenth and seventeenth centuries, until recently the basis of European art has been deeply iconographic. As Sir Herbert Read has pointed out,

> . . . pottery is at once the simplest and the most difficult of all the arts. It is the simplest because it is the most elemental; it is the most difficult because it is the most abstract. Pottery is pure art; it is freed from any imitative intention . . . Sculpture, to which it is most nearly related, had from the very first an imitative intention and is perhaps to that extent less free for the expression of the will to form than pottery; pottery is plastic art in its most abstract essence.[8]

The task these ceramicists set themselves was to rediscover the essential characteristics of the medium. Obviously their first step was to free themselves of all dogma and convention. It is true that their earliest work was often extremely eclectic, but they felt the need to know the past before they could break

[7] Reuben Nakian's ceramics, for example, follow these guidelines. All of his major work is in metal.

[8] Sir Herbert Read, *The Meaning of Art* (New York: Pitman, 1951), p. 41.

away from it. There were few ceramics of any importance to be seen in Los Angeles; reproductions from books served as their museum. The photograph is notorious for blurring and distorting scale, and as a result, very often a shape based on some prototype from the past was blown up to an enormous size. Although they admired Bernard Leach, they felt out of sympathy with his quasi-oriental outlook and approach. They did not want to reconstruct oriental ceramics but to create a viable approach of their own. It is true that the new and original was more admired in Japanese art than in the Chinese or the Korean, and that from the seventeenth century onward Japanese ceramics had continuously demonstrated artistic daring, ingenuity, and invention. But at the basis of the Japanese aesthetic was the notion of ". . . utility as the first principle of beauty."[9] The rejection of this tradition led to a major breakthrough.

The fact that a pot need no longer act as a *vessel* assumed great significance. Being wheel-thrown, pottery is invariably symmetrical and although the Japanese raku tea bowl, for example, is much admired for its imperfection of shape—its lack of perfect symmetry—nevertheless it is basically circular, and as such, symmetrical. Voulkos and Mason began to punch and squash forms into shapes that minimized symmetry and equilibrium. One of Mason's vases, for example, is triangular, and by using a highly organic glaze and surface treatment, each facet when viewed from a different angle presents a totally dissimilar appearance. Clay is a highly fluid and malleable material with a life of its own. Sensing the form-expressed emotion that lay at the heart of Abstract Expressionism, these ceramicists began to exploit shape and surface for its expressive potential. A free rein was allowed for imperfections arising from the natural limitations of the material. Inextricably interwoven, shape, surface, and coloration took on a highly organic quality.

The temperament of each artist soon began to play a more assertive role. Price began to explore deeply a limited range of forms and was always concerned with the linear edge formed by the outside of a pot or plate. The relationship, for example, of a plate to the supporting edge of the surface was a matter of importance to him, particularly the manner in which the negative space was formed. As a consequence of this approach, his work became increasingly considered and reductive. In contrast, Voulkos's ceramics began to assume all the qualities of an explosive release and although completely abstract they began to reveal strong anthropomorphic overtones. Mason's work, however small, gave the impression of massiveness and weight. Not only highly inventive, but extremely vigorous in conception and execution, the work of all these artists began to owe little to

[9] Soetsu Yanagi, quoted by Bernard Leach, A *Potter's Book* (London: Faber & Faber, 1940), p. 8.

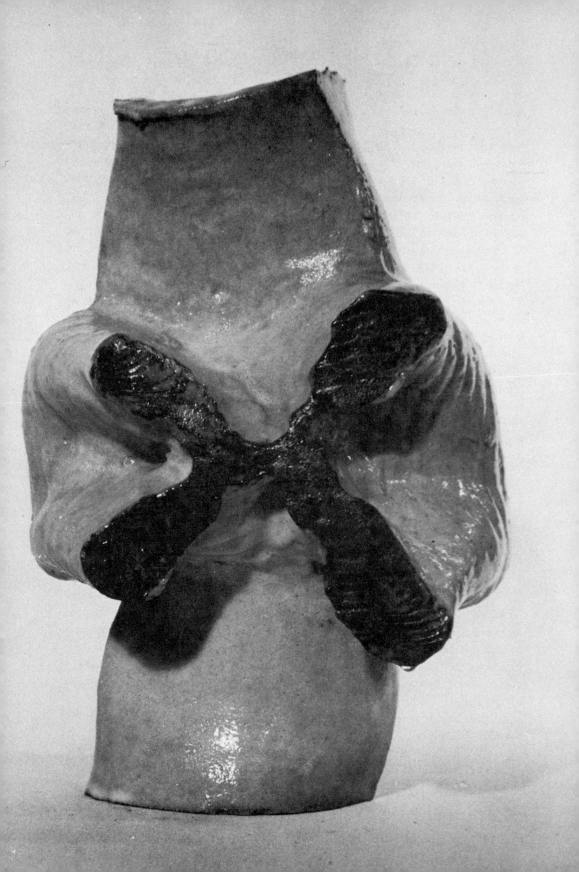

the past. Each step made not only fortified their confidence but opened up, with increasing rapidity, new avenues to be explored. Probably the most decisive shift by Voulkos was in constructing wares of multipart form. Dependence on the repertoire of shapes inherited from functional vessels ceased, synthetic forms could henceforth be created. Although it took time to exploit this idea, it nevertheless inevitably led toward a more sculptural concept. Another important move by Voulkos was the use of epoxies for joining parts together; this was followed by the employment of epoxy paints side by side with glazes. In this manner the aesthetic concept of "truth to materials" was abandoned and by this use the way opened for the development of polychrome sculpture on the West Coast.

In 1957 Bengston decided to abandon ceramics for painting. Voulkos, Mason, and Price began to move very heavily into sculpture. Voulkos and Mason continued to make ceramics side by side with their sculpture, and do so to this day, while Price continues to make cups. Although McClain was basically interested in the pot form, he made a few ceramic sculptures, as did Frimkess, who is currently backtracking in his involvement with classical and archaic thrown shapes. In 1959 Voulkos moved to the University of California at Berkeley; it was there that James Melchert and Ron Nagle came under his influence. Melchert's *Legpot* (1962) with its low center of gravity is probably his most important early ceramic work. Evolving from this piece were a number of mixed-media sculptures, to be followed later by a series of polychrome ceramics with an iconography overtly derived from aspects of Pop art. Manuel Neri, who is also from northern California, is better known as a sculptor. An old friend of Voulkos, he has long had an interest in ceramics but worked in the medium only sporadically. Nagle's pots are extremely small in scale and a reminder of his admiration for Morandi. He uses very simple and direct techniques in constructing all his works, some of the parts of which are thrown. In contrast to the Japanese raku tea bowls, which are dumpy and with a great weight of material compressed into the form, Nagle's look extremely delicate, light, and sensuous.

In 1958 the shift into sculpture began. The faceted Cubist structure of Wotruba's sculpture was to provide Voulkos with a clue to the manner in which he could maintain the highly spontaneous character of his art, yet work at a massive scale. He began to pile thrown cylinders of clay in an extremely capricious and daring manner. Time after time these mountainous structures of clay would collapse, and very few works were produced despite prodigious labor on his part. By constantly repeated efforts he eventually obtained mastery over the material and produced a number of large sculptures that survived the eventual firing process. Clay began to have emotional limitations for him and, drawing upon his youthful experience as a foundryman, he switched to the use of

63. John Mason: Vase, gray and brown stoneware.
Los Angeles, 1957. H. 11¹³⁄₁₆″ (30 cm). Collection the
artist. Photograph: Frank J. Thomas.

64. James Melchert: *Plate with Muffin Tin*.
San Francisco, 1963. H. 23⅝″ (60 cm).
Collection Professor and Mrs. R. Joseph Monsen,
Seattle, Washington.

bronze. Mason overcame the technical difficulties of making large sculptures of clay by collaging skins of clay one over the other. All of his sculpture aspires toward the monumental; as early as 1958 he made a number of large ceramic wall reliefs. The small clusters of seeds or pods that decorated Price's pots led him into his later typical biomorphic polychrome sculptures.

The peak of the ceramic development was undoubtedly between the years 1956 and 1958. During this period grew the first radical movement to revolutionize totally the whole approach to ceramics. What was done in those days is now mainstream ceramics.

A Decade of Ceramic Art: 1962–1972, from the collection of Professor and Mrs. R. Joseph Monsen

Suzanne Foley

"At a time in our society of groping for larger purposes or of despair in not being able to define them relevantly, it is evident in areas broader than art expression that statements about immediate experience, reactions to the moment and the momentary, are those that have the most significance. The expansion of work in ceramic art and the variety of subject matter treated can be attributed in large part to the immediacy and intimacy of clay as a medium."

The exhibition "A Decade of Ceramic Art," held at The San Francisco Museum of Art (October 14–September 3, 1972), produced a reflective mood in American ceramics, on the one hand confirming a period of vitality and growth, and on the other generating concerns for identity within the growing plurality of art in the 1970s. The catalogue essay by the exhibition curator Suzanne Foley deals with the development of ceramic expression over a decade through the objects in the collection of Professor and Mrs. R. Joseph Monsen of Seattle.

A Decade of Ceramic Art: 1962–1972

In the past ten years the scope of ceramic art in America has broadened into a variety of new areas of expression and distinct bodies of work are being produced. Activity on the West Coast in two decades has defined influential developments and is a pacesetter in new directions. As with art in general, today the coin has turned from consideration of a medium as an artist's vehicle of expression to the artist as promulgator of his ideas through the media that best convey them. Clay has been used by artists of differing motivations, those with painting and sculpture considerations as well as those in the craft tradition. In the Surrealist-oriented Western world the presence of an object made of clay is quite different from the oriental Tao, the spirit of the object, or from a Zen oneness with nature. The object here is important in its gestalt, its presence. It is what it is. With its unique characteristics and limitations, its plasticity and variability, clay primordially has lent itself to object-making. It is the both/and quality of clay objects that has characterized the most innovative work today; the integration of both the three-dimensional considerations of mass that sculpture offers and the anonymous surface to be painted that painting, design, and color focus on. The resulting objects maintain their being in a world of objects, participating in situations or experiences.

In the early 1950s, potters in this country were increasingly involved in the Oriental tradition of ceramics through the writings and lecture tours of the English potter Bernard Leach and his mentor Hamada, the prominent Japanese folk potter. Working at the potter's wheel in a stoneware clay body, the craftsman aimed at producing with the greatest skill at his command a handsome form to function as vase, pot, or plate. The clay material and the potter were true to each other, and the finished vessel reflected this communion. The finger ridges circling the pot were evidence of the pot's growth on the wheel. The glazes for this high-fire ware produced muted colors with interesting textures created by running colors or metallic oxides. This adopted craft tradition was promulgated through the American Craftsmen's Council in conferences and its magazine, *Craft Horizons*. Its effects could be measured in competitive exhibitions throughout the United States, especially in the Syracuse Ceramic National, the most prominent and prestigious of these. Most of the outstanding ceramic craftsmen were working as studio potters often involved in workshop programs while a few taught at art schools or universities.

Changes, like chemical reactions, come about with catalysts or in catalytic environments. The place was Los Angeles and the catalyst Peter Voulkos, who in

1954 came from the Archie Bray Foundation in Helena, Montana, where he had worked in production pottery to establish a ceramics department at the Los Angeles County Art Institute. His reputation as a potter who had captured prize after prize in ceramic exhibitions preceded him. Dynamic activity, generated by Voulkos and the people who studied and worked with him, ensued. John Mason, Paul Soldner, Malcolm McClain, Billy Al Bengston, Kenneth Price, Michael Frimkess, and Henry Takemoto used up tons of clay as they worked long hours in the five years Voulkos was in Los Angeles. Voulkos found that the Abstract Expressionist painting and sculpture exhibited in Los Angeles galleries and museums reflected his innate sensibilities. The gesture, a physical record of the process of creation, as well as the compositional unity from dissonance, found direct application in clay. In addition to the current painting and sculpture, the ceramics of Picasso and those made by Miró with Artigas were influential through their directness—allied to primitive expression. The Surrealist-derived images used in their decorations were free and spontaneous.

In 1961 Rose Slivka's article "The New Ceramic Presence," in *Craft Horizons*,[1] defined with great perception this exciting and obviously controversial new direction in ceramic art. The form of a pot was no longer unified in its aim to determine the function. Pots and vessels of large scale, some five and six feet high, were thrown and manipulated, rent or patched, assembled or broken apart, and hand-built from slab and thrown pieces. Individuality of expression and uniqueness characterized these cups, pots, and plates and Peter Voulkos's production was a challenge stimulating the artists working around him. Their attitude toward color and decoration was another radical contribution to work in clay. Color was as much an element as clay in defining or defying surface and form. Bright colored, low-fire glazes or even acrylic paints were brushed across dissimilar surfaces, or in decoration on the surface they echoed a form such as a hole or gash that was present in the clay. The entity of the pot was alive with tensions created by the interaction of its color and shape. Formal concerns dealt with in this expression were quite apart from the concerns in the craft tradition. While most of the work created at this time had functional reference (cups, plates, vases, pots), when nonfunctional sculpture was produced, it was hardly noticed to be different. It was evident that this direction in ceramics had removed clay work from the craft tradition and set it on its own path.

Peter Voulkos's move to the University of California, Berkeley, in the summer of 1959 ended that concentrated period of group activity in Los Angeles. In Berkeley he continued for the next four years to make pots and plates, sharing

[1] Rose Slivka, "The New Ceramic Presence," *Craft Horizons* (July–August 1961), pp. 31–37.

with artists who had come to study with him his own special feelings about form and the material of clay. In clay he worked fast, intuitively, but many of his ideas about balance, especially cantilevering, went beyond the limitations of clay, and he began executing them in bronze. The work of other artists who had been in the Los Angeles group developed in various ways, some like Billy Al Bengston in other media entirely and others like John Mason still innovatively within the discipline of clay. Mason's stoneware pots were always more contained and full of latent energy than Voulkos's explosive forms and when they became sculpture, they were closest to the formal problems of mass and tension in stone sculpture than any other Los Angeles work in clay. Mason has continued to refine his sculptural form, from multiarmed totems, to cross or X-shapes, to large primary-color slab rectangles, minimal in overall shape but painterly in the sensuous, richly glazed surfaces.

The freedom of the new aesthetic in ceramics, called "Abstract Expressionist Ceramics" by John Coplans in a 1966 exhibition at University of California, Irvine,[2] had widespread impact that is still being felt in this country. Some artists like Rudy Autio, who had worked with Voulkos at the Archie Bray Foundation in Montana, responded intuitively. Autio's bold vessels balance thrown and hand-built forms in a bulging whole, or in a ponderous tower shape where he chooses a crisp geometric outline. In contrast to the brute force of weighty material that Autio's work presents, a fresh look at a classical attitude was reflected in the delicate pieces of Toshiko Takaezu. A refined spherical profile, the pot was gently slapped and distorted after being carefully thrown. Small pieces of clay were often dropped inside before the pot was sealed and assembled in multisphere pieces. These are the "spirit" of the pot that speak when it is shaken. Takaezu's glazes are subtly colored and controlled as they seem to cascade over the pot. Henry Takemoto's hand-built triangular vases on stems with Miróesque decoration have a bold organic quality that is shared in the work of Bruno LaVerdière. The two also threw pots of classical form that were decorated in a Japanese folk-pottery style with a bold overall design. Arabesques and dots recall the patterning of a Japanese rock garden.

Japanese ceramics have been of increasing interest to American craftsmen from the 1950s on. Ceramic ware holds an almost ritualistic place in Japanese life, in particular in the Zen tea ceremony where the irregularities or impurities of a tea bowl are savored for their character and distinctiveness. Pots from the sixteenth century, like Iga ware made in rural regions, have a boldness and directness that appealed to the American. The ancient process of raku interested

[2] "Abstract Expressionist Ceramics," Art Gallery, University of California, Irvine, October 28–November 27, 1966. Catalogue essay by John Coplans.

Paul Soldner, especially, and beginning in 1960 he worked with the technique, adapting it to his own aesthetic. The low-fire clay body is pulled red hot from the kiln and placed in a bucket of sawdust or leaves where the surface of the pot is smoked and stained. Then it is cooled quickly in water. Whether in traditional classic shapes or freely formed hand-built pieces, the prevailing aesthetic is one of rough crude ware. Dark matte glazes or glazes of volcanic crustiness contribute to the bold expressiveness of these pieces and result in richly textured surfaces.

An exhibition at The San Francisco Art Institute, "Work in Clay by Six Artists," in late 1962, most of which was shown in early 1963 at the J. Blumenfeld Gallery in New York as "New Images,"[3] indicated the kind of ideas generating in the Bay Area in the early 1960s. They basically were fed from the profusion of sculptural activity at that time. The choice of clay was just one choice of several for these artists. The sculptor Manuel Neri made lumpy arches of clay covered with the same bright, splashy reds, yellows, and pinks characteristic of the palettes of Elmer Bischoff and Joan Brown, colleagues at the Art Institute. James Melchert used clay, wood, and metal forms in large abstract organic sculpture. When his work was more tradition bound—plates, bottles, and platters—it invariably included an enigmatic touch of mixed media. He used silver lustre to make a bottle look wet, a lead inlay in a ceramic plate or a muffin tin glued to a plate; a ceramic box had a four-foot-long *Legpot* (1962) appended. Ron Nagle made thin, soft-colored cups, as well as roughly formed, pop-imagery tombstones. In the early 1960s Melchert and Nagle had visited Kenneth Price's studio in Los Angeles and had been greatly impressed by the bright colored, low-fire glazes this artist was using in his cups and ovoid-form pieces. Price had left Los Angeles and the Voulkos milieu in 1958 to attend Alfred University in New York, the prominent ceramic engineering school, where he learned a great deal about glazes. He returned to Los Angeles to work in his extremely individual and influential biomorphic forms in which intense color was a dominant expressive component. This use of color on clay work provided for the San Franciscans the same expressive means that their painter colleagues were involved with. They began working with low-fire earthenware (usually associated with dime-store and souvenir ceramics) because low-fire glazes give bright, primary colors. Each developed his vocabulary of painted and built imagery. Nagle continued to refine his cups, building from earthenware slabs the most delicate cup forms with pale

[3] John Coplans, "Work in Clay by Six Artists," San Francisco Art Institute (review), *Artforum* (February 1963), p. 46; M. C. Richards, "California Ceramics" (review), *Craft Horizons* (March–April 1963), p. 43.

65. Robert Arneson: A *Hollow Jesture*, earthenware.
Davis, California, 1971. H. 19⅞″ (50 cm). Collection
Professor and Mrs. R. Joseph Monsen, Seattle,
Washington. Photograph: Courtesy San Francisco
Museum of Modern Art.

66. Ken Vavrek: *Untitled Sculpture*, earthenware.
Philadelphia, 1970. H. 20³⁄₁₆″ (51.2 cm). Collection
Professor and Mrs. R. Joseph Monsen, Seattle,
Washington. Photograph: Courtesy San Francisco
Museum of Modern Art.

sensitive colors. Their preciousness was underlined by the wooden box with flocked vacuum-formed liner he prepared for each. These then became pieces "about cups: the spirit of cups, cups reincarnated, cups purified by removal of function."[4] Melchert's earlier use of disparately juxtaposed materials combined for formal reasons gave way to disparately juxtaposed themes or orders in a structural situation. The "ghost ware" series developed an iconography of recalled images—*tread carefully among the ghosts from the past*—involving an ascetic, pale head in a context of formed or painted-on Mickey Mouse ears, Benday dots, stripes, parts of words, or coded messages. The being of the object is its power to combine literary, symbolic allusions, and the reality of present experience, intellectual, and visceral reactions.

A similar intellectual quality was manifest in the New York painting attitude, Pop art, where the everyday image and experience were sanctified by fine art. It seemed a natural that the unsanctified art of ceramics would bring back the popular image. Especially if your name is Robert Arneson, and "one afternoon in early September of 1961 while demonstrating pottery techniques at the California State Fair along with Tony Prieto and Wayne Taylor, I threw a handsome, sturdy bottle about quart size and then carefully sealed it with a clay bottle cap and then stamped it NO RETURN. That's what it's really all about, isn't it!"[5] It is in attitude that Arneson's work has made its mark and had its influence. His art manifests preoccupation with ideas: objects as ideas. The ideas may reflect iconoclasm, the sacrosanct bathroom ceramic ware, proprieties of sex imagery, or nostalgia for the artifacts of our time, the ranch house, or "re-uttering" the art of another time, the Sung celadon, all with visual metaphor, pun, and an understated, well-turned phrase.

Arneson's six-packs and *7-Up* (count them) (1964) were hand-built out of stoneware, and the material in its forming took on equal aesthetic importance with the subject. The expressionistic handling of expressionless subject matter, with a twist of editorializing (the typewriter keys replaced by fingers), became the classic exemplar in ceramic sculpture of the newly popularized word, *Funk*, greatly generalizing its earlier meaning. If it was expressionistic and surreal—and offensive—it was Funk. When he turned to the theme of his Davis, California, ranch house on Alice Street, Arneson, the raconteur, put the material, now

[4] Alan R. Meisel, "Letter from San Francisco," *Craft Horizons* (March–April 1969), p. 43.

[5] Museum of Contemporary Crafts, New York, "Clayworks: 20 Americans," June 18–September 12, 1971. Letter from Robert Arneson to Paul Smith reproduced in the catalogue.

169

earthenware, to work for him. So his ideas have evolved; each piece, watercolor, painting, or ceramic, is an anecdote. The flowerpot series: what is more indigenous to ceramics than flowerpots? or bricks? In a work like *How to Make the Big Dish* (1967), a large plate painted with four-part instructions for throwing a dish on the potter's wheel, the how-to books plus the china-painting hobby are all mixed in with a very tongue-in-cheek set of instructions. Since Arneson considers the limits of his concern to be the history of ceramics and ceramic processes—*re-uttered,* a series of porcelain pieces with celadon glaze on the subject of *Art Works* (1969), almost Dadaesque in their iconoclasm, came as no transgression. Then plates modeled in perspective with meals or snacks half eaten (Oldenburg is a hard act to follow), resembling watercolors in three dimensions, are an enigma in what they are and what they appear to be. A larger-than-life-size series of self-portrait heads offers the epitome of presence in ceramic art.

Since the ideas of the artist are the dominating force over the materials he uses, the rules of the game are very open-ended. In fact, that is the only rule. Clay bodies have no hierarchies; a body is chosen to make an object from because of the working and aesthetic qualities it possesses; earthenwares, stonewares, and porcelains are used for varying effects. Forms are preconceived and arrived at by the method most appropriate to achieve them: earthenware is thrown, hand built, slab built, and slip cast; decoration is equally wide open: low-fire intense color glazes, metallic lustres (low-fire), ceramic decals (china decoration to souvenir in subject matter), underglaze paints, china paints (overglaze), celadon glaze, and even acrylic paint on the surface after all firings. In this same context, clay as a medium is often only one of the materials used to make the final object.

Poles of expression are evidenced in ceramic "idea" art. The storytelling objects illustrate characters or events in the artist's world of fact, dream, or fantasy. Prime among these is David Gilhooly's frog world. These are basically expressionistic in clay handling and color application. The other end of the spectrum reflects a "cooler," more anonymous clay handling, generally in a hard-edge form and color. This style provides a vehicle for nonobjective subject matter or symbolic assemblages of forms, most of which are derived from cartoon imagery or nostalgia for past art forms. Ralph Bacerra and Ken Vavrek make nonobjective forms while Howard Kottler evidences nostalgia for Art Deco and Clair Colquitt uses stylized comic-book imagery in pots and bowls.

The mythologies evolved by many artists are so delightful in conception—witty and satirical—and so loaded in meaning. David Gilhooly is virtually a bottomless resource as he looks at society via the animal world. His animals, be they wild boar or family dog, are all lovable in their life-size, almost human, presence, benevolently lying at one's feet. As revealer of the history of the frog

67. David Gilhooly: *Elephant Ottoman #2*, earthenware, vinyl. Davis, California, 1966. D. 20½″ (52 cm). Collection Professor and Mrs. R. Joseph Monsen, Seattle, Washington. Photograph: Schopplein Studios.

civilization, a parallel civilization to our own, Gilhooly began in prehistorical time with a journey to the center of the earth and has revived on subsequent pots and pedestals the histories of many prominent frog personalities. In his explorations of primitive frog culture, the *Honky Frog* series, he carves the artifact from a red clay log he has made, ultimately freeing the image within. These "represent a great enjoyment of 'primitive'. . . stuff, but more than just the object, the place of the object in the culture (ritual, life, ceremony, magic) of the makers, I especially like the view of these less technologically sophisticated peoples for Western man (us). The way he interprets and appreciates our culture—as badly as we interpret his. Though usually we're worse."[6] Clayton Bailey, who for many years peopled his shelves with critter-ware of great tactile and audial dimension, now has unearthed for civilization a major unknown in the skeleton of elusive Bigfoot. Maija Woof builds her world of reality from the animals of her fantasy —literally, for the animals function as parts of the total image. Chris Unterseher has memorialized in plaques or tableaux some of the more significant—or insignificant—moments of life and society, both from his own past, his love of surfing, and the lives of such institutions as Boy Scouts, automobile manufac-

[6] Letter from David Gilhooly to Hansen Fuller Gallery, San Francisco, undated.

68. Irv Tepper: *Lemon Meringue Sea*, earthenware. Seattle, Washington, 1971. L. 19⁵⁄₁₆″ (49 cm). Collection Professor and Mrs. R. Joseph Monsen, Seattle, Washington. Photograph: Dudley, Hardin and Yang. Courtesy San Francisco Museum of Modern Art.

69. Richard Shaw: *Duck Teapot*, earthenware. San Francisco, California, 1967. H. 7⅞″ (20 cm). Collection Professor and Mrs. R. Joseph Monsen, Seattle, Washington. Photograph: Dudley, Hardin and Yang. Courtesy San Francisco Museum of Modern Art.

turing, all explicitly documented in pressed-in and written letters on the pieces.

Many of the objects have a surreal overtone in the puns that they demonstrate or in the puns that they are! Irv Tepper, whose obsession with food offers little plastic people (from HO gauge railroad-land) the crests of meringue pie topping to surf in *Lemon Meringue Sea* (1971). Peter VandenBerge's larger-than-life-size vegetables become baroque objects unto themselves, and along with Richard Shaw's painted armchair, Sandy Shannonhouse's porcelain dish of petit fours, and Marilyn Levine's ceramic leather bags are an enigma of soft things made hard, and for the latter two in fool-the-eye realism. Jack Earl's puns on rococo objets d'art show in meticulous detail the most incongruous images. Also surreal in juxtaposition of elements or their context are works like Howard Kottler's plates with altered decals of famous paintings, Richard Shaw's *Duck Teapot* (1967), Victor Cicansky's shoe decanter, Clayton Bailey's self-portrait pitcher (Toby jug?). The cup form itself has provided many ceramic artists a basis for defying or obscuring its function ever since Kenneth Price made animal handles. So many of these pieces make tongue-in-cheek reference to the fads and fancies of production ceramic ware, where milk pitchers look like cows and whiskey comes in ceramic houses.

Functional ceramic ware itself provides subject matter or at least provides vehicles for formal expressions. The elements chosen for integration in these bowls, pots, and sculptured pieces come from easily read, popular sources, such as stylized comic-book imagery (rampant since the Peter Max era) or the nostalgia for styles of the recent past like Art Nouveau or Art Deco. This generalized vocabulary of stars, lips, stripes, and arabesques is selectively employed by each artist to develop his personal expression. Forms and colors for their very natures or for symbolic connotations are utilized in these intensely colored pieces, fabricated to appear like production ware, with little trace of the artist's hand evident. Howard Kottler calls it "Palace-Pottery," which he defines with the overview of artist, critic, and historian:

> 1. Clay ware which exemplifies the style of a nation, as opposed to folk pottery where the primary concern is aimed toward the production of utilitarian objects for daily use.
> 2. The stylistic singularities found in the palace ware of any given period are similar to other works of art produced at the same time in that area and national setting.
> 3. The absence of any regimentation imposed by function or utilitarianism with a shift to individual freedom of expression.
> 4. Ritual objects.

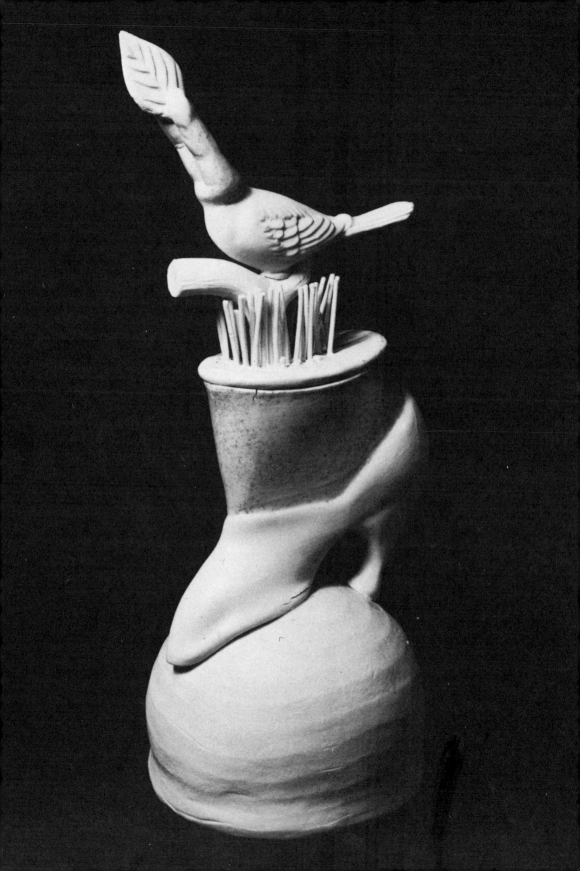

5. Experimental search in the development and extension of the possibilities of working with clay.

6. Objects that stimulate the intellect in places that stimulate the body.[7]

Radio City Pot (1967) or *Royal Paisley Pot* (1970) echo the Art Deco production ceramic ware of the 1930s, the most experimental ceramic work in its time. In his enjoyment of and preoccupation with these forms Kottler creates artifacts of our own time. The surface appeal of his pieces is highly tactile, with lustres and furs for eyes and fingers to caress. Patti Warashina Bauer's pots employ the decoration—a decaled egg in a bed of ceramic grass on the lid or steam zigzagging up the cover of a platter—as pun on the function of the piece with quite a surreal overtone. Clair Colquitt's bowls and vases mix metaphors by using lighthearted comic-book forms as handles and decoration on a pseudoclassic oriental vase form. More personal imagery is revealed in Jacquelyn Rice's fur-lined cave containing varied sizes of pyramids. Lucian Octavius Pompili's unglazed porcelain teapots and cups sprout leaves, branches, and hands in surreal implementation. Kenneth Vavrek's bullet-shaped sculpture is hardly sinister or phallic in its brightly colored and lustred monumental form. Pat McCormick's calligraphic descriptions in space with a monochromatic tube shape, and Ralph Bacerra's hard-edge designs in three dimensions are totally concerned with design and color elements in the clay medium.

In overview it is not hard to grasp why so many artists are working with such energy in ceramic art. At a time in our society of groping for larger purposes or of despair in not being able to define them relevantly, it is evident in areas broader than art expression that statements about immediate experience, reactions to the moment and the momentary, are those that have the most significance. The expansion of work in ceramic art and the variety of subject matter treated can be attributed in large part to the immediacy and intimacy of clay as a medium. Most of the objects make reference to specific situations or experiences. In their intimacy they often reveal profound statements through the metaphor of the familiar and recognizable. Even when there is formal reference to functional ware, bowls, casseroles, or cups, it too is a vehicle for the total statement and a participant in the metaphor. So that quality of seeing the general in the specific is the insight ceramic art contributes to today's artistic expression.

[7] Lee Nordness, *Objects: USA* (New York: The Viking Press, 1970), p. 118.

70. Lucian Octavius Pompili: *Cup with Lid*, porcelain. Davis, California, 1971. H. 8⅜" (21.2 cm). Collection Professor and Mrs. R. Joseph Monsen, Seattle, Washington. Photograph: Roger Gass. Courtesy San Francisco Museum of Modern Art.

The California
Clay Rush

Sandy Ballatore

"Shep and Sweet did away with the ceramic object. In its place one was treated to the spectacle of hundreds of pounds of clay and dirt drying, settling, and dissolving in water, as if to obliterate even the material possibility of ceramic sculpture once and for all. The aptness of their gestures for the future of ceramic art in California will remain to be seen."

Sandy Ballatore's essay, "California Clay Rush" (*Art in America*, July/August 1976), examines the position of ceramics on the West Coast as a regional art form. Terming it "as indigenous as the movies," she highlights the often contradictory ways in which the movement has evolved, illustrating both the aesthetic versatility of clay as well as the strikingly different sensibilities of the state's two great cities. She also introduces issues that did not surface in "A Decade of Ceramic Art": the growth of a process-art-oriented avant-garde and the growing interest of artists from other media in clay's expressive qualities. Sandy Ballatore is an art critic, a resident of Southern California, and an editor of *Artweek*.

The California Clay Rush

California ceramics, despite their abundance of Pop art rehashing, cornball belly laughs, and technical trickery, support a large and active network of dialogues among artists, involving material, tradition, culture, and self. It is a network lively with contrast and controversy. Most ceramic sculptors fall into one of two broad groups that might be roughly characterized as Southern California Formal

and San Francisco Funk, and there is an ongoing skirmish between high-art/ low-art factions at the putative boundaries of fine art and crafts.

The phenomenon as a whole can be generalized, however. It involves non-functional, nontraditional ceramic forms that have been spawned, nurtured, and exhibited in California beginning with the Abstract Expressionist period of the 1950s and continuing to the present. Originally, I had intended to discuss here only very new work, but the influence of Peter Voulkos, the acknowledged progenitor of California ceramics, still hangs heavy. Most new work still relates in some way to the energies Voulkos has radiated through twenty years in Los Angeles—and now in Berkeley. The lineage of a master and a few followers, begun in the 1950s, has become a family tree. Understanding requires an examination of the tree as well as of its fruit.

Clearly the soil and atmosphere of California have been nearly ideal for promoting the growth of the ceramics movement, and they help explain some of its peculiarities. The nourishing elements include the raw physicality of the natural environment and its proximity to daily-life activities, and a multicultural ambience that provides close contact with oriental ceramic traditions, Mexican folk art, American Indian pottery, Los Angeles Deco, and Tijuana junk. Also important for the artists is their distance, both physical and intellectual, from New York and its "mainstream" concerns. A strong pop-culture influence should also be mentioned. In this rich environment, quirkiness proliferates in the form of such "down-homeisms" as slapstick humor, *faux-naïf* absurdity, deliberate crudeness, flashy trompe-l'oeil, and rampant eclecticism. Finally, on a practical level, a taste for cooperative workshops eases production and a university system employing skilled ceramic sculptors brings avant-garde thinking to malleable minds. The last fact is crucial, being responsible for the unbroken continuity of the movement—as well as, of course, for a certain amount of incestuous inbreeding and encouragement of imitative thinking. The movement's very genesis occurred at a school: the Otis Art Institute in Los Angeles, in 1954.

The pioneer then (and guru still) was Voulkos, whose seemingly simple decision to carry an Abstract Expressionist type of sculptural vocabulary into the medium of fired clay was to have lasting repercussions. A man of terrific energies, he soon had several disciples and compatriots. Ken Price, Billy Al Bengston, and John Mason worked side by side with him during the four years he taught at Otis, and painters such as Craig Kauffman and Robert Irwin were friends and interested observers. The experimental spirit was intense. Voulkos's sculpture evolved as vertical, slapped-together piles of fired clay built to unheard-of heights of five feet or so. (The sculptor closest to him in style, Mason, later constructed a special kiln to accommodate his own even larger pieces.) "There were times,"

71. Ron Nagle: *Cup*, low-fired earthenware, multifired. San Francisco, 1976. H. 4¹⁵⁄₁₆″ (12.5 cm). Photograph: Courtesy Braunstein/Quay Gallery, San Francisco, California.

Voulkos told me recently, "when we tried to make the ugliest form in the world, but it still came out real good." Besides providing an initial impetus toward getting clay off the potter's wheel—a tool to which he would later return—Voulkos continued to attract and motivate others, including Malcolm McClain, Paul Soldner, Michael Frimkess, and Henry Takemoto at Otis, and, after Voulkos moved on to Berkeley in 1958, Jim Melchert, Ron Nagle, Stephen De Staebler, and Robert Arneson. As these students became teachers, a ripple effect commenced. For example, in the early 1960s Richard Shaw studied with Nagle, then around 1970 Ed Blackburn studied with Shaw (all this at The San Francisco Art Institute). In 1962 another scene began to evolve simultaneously at U.C. Davis (near Sacramento) around an artist who was becoming the second most influential figure in California ceramics, Robert Arneson.

Arneson carved out his own territory at U.C. Davis, which soon was to become a breeding ground for some of the rougher forms of Funk. Among other nonformalists there at one time or another have been painters Roy de Forest, William Wiley, and Bill Allen, and ceramicists David Gilhooly, Chris Unterseher, Ann Adair, and Sandy Shannonhouse, plus Levine and Shaw. No

place for a purist, that. To Voulkos's exploratory attempts to make the "ugliest form in the world," Arneson might be said to have added, in his earlier work at least, an ambition to make the most grotesque images. Among his breakthrough pieces are such anthropomorphic shockers as a man-eating toilet and a typewriter with red-lacquered fingernails for keys.

The ruggedness and swagger of Arneson's pungent performances might be seen as distantly akin in spirit to the muscular bravura of Voulkos. Marking a more complete break in the early 1960s were the small-scale works, often with combinations of abstract and humorous or ironic figurative elements, of Frimkess and Price. Price, in Los Angeles, was the first to use low-fired clay, thereby obtaining bright colors, and his highly finished *Lizard Cup* (1960) signaled a new sensibility whose first appearance was forcefully evoked for me by Nagle:

> There were two things that Price and Frimkess brought in . . . that I felt akin to, and they were lightness and humor. At that time what was going on reflected all the attitudes of the 1950s—big, macho stuff . . . It took a lot of guts to go out and make those little dinky things with bright colors on them . . . There are people to this day who think ceramics are supposed to look like *earth!*

Though he has produced a variety of abstract forms—and is reportedly now working on a big walk-in environment at his home in Taos, New Mexico—Price, like Nagle, has repeatedly returned to the cup motif, with its allusions to intimacy and function (though few of his cups are at all functional). "Doing cups" has been very popular in California since Price and Nagle focused on the form, as has "doing" teapots, cookie jars, paper plates, soup bowls, pitchers, cartons, paper bags, etc. The easy whimsicality of much of this derivative work points up, by contrast, what the cup is in the hands of Price and Nagle: a serious small-scale sculptural alternative. Both artists use the form to synthesize aspects of painting and sculpture, as in Price's recent series involving tumbling and clustering geometric volumes—looking almost offhandedly stuck together, but specifically referring to post-Cubist abstraction.

Nagle's respect for modernist painting—its concentration on color, surface, and edge—is combined with his love of the ceramic excellence of other historical epochs; he speaks often of the Momoyama period of Japan. In his recent work, cylindrical and conical forms, often in groups of three, appear to balance precariously, gently touching each other or pulling away unpredictably. Contrasting textures—pitted next to smooth next to soft matte—energize these slip-cast, low-fired pieces, which are displayed on boxes or pedestals topped with clear glass and which radiate an aura of harmony and resolution.

To the extent that their use of the cup form is in itself ironic and that they have indulged in broader whimsy on occasion (reptiles, nude women, and excrementlike blobs in Price's case), Price and Nagle can be related to Arneson and the Bay Area tradition of humor, despite the fact that Price has always head-quartered in Los Angeles. Among younger artists located stylistically between the extremes of purity and bumptiousness are Shaw and Robert Hudson, who make peculiar, delicately crafted constructions of stylized or geometricized and natural forms. (A current Shaw specialty is Harnett-like trompe-l'oeil, accomplished with fired-on silk-screen decals of images from playing cards, drawings, etc.) More decidedly bumptious are Gilhooly and Clayton Bailey, each of whom has created a private mythology populated by hundreds of characters, exclusively frogs in Gilhooly's case. This whole business of hilarity in California ceramics is a critic's headache that could do with a little discussion here.

Humorous art, especially when executed in the "lowly" medium of clay, faces much condescending rejection from purists. Writing about Arneson, Dennis Adrian (*Art in America*, September 1974) discussed the closed-mindedness often encountered in "the English-speaking/thinking audience," which tends to interpret the pun (Arneson's favorite rhetorical device) as simplistically humorous. But, he points out, "as any scholar of Joyce or translator of Japanese poetry will wearily insist, the primary function of any kind of pun is the expansion of meaning, within a discrete form, into at least two simultaneous modes of thought." However, much ceramic sculpture succumbs to the dogged compulsion to tell the same joke—even a rather good joke, loaded with multiple associations—over and over to the point of exhaustion. Of course, the use of humor and of such crowd-pleasing tactics as trompe-l'oeil (as in Marilyn Levine's renditions of scuffed leather bags, shoes, and whatnot, which might just as well be the real thing) ensures a quick accessibility to the public; depending on how one looks at it, this may be viewed either as contributing to the vitality of the scene or as flooding it with ignoble junk.

The Funk affinities of ceramic work generally associated with San Francisco and Sacramento are, of course, shared by the dominant painting and sculpture in those centers. (In fact, Hudson is perhaps best known for his sculpture and he also paints.) In contrast, ceramics in Los Angeles are more formal and less apt to be figurative; they share aesthetic concerns with a broad spectrum of avant-garde art done there in other mediums. Prominent among the leading Los Angeles ceramicists in addition to Price, who include Soldner and Jerry Rothman, is Mason, whose work has been responsive to stylistic crosscurrents in American art ever since he studied with Voulkos in the 1950s. From 1957 to

74. George Geyer: *Water Tank Pieces*, in process: plastic clay, slaking in water tanks. Los Angeles, 1975. Approx. 72″ (1.83 m). Photograph: Courtesy Los Angeles Institute of Contemporary Art, California.

taken the environmental/conceptual/process orientation fostered by Mason to a violent extreme. Judy Chicago, known for her paintings of an abstracted "female" iconography, has infiltrated the world of china painters, painting her jewellike butter/vagina/flower images on flat porcelain forms, with poetic messages in script around the perimeters; the process is complex and involves multiple firings. More than any work I have seen of Chicago's, the porcelains, which are gradually increasing in scale as she masters the craft, elevate female imagery beyond politics. Robert Graham's best-known works have been small constructions comprising realistic wax figures in domestic environments encased in Plexiglas. Now he is making porcelain relief sculptures that establish a contemporary dialogue with ancient classical form. Isolation, replication, and anthropological overtones are felt in miniature body parts, heads and faces both recessed and obtruded in unglazed, off-white porcelain fragments.

The ambition of certain other Southern California artists, meanwhile,

75. Tom Colgrove: *Wall Learning Sculpture*, in process: glass, slurry. Los Angeles, 1975. Approx. 54″ (1.37 m). Photograph: Courtesy Los Angeles Institute of Contemporary Art, California.

would seem to be literally to merge the ceramic movement with the flow of current avant-garde art. I have in mind the work of Larry Shep and Roger Sweet that was seen in a 1975 exhibition at the Los Angeles Institute of Contemporary Art (also in the show were Tom McMillan, George Geyer, and Tom Colgrove). Shep and Sweet did away with the ceramic object. In its place, one was treated to the spectacle of hundreds of pounds of clay and dirt drying, settling, and dissolving in water, as if to obliterate even the material possibility of ceramic sculpture once and for all. The aptness of their gesture for the future of ceramic art in California will remain to be seen.

Viewpoint: Ceramics 1977

Erik Gronborg

"The most recent trend in ceramics has been the exploration of all the technological possibilities of a complex industrial society. The ceramic artists have moved away from the self-indulgent physical 'involvement' with clay to an emphasis on the product and the use of whatever techniques and materials that will produce the desired effect."

Erik Gronborg is a sculptor and ceramist. His interest in clay began shortly after winning the City of Paris Award at the Paris Sculpture Biennale in 1962. He has since participated actively both as an artist and as a perceptive commentator on the stylistic drift of ceramics. *Viewpoint: Ceramics 1977* was written as the introduction to an exhibition of the same name by the Grossmont College Art Gallery, El Cajon, California. The illustrations are drawn from the work shown in that exhibition.

Viewpoint: Ceramics 1977

. . . an awareness of styles, or some common attitudes, can be of help in understanding what the artist is trying to achieve."

This is the first in a series of annual group exhibitions of artists working in clay. The artists are selected for their individual appeal, allowing whatever diversity or uniformity that may result, without any attempt to establish a style.

Though it may be possible to set a date for the origin of a new style or mode

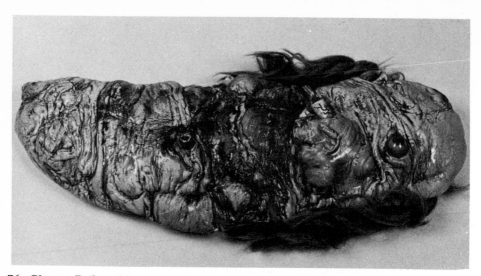

76. Clayton Bailey: *Alien Life Is Created out of Mud,* mixed media. Hayward, California, 1975. D. 17¾" × 11¹³⁄₁₆" (45 cm × 30 cm). Photograph: Claire Meyer.

of working, there is rarely a fixed terminal date. Each style appeals to a certain sensibility, background, and social attitude. It is usually broad enough to provide opportunities for individual expression and accommodation to changing ideas. Therefore, though a new style may attract the public spotlight for a time, numerous artists will continue to find valid expression of their sentiment within the "old" style. The public art world today as reflected in museum exhibitions and art publications seems to acknowledge this diversity of overlapping styles, and to express a willingness to seek the personal meaning, the skill of the hand, and the sure eye in each artist, irrespective of style. This exhibition, "Viewpoint: Ceramics 1977," attempts to do this, looking at the work of a small group of artists, without definition and comparison.

Writings on contemporary ceramics have generally tried to describe a logical progression of developments or styles, from earthy, brown, wheel-thrown casseroles and weed pots to Voulkos and Abstract Expressionist handling of clay with all the physical involvement of massive amounts of clay, slabbed and torn and twisted. Then to Arneson and Bay Area Funk, with whimsical images of popular culture on a small scale and in bright colors, followed by a great exploration of techniques and materials not previously considered part of the potter's skill: mold-making and slip-casting, the use of underglazes, enamels, and lustres, multiple firings, airbrushing, and photographic techniques, and finally progressing to nonobject noncrafted nonfired works in clay: environment-, process-, video-, and performance-oriented. However, in looking at ceramics only as it fits

this progress story, exclusive emphasis is placed on radical innovation within this definition of progress, and the individual artist is only important as far as he or she supports the theory. Ignored are the qualities of craftsmanship and personal expression, and with it the great diversity that exists in the field of ceramics today.

Nevertheless, an awareness of styles, or some common attitudes, can be of help in understanding what the artist is trying to achieve. Art appreciation is not an inherent ability, but an acquired skill based on a knowledge of the ideas and principles that motivate the artists. Therefore it may be appropriate to review briefly some of the most common styles that characterize contemporary ceramics.

The philosophical framework for "traditional" pottery is the village potter, the maker of utilitarian pottery serving the immediate needs of his society. The craftsman works within a self-imposed set of technical processes, shaping the earthy stoneware clay on the potter's wheel into familiar utilitarian pots, plates, and pitchers, with emphasis on the usefulness of these pots: lids that fit, teapots that do not drip. The craftsman approaches the making of pots as a production, turning out considerable numbers of almost identical works, without a need for each work to involve a unique statement of creative exploration. Since most of the pottery consists of quite simple wheel-thrown forms that no potter could claim as his or her creative invention, since they have been commonly used for centuries, the artistic achievement in this traditional pottery is the display of skill, and a good sense for shape and proportions, and the relationship of the decoration and glazes to the pot, and above all the quality of the glazes. Traditional pottery is only a simple craft without the exquisite subtlety of stoneware glazing, with all the effects of mattes and stains, spots and streaks, overlapping, bleeding colors, in the most delicate variations. A hundred shades of brown can produce beautifully rich, colorful ceramics in the hands of a fine potter, revealing a distinct personality.

The Abstract Expressionist ceramic artists rejected the importance of utility in their work in favor of greater expressive possibilities. It is an even more self-indulgent expression than Action Painting (another word for Abstract Expressionism) because of the very physical nature of the clay and the involvement of the artist, his hands or whole body squeezing, slashing, tearing, slabbing, and throwing the clay. The key word to describe this work is *process*. What to the uninformed is a shapeless lump of accidents, a useless pot full of holes, is a graphic record of the physical forces that shaped the work, a sense of spontaneity and of time, and the distinct differences between a cut and a torn edge,

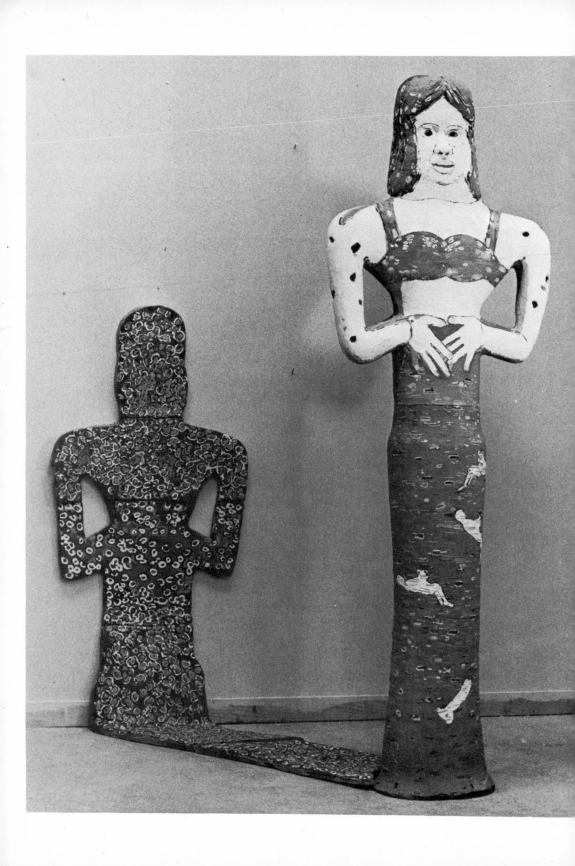

and the recognition of a hole punched through from the inside with ragged edges like a bullet hole through a tin can, and of leather stretched with surface cracks like old leather. That is the formal language of this style of ceramics. Once the viewer can see beyond the "accidents," he or she can appreciate the dynamic touch, powerful or delicate, and the sure sense of the best artists for organizing all these effects into a formally exciting whole, just as a painter organizes figures, shapes, lines, and colors. What may seem accidental in execution becomes deliberate in concept. It is the eye and mind of the artist that determine when the work is complete, not the way in which the details came into being.

Bay Area Funk ceramics, coinciding in time with Pop art as a response to the machismo of Abstract Expressionism, shows us artists playing, having fun, delighting in every color in the rainbow. Gone are the subtle impressions, holes, and wrinkles. As if finally acknowledging that they are not village potters, but sophisticated urban citizens, the Funk artists willingly give up all the earthy colors and "natural" surfaces. Clay is simply the most flexible, responsive ma-

77. Viola Frey: *Vessel Figure and Shadow*. Oakland, California, 1976. H. 70⅞" (1.8 m). Photograph: Claire Meyer.

78. Erik Gronborg: Stoneware bowl with low-fire glazes and photo decals. San Diego, California, 1977. 13" (33 cm). Photograph: Claire Meyer.

79. Wayne Higby: *Winter Inlet*. Alfred, New York, 1975.
D. 30⁵⁄₁₆″ × 7⅞″ × 8⅞″ (77 cm × 20 cm × 22.5 cm). Photograph:
Claire Meyer.

terial in which to make their fantasies and images of their environment: toilets,
sofas, nostalgic knickknacks, Tarzan jungles, and weird monsters. These images
are frequently modeled without any regard to surface quality, just as a six-year-
old kid works his Play-Doh. The glazes are often store-bought, commercial low-
fire glazes, without the spots and streaks of the reduction stoneware. The glazes
are looked upon simply as colors: red, green, blue, and so on. The artistic
achievement of these works is not in the formal qualities of delicacy of glazes, or
expressive cuts and tears. It is in the idea. The realization of that idea, of the
image, is the real effort of the artist; and the artist is recognized by the imagery
or subject matter, not the handling of the clay and glazes. At its best, works of
this style are characterized by great visual wit, showmanhship worthy of the best
stand-up comics, and the ability constantly to surprise the viewer.

The most recent trend in ceramics has been the exploration of all the tech-
nological possibilities of a complex industrial society. The ceramic artists have
moved away from the self-indulgent physical "involvement" with clay to an
emphasis on the product and the use of whatever techniques and materials that
will produce the desired effect. Techniques not previously part of the potter's
skill, and often considered improper, if not outright deceptive, are now in com-
mon use: air-brushing and glaze-spraying, mold-making and slip-casting, under-
glazes, china•paints, lustres, acrylic paints, and combinations with other materials
such as metal, plastics, and feathers, and images on clay using various photo-
graphic techniques. The works often require very complex planning of numerous
steps, such as tedious masking off of areas before spraying, or multiple firings, up

to as many as fifteen firings to gradually create the desired surface and image quality. It is a way of working as far removed from the village potter as the Detroit assembly line is from the old blacksmith. *Process* is still a key word in the making of ceramics; but it is a mechanical rather than a natural, organic process. The works are as perfect as a new automobile or television set.

Though much of the ceramics being done today is sculptural and nonfunctional, there are still many artists making *decorated pots*. These artists find a challenge in working with the subject of the vase or plate rather than with the human figure or slabs and cylinders. In keeping with the pottery tradition, there is in this work a strong emphasis on decoration and pattern. As descendants from the classical Greek vase or the china-painted Ming dynasty vase, the *decorated pot* shows the clear subordination of images and colors to an overall sense of organization, symmetry, regular sequences of identical shapes, with the "message" or subject matter (landscape, political statement, portrait, etc.) im-

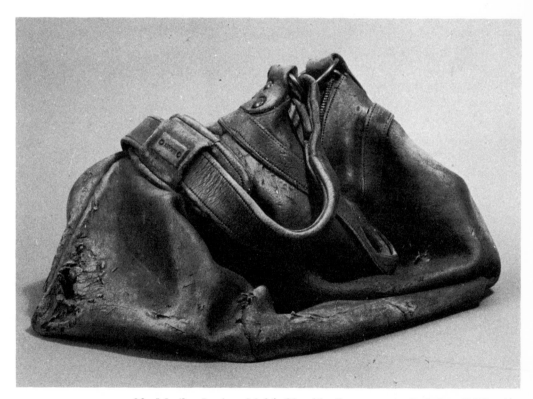

80. Marilyn Levine: *Maki's Shoulder Bag*, ceramic. Berkeley, California, 1975. D. 6⅞" × 13¹³⁄₁₆" × 12¹³⁄₁₆" (17.5 cm × 35 cm × 32.5 cm). Hansen Fuller Gallery, San Francisco, California. Photograph: Claire Meyer.

portant only as it successfully relates to the total design. The works in this group utilize all the techniques previously mentioned: rough, expressionistic slab-built plates with a few cuts and holes and a simple slip decoration, or a slip-cast box air-brushed with underglazes, or a wheel-thrown vase with comic-strip drawing in china paints. Rather than trying to divorce themselves from the pottery tradition in order to gain respectability as sculptors, the makers of the *decorated pot* are expressing a belief in the vitality and the creative possiblities of a separate artistic tradition based on the pottery of the past.

These various styles cannot be seen as absolute definition of what the artist can do. There is a considerable overlap of work that includes elements from several of the styles, such as Pop imagery made in a technique involving slip-cast elements and air-brush glazing.

One may question, why present exhibitions of ceramics, rather than just sculpture? Why do we not make general categories of bronze cast sculpture, or plastic sculpture, or acrylic painting? The only answer to me is that there is a particular tradition of involvement with clay and glazes, which gives these ceramic works, whether pots or sculpture, a certain character. Though the trends in ceramics largely follow general stylistic developments in art, the ceramic works never quite lose the craft element: the manipulation of a plastic mass, the emphasis on *object*, the ready use of color as part of the glaze tradition, the small scale and preciousness of appearance, and the reference in various degrees to the useful object, the pot and the plate. These are the qualities that make the difference between *ceramics* and *sculpture made of clay*.

Bibliography

The bibliography has been arranged under the names of the contributors to this anthology. An asterisk following the name of a contributor indicates that the bibliography accompanied the original essay. The bibliography has been assembled to give a reading list for the period and aesthetic covered in the anthology as well as to indicate the depth of contribution to ceramic literature by some of the contributors.

BALLATORE, SANDY

"Clay Works in Progress." *Journal* (November/December 1975).

Foley, Suzanne, and Prokopoff, Stephen. *Robert Arneson.* Chicago: Museum of Contemporary Art, and San Francisco Museum of Art, 1974.

Foote, Nancy. "The Photo-Realists" (Interview with M. Levine). *Art in America* (November/December 1972).

Frankenstein, Alfred. "The Ceramic Sculpture of Robert Arneson." *ARTnews* (January 1976).

Haas, Charlie. "Judy Chicago's 'The Dinner Party': A Room of Her Own." *New West* (August 1, 1977).

Haskell, Barbara. In *John Mason: Sculpture.* Pasadena: Pasadena Museum of Modern Art, 1974.

San Francisco Museum of Art. *Richard Shaw/Robert Hudson: Works in Porcelain.* Essay by Suzanne Foley. San Francisco, 1973.

Slivka, Rose. "The New Clay Drawings of Voulkos." *Craft Horizons* (September/October 1968).

CARDEW, MICHAEL

Cardew, Michael A. "Industry and the Studio Potter." *Crafts* (The Red Rose Guild of Craftsmen), 1942.

———. *A Preliminary Survey of Pottery in West Africa.* Lagos: Department of Commerce and Industry, September 15, 1950.

———. "Pioneer Pottery at Abuja." *Nigeria Quarterly,* no. 52 (1956).

———. "Design." *Currency* (Magazine of the Austrian Reserve Bank) (July 1969).

———. Introduction to *Nigerian Pottery.* Edited by Leith Ross. Ibadan: Ibadan University Press, 1970.

———. "Potters and Amateur Potters." *Pottery Quarterly,* no. 38 (1971).

———. "Life as a Potter." *American Crafts Council,* Gatlinburg (June 1971).

———. "Ladi Kwali." *Craft Horizons* (April 1972).

———. "A View of African Pottery." *Ceramics Monthly* (February 1974).

———. "What Pots Mean to Me." *Ceramic Review* (March/April 1975).

———. "The Fatal Impact." In Clark, Garth R., *Michael Cardew.* Tokyo: Kodansha International, 1976, pp. 215–224.

Clark, Garth R. "Michael Cardew and Associates." *Crafts,* London (July/August 1975).

———. *Michael Cardew.* Tokyo: Kodansha International, 1976.

———. "The Fire's Path—Michael Car-

dew." *Studio Potter*, Goffstown (1976).

Counts, Charles. "Michael Cardew." *Craft Horizons* (February 1972).

Crafts Advisory Committee. *Michael Cardew: A Collection of Essays*. London: Crafts Advisory Committee, 1976.

Hennel, Thomas. *The Countryman at Work*. London: Architectural Press, 1947.

Marsh, Ernest. "Michael Cardew, A Potter of Winchcombe, Gloucestershire." *Apollo* (March 1943).

O'Brien, Michael (Seamus). "Abuja After Michael Cardew." *Ceramic Review*, 34 (July/August 1975).

Pleydell-Bouverie, Katherine. "Michael Cardew: A Personal Account." *Ceramic Review*, 20 (March/April 1973).

COPLANS, JOHN*

Abner, Jonas. *Clay Today*. Exhibition catalogue. Ames: State University of Iowa, December 1962.

Ashton, Dore. "New Talent Exhibition at The Museum of Modern Art." *Craft Horizons*, 20 (March 1960).

Brown, Conrad. "Peter Voulkos." *Craft Horizons*, 16, no. 5 (September 1956).

"The Clay Movement." *Time*, 82, no. 8 (August 23, 1963).

Coplans, John. "Sculpture in California." *Artforum*, 2, no. 2 (August 1963).

———. "Out of Clay; West Coast Ceramic Sculpture Emerges as a Strong Regional Trend." *Art in America*, 51, no. 6 (December 1963).

———. "Circle of Styles on the West Coast." *Art in America*, 52, no. 3 (June 1964).

———. "Los Angeles: The Scene." *ARTnews*, 64, no. 1 (March 1965).

———. "Peter Voulkos." *ARTnews*, 64, no. 2 (April 1965).

———. "Voulkos: Redemption Through Ceramics." *ARTnews*, 64, no. 4 (Summer 1965).

Koyama, Fujio. *Contemporary International Ceramic Art*. Exhibition catalogue. National Museum of Modern Art, Tokyo, Japan, 1964.

La Porte, Paul. "John Mason: Ceramic Sculpture." *Artforum*, 1, no. 8 (February 1963).

Lippard, Lucy R. *Kenneth Price*. Exhibition catalogue. Los Angeles County Museum of Art, July 1966.

Los Angeles County Museum of Art. *Peter Voulkos*. Exhibition catalogue. April 1965.

———. *Robert Irwin/Kenneth Price*. Exhibition catalogue. July 1966.

———. *John Mason*. Exhibition catalogue. November 1966.

The Museum of Modern Art, New York. *Sculpture and Paintings by Peter Voulkos, New Talent in the Penthouse*. Exhibition catalogue. February/March 1960.

Norland, Gerald. "John Mason." *Craft Horizons*, 20, no. 3 (May/June 1960).

Pyron, Bernard. "The Tao and Dada of Recent American Ceramic Art." *Artforum*, 2, no. 9 (March 1964).

Reed, Gervais. *Adventures in Art*. Exhibition catalogue. Seattle World's Fair, 1962.

Slivka, Rose. "The New Ceramic Presence." *Craft Horizons*, 21, no. 4 (July/August 1961).

Soldner, Paul. "Ceramics West Coast" (Interview with Peter Voulkos). *Craft Horizons*, 26, no. 3 (June 1966).

FOLEY, SUZANNE*

Cicansky, Victor. "Contemporary Ceramics II, Tokyo." *Artscanada* (Spring 1972).

Giambruni, Helen. "Abstract Expressionist Ceramics." *Craft Horizons* (November/December 1966).

Gronborg, Erik. "The New Generation of Ceramic Artists." *Craft Horizons* (January/February 1969).

Jack, David. "Nut Art in Quake Time." *ARTnews* (March 1970).

Malcolm, Janet. "On and Off the Avenue: About the House." *The New Yorker*, September 4, 1971.

National Museum of Modern Art. *Contemporary Ceramic Art: Canada, U.S.A., Mexico and Japan.* Essay by Kenji Suzuki. Kyoto, Japan, 1971.

Nordness, Lee. *Objects: USA.* New York: The Viking Press, 1970.

Pugliese, Joseph. "At Museum West: Ceramics from Davis." *Craft Horizons* (November/December 1966).

Richardson, Brenda. "California Ceramics." *Art in America* (May/June 1967).

Slivka, Rose. "Laugh-in in Clay." *Craft Horizons* (October 1971).

Soldner, Paul. "Ceramics West Coast." *Craft Horizons* (June 1966).

Zack, David. *Nut Pot Bag or Clay Without Tears.* Davis, Calif.: Art Center of the World, 1971.

LEACH, BERNARD

Arts Council of Great Britain. *Bernard Leach: 50 Years a Potter.* Exhibition catalogue. 1961.

Barrow, Terry, ed. "Essays in Appreciation of Bernard Leach." *New Zealand Potter*, Special Issue (February 1960).

Cardew, Michael A. "Bernard Leach." *Studio* (November 1925), pp. 298–301.

———. "Bernard Leach Recollections." In "Essays in Appreciation of Bernard Leach," *New Zealand Potter*, Special Issue, edited by Terry Barrow (February 1960).

Ceramics Monthly Portfolio. "Bernard Leach." *Ceramics Monthly* (June/July 1976).

Digby, George Wingfield. "Bernard Leach—Bridge Between East and West." In "Essays in Appreciation of Bernard Leach," *New Zealand Potter*, Special Issue (February 1960).

Fieldhouse, Murray. "Workshop Visit to the Leach Pottery." *Pottery Quarterly*, no. 1 (1954), pp. 17–27.

Hodin, J. P. "Bernard Leach and His 30 Years in the Service of Ceramic Art." *Studio* (March 1947), pp. 89–92.

———. "Der Keramiker, Bernard Leach." *Werk* (April 1947).

Leach, Bernard. *An English Artist in Japan.* Tokyo, 1920.

———. "A Potter's Outlook." *Handworkers Pamphlets*, St. Dominic's Press, Sussex, no. 3 (1928), p. 39.

———. *The Potters Book.* London: Faber & Faber, 1940.

———. *Fifteen Craftsmen on Their Crafts.* Edited by John Farleigh. London: Sylvan Press, 1945.

———. "The Contemporary Studio Potter." *Journal of The Royal Society of Arts*, London (May 21, 1948).

———. "American Impressions." *Craft Horizons* (Winter 1950).

———. *A Potters Portfolio: A Selection of Fine Pots.* London: Lund & Humphreys, 1951.

———. *The Integration of the Craftsman.* The Report on the International Conference in Pottery and Textiles at Dartington Hall, Totnes, Devon, July 17–27, 1952.

———. "The Contemporary Studio Potter." *Pottery Quarterly*, 5, no. 18 (1955).

———. *Kenzan and His Traditions.* London: Faber & Faber, 1960.

———. *A Potter in Japan, 1952–1954.* London: Faber & Faber, 1960.

———. "Looking Backwards and Forwards at 72." In "Essays in Appreciation of Bernard Leach," *New Zealand Potter*, Special Issue (February 1960).

———. *The Unknown Craftsman.* Tokyo: Kodansha International, 1972.

———. *Shoji Hamada.* Tokyo: Kodansha International, 1975.

Lewis, David. "Leach and Hamada." *Studio,* 144 (1952), pp. 114–117.

Lippe, Jens von der. "Bernard Leach Stengods." *Bonytt,* nos. 5/6 (1949).

Marsh, Ernest. "Bernard Leach." *Apollo* (1943), pp. 14–16.

Pleydell-Bouverie, Katherine. "At St. Ives in the Early Years." In "Essays in Appreciation of Bernard Leach," *New Zealand Potter,* Special Issue (February 1960).

Richman, Robert. "The Leach Pottery at St. Ives." *Craft Horizons,* 10, no. 3 (1950), pp. 24–28.

St. Ives Council. *Bernard Leach.* c. 1968.

MORRIS, WILLIAM

Eyles, Desmond. *Royal Doulton, 1815–1895: The Rise & Expansion of the Royal Doulton Potteries.* London: Hutchinson, 1965.

Gaunt, William, and Stamm, Clayton, M.D.E. *William de Morgan.* London: Studio Vista, 1971.

Hillier, Bevis. *Pottery & Porcelain, 1700–1914.* London: Weidenfeld & Nicolson, 1968, and New York: Meredith, 1968.

Jewitt, Llewelyn Frederick William. *The Ceramic Art of Great Britain from Prehistoric Time to the Present Day.* 2 vols. London: S. Virtue & Co., 1878. 2d ed., 1882. Reissued as *Jewitt's Ceramic Art of Great Britain, 1880–1900.* Edited by G. A. Godden. London: Barrie & Jenkins, 1972.

Marryat, Joseph. *Collection Towards a History of Pottery & Porcelain in the Fifteenth, Sixteenth, Seventeenth & Eighteenth Centuries.* London: John Murray, 1850.

Morris, May. "William de Morgan."

Burlington Magazine, London (August/September 1917).

Morris, William. "The Lesser Arts of Life." In *Lectures on Art Delivered in Support of the Society for the Protection of Ancient Buildings.* Edited by J. H. M. London. 1883.

———. "Comments on Lecture." *Pottery Gazette,* London (January 1883).

Royal Academy of Arts, London. *Handley Read Collection: Victorian & Edwardian Decorative Art.* London, 1972.

Solon, Louis Marc Emanuel. *The Art of the Old English Potter.* London: Derby, Bemrose & Sons, 1883.

Stirling, A. M. W. *William de Morgan and His Wife.* Preface by Sir W. Richmond. London: T. Butterworth, 1922.

Thomas, Lloyd E. *Victorian Art Pottery.* London: Guildart, 1974.

Wakefield, Hugh. *Victorian Pottery.* London: H. Jenkins, 1961.

MOUREY, GABRIEL

d'Albis, Jean. "Autour du rosaire d'Ernest Chaplet." *l'Estampile,* no. 24 (1977).

Eidelberg, Martin. In *Japonisme: Japanese Influence on French Art, 1854–1910.* Published jointly by The Cleveland Museum of Art, The Rutgers Art Gallery, and Walters Art Gallery, 1975.

Französische Keramik zwischen 1850–1910. Köln: Kunstgewerbemuseum, 1974.

Lecomte, George. "Auguste Delaherche." *Art et Décoration,* 40 (1921).

Marx, Roger. "Auguste Delaherche." *Art et Décoration,* 19 (1906).

———. "Souvenirs sur Ernest Chaplet." *Art et Décoration,* 27 (1910).

Musée National de Céramique, Sèvres. *L'Art de la Poterie en France de Rodin à Dufy.* Sèvres, 1971.

"The Renaissance of the Potter's Art in France." *Studio* (1893), pp. 180–181.

Rudder, J. L. de. "Jean Carriès." *l'Estampile*, no. 32 (May 1972).

Schurr, Gerald. "Jean Carriès, ou le génie du grès." *Gazette de l'Hôtel Drouot*, no. 38 (November 1972).

SOLON, LOUIS MARC EMANUEL

Solon, Louis Marc Emanuel. *A Brief Account of Pâte sur Pâte.* Stoke-on-Trent, 1894.

———. *A Brief History of Old English Porcelain and Its Manufactories.* London: Bemrose & Sons, 1903.

———. *A History and Description of Italian Majolica.* London: Cassell, 1907.

———. *A History and Description of the Old French Faïence with an Account of the Revival of Faïence Painting in France.* London: Cassell, 1903.

———. *The Ancient Art Stoneware of the Low Countries and Germany or "Grès de Flandres" and "Steinzeug": Its Principal Varieties and the Places Where It Was Manufactured During the XVIth and XVIIth Centuries.* 2 vols. London, 1892.

———. *The Art of the Old English Potter:* London: Derby, Bemrose & Sons, 1883.

———. *Catalogue of the Solon Collection of Early English Pottery.* Stoke-on-Trent, 1912.

———. *Pottery Manufacture in Staffordshire During the Last Century.* Stoke-on-Trent, 1901.

———. *Pottery Worship: The Fallen Idols.* 7 pts. Stoke-on-Trent, 1898.

———. *The Rouen Porcelain and the Saint-Cloud Porcelain.* London, 1905.

———. *The Solon Collection of Pre-Wedgwood English Pottery.* Stoke-on-Trent, 1902.

GARTH CLARK was born in 1947 in Pretoria, South Africa, and has an M.A. in Ceramics from the Royal College of Art in London. After working in public relations until 1973, he decided to become a ceramics art historian. Since then he has been involved in research and lecture tours in Africa, Asia, and America. He is currently Visiting Professor of Art at California State College in Fullerton.

His books include *Potters of Southern Africa* (1974), written with his wife Lynne, and *Michael Cardew* (English edition 1977). *Ceramic Review, Crafts, Studio Potter,* and *Ceramics Monthly* are some of the periodicals in which his articles have appeared.